Becoming an Ac

The collaboration of director and actor is the cornerstone of narrative filmmaking. This book provides the director with a concrete step-by-step guide to preparation that connects the fundamentals of film-script analysis with the actor's process of preparation.

This book starts with how to identify the overall scope of a project from the creative perspective of the director as it relates to guiding an actor, before providing a blueprint for preparation that includes script analysis, previsualization, and procedures for rehearsal and capture. This methodology allows the director to uncover the similarities and differences between actor and director in their preparation to facilitate the development of a collaborative dialogue. Featuring chapter-by-chapter exercises and assignments throughout, this book provides a method that enables the director to be present during every stage of production and seamlessly move from prep to filming while guiding the actor to their best performances.

Written in a clear and concise manner, it is ideal for students of directing, early career and self-taught directors, as well as cinematographers, producers, or screenwriters looking to turn their hand to directing for the first time.

Regge Life is a producer, director, and writer for film and television. He is currently the Senior Distinguished Director in Residence at Emerson College in Boston, MA, and has enjoyed a continuing career in film, theater, and television. His most recent work is a film adaptation of the Akutagawa Prize-winning novel *Cocktail Party* by Tatsuhiro Oshiro. He is a member of the Directors Guild of America, Stage Directors and Choreographers Society, four-time CINE Award winner, Sony Innovator, Fulbright Journalist Fellow, Emmy Nominee, and member of the Black Filmmakers Hall of Fame.

"Regge Life shares his approach to directing, honed by first-hand experience in the American film industry and informed by a valuable international perspective. This is a text that should find a place on the bookshelf of any prospective film and television director."
<div align="right">Tom Kingdon. Author of *Total Directing*</div>

"Finally a book that examines the most important relationship in film making, the director and actor."
<div align="right">John Chase Soliday, Associate Professor, Director of Undergraduate/Graduate Studies, Cinema Arts Department, University of Miami Florida School of Communication</div>

"Regge Life has written an easy-to-understand deep dive into the preparation essential for directors of theatre, film and television to create their best storytelling. He provides step-by-step how-to tools, practice examples, personal stories, technical recommendations, and helpful daily practices that define the director's homework. His incisive point-of-view, forged through decades of global experience and classroom teaching, demystifies the art of directing. A blueprint for gaining command of and confidence in one's directing work, this is must reading for the novice, early career practitioner, and seasoned veteran."
<div align="right">Benny Sato Ambush, Professional SDC Director, Educator, Published Commentator</div>

"Throughout his text, Regge Life goes beyond the mere technical and mechanical concerns of directing for the camera to focus on the social and emotional aspects of human interaction — the crucial connection at the heart of successful storytelling. Readers of *Becoming an Actor's Director* will find themselves in the hands of a master teacher."
<div align="right">Jabari Asim, Associate Professor and MFA Program Director, Creative Writing Deparment of Writing, Literature and Publishing, Emerson College</div>

Becoming an Actor's Director

Directing Actors for Film and Television

Regge Life

Routledge
Taylor & Francis Group
LONDON AND NEW YORK

First published 2020
by Routledge
2 Park Square, Milton Park, Abingdon, Oxon OX14 4RN

and by Routledge
52 Vanderbilt Avenue, New York, NY 10017

Routledge is an imprint of the Taylor & Francis Group, an informa business

© 2020 Theodore R. Life

The right of Theodore R. Life to be identified as author of this work has been asserted by him in accordance with sections 77 and 78 of the Copyright, Designs and Patents Act 1988.

All rights reserved. No part of this book may be reprinted or reproduced or utilized in any form or by any electronic, mechanical, or other means, now known or hereafter invented, including photocopying and recording, or in any information storage or retrieval system, without permission in writing from the publishers.

Trademark notice: Product or corporate names may be trademarks or registered trademarks, and are used only for identification and explanation without intent to infringe.

British Library Cataloguing-in-Publication Data
A catalogue record for this book is available from the British Library

Library of Congress Cataloging-in-Publication Data
Names: Life, Regge, author.
Title: Becoming an actor's director : directing actors for film and television / Regge Life.
Description: London ; New York Routledge, 2020. | Includes index.
Identifiers: LCCN 2019027791 | ISBN 9780367191870 (hardback) | ISBN 9780367191900 (paperback) | ISBN 9780429200946 (ebook)
Subjects: LCSH: Motion pictures–Production and direction–Vocational guidance. | Television–Production and direction–Vocational guidance.
Classification: LCC PN1995.9.P7 L475 2020 | DDC 791.4302/33–dc23
LC record available at https://lccn.loc.gov/2019027791

ISBN: 978-0-367-19187-0 (hbk)
ISBN: 978-0-367-19190-0 (pbk)
ISBN: 978-0-429-20094-6 (ebk)

Typeset in Sabon
by Newgen Publishing UK

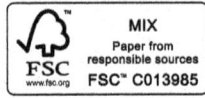 Printed in the United Kingdom by Henry Ling Limited

This book is dedicated to Yoji Yamada and Jay Sandrich who defied the rules to grant me the opportunity of a lifetime.

Contents

Foreword by Tom Kingdon — ix
Introduction — x
Preface — xv
Acknowledgments — xix

1 What is directing and the "prose" of preparation — 1

2 Storyline Facts: The bridge to the Three Questions to Choice — 11

3 The Three Questions to Choice: Walking in the actor's shoes — 16

4 The Five Tools: Bringing the ensemble together – Part I — 27

5 The Five Tools: Bringing the ensemble together – Part II — 34

6 Moments and Beats — 56

7 Marking your script — 62

8 The Improvised Monologue: Exploring collaboration through personal experience — 71

9 The Scripted Monologue: Prelude to directing a two-person scene — 84

10 Presenting and responding to the monologues — 92

11	Scene work: Conducting the full rehearsal	99
12	Previsualization	110
13	Digital capture: Putting it inside the frame	145
14	Responding to scene work	153
15	Building your sixth sense: Breaking out of your comfort zone	157
16	The power of improvisation	162
	Epilogue	167
	Addendum	171
	Index	180

Foreword

What the director needs to know about the acting process:

You need to understand what acting is.
You need to understand what goes into a performance.
Performance is physical, and you need to experience that.
You need to know what actors are capable of.
You need to be able to evaluate a performance.
You need to be able to understand the acting language.
You need to understand various approaches to acting.
You need to be able to give an actor what they need in order to perform.
You need to understand what an actor specifically needs from a director.
You have to develop your intuition through life experience.
You have to understand improv.
You need to have acting exercises up your sleeve for younger actors.
Acting is the core discipline: From it springs writing and directing.

<div align="right">Tom Kingdon, Total Directing</div>

Introduction

In February 2019, Olivia Coleman accepted the Oscar for Best Actress and stated for all the world to hear, "Yorgos, my best director," honoring Yorgos Lanthimos, the director of *The Favorite*. Regina King accepted the Oscar for Best Supporting Actress in *If Beale Street Could Talk*. Honoring director Barry Jenkins, she shared, "Barry, you nurtured her and surrounded her with so much love and support so it's appropriate for me to be standing here. I am an example of what it looks like when support and love is poured into someone." Mahershala Ali, while accepting his Oscar for Best Supporting Actor, added his praise, "Peter Farrelly, I thank you for your leadership and your guidance and for also giving us space, like giving us space to really work it out." All three directors were praised that evening for being actors' directors, practitioners of the origins of feature filmmaking. Directors immortalized in still photographs: Alfred Hitchcock, Elia Kazan, Lena Wertmuller, and many others, often seated right beside the camera, just a few feet away from the performers to witness the work intimately. Before video monitors allowed the director to view a filmed performance, the "take" to print was all determined live, in the Moment, by the director's eye and affirmed by the cinematographer's nod. This was how movies were made and, in many cases, are still being made to this day.

The collaboration of actor and director is the cornerstone of narrative filmmaking. When directors and actors are working together in a shared language that combines directing methodology with acting vocabulary, they give birth to a creative collaboration, a delicate dance of ideas, creativity, and inspiration. This is the ideal relationship between the director and the actor – the ultimate bond.

This book, *Becoming an Actor's Director*, is focused on the process of becoming an "actor's director." A director needs the knowledge of the actor's process coupled with the craft of directing preparation. This is the necessary foundational work that every director must commit to in

order to begin a project. Preparation qualifies the director to collaborate with the actor to build and develop a character and to tell the story. This is a craft that directors of live theater study as a matter of course, but many young media-makers unfortunately do not. Some filmmakers are more versed in technology – newer cameras, faster lenses, apps, wireless communication between devices, color grading, etc. How to work with actors is a part of their training that is sorely missed or in some cases ignored. "Let the actor be responsible for the performance. Just make sure all your technology is working and your 'shot' is what you want" is often the director's only goal. In this scenario, storytelling, the foundation of narrative structure, is sidelined or overlooked. As a result, there is a disconnect due to the lack of direction focused on the actor's performance. When this occurs, actors find themselves in service to the 'shot' and not free to follow the instincts of the characters. To move with their performance now "in the body," this kinesthetic activity should be what motivates the movement of the camera to "capture" the action – to "capture" the true act of storytelling.

As most instructors know, students and young filmmakers do their best to avoid proper preparation. I have often heard this statement, "Why prep? I have been told that I am an auteur; people have called me an artist; just let me be creative, free in the Moment with no boundaries or rules." At these times, I am compelled to share this dogma: "Fail to prepare – prepare to fail." Young directors have to learn that preparation is not busy work but a vital part of the path to being an auteur.

There is a misconception in the community of young filmmakers due to the way the work of notable directors is covered by the entertainment industry and press that give the impression that these filmmakers just show up on set and make magic happen. There is still the image of the Director (big D intended here) wearing a beret, holding a cup of cappuccino, and shouting into a megaphone what they want the actor to do. This is directing: telling the actor what to do, which includes how to say the lines, how to move, what gestures to use, etc. As I say to my students at the start of each and every semester, after you read a script, like it or not a movie begins to play on the inside of your forehead. But that probably isn't going to be the movie that gets made unless you are doing animation or perhaps puppetry. The director's partner in storytelling is the actor. They need to be working together in a step-by-step process that begins with casting and moves into rehearsal and finally into production. Preparation is needed and necessary to put both actor and director on the same page with regard to the development of a character. When there are creative differences (note I do not use the word

"disagreement"), it is not about who is right: it is about what is right to tell the story. What the project is about and how that propels the story is the bottom line. It is my hope that in this world of young people living in their cellphones and expecting instant gratification with everything in life, young directors and students of directing will realize there is more to learn if they want to work collaboratively with actors.

In writing this book, I have been greatly influenced by these books on directing: Judith Weston's *Directing Actors*, Tom Kingdon's *Total Directing*, John Badham's *On Directing*, and Sidney Lumet's book, *Making Movies*. These are all excellent reads and cogent guides for directing. I wanted to deconstruct portions of each of these books, partnering them with my methodology, to focus on director preparation and to create a step-by-step roadmap that will allow the director to prepare thoroughly via a structure that works in concert with the actor's preparation when building and developing a character.

Directors are master storytellers so if the director is prepared they can be present and in the Moment with the actor and thereby be one to one with the acting process. All actors strive to be "present" or "in the Moment" with their scene partner and the given circumstances of the world of the movie, television show or play. What has been missing in film-director training is the bridge linking theatrical rehearsal techniques based on actor training to the process of filmmaking and digital production.

Like most methodologies, this is a process, so, as a young director, focus on the process and not immediate gratification. With encouragement and consistency, you will understand the importance of preparation as little by little it sinks into your bones and becomes easier to do. A process of discovery emerges that becomes enjoyable in the same way it is for an actor when they finally get to the place where they stop acting and experience what it is like to "be" the character. This is crucial because many young directors are directing their actors for a result (result-oriented direction, or ROD), based on the movie playing on the inside of their forehead. This is a spot-on term coined by Judith Weston. In order to address this and to slowly wean the young director away from this expectation, trust the process. Trust the steps of preparation and allow each step to birth the step that follows. Actors are taught this methodology from the beginning of their training. They are made to understand that there are steps to becoming an actor. Steps that begin with games and improvisation, breathing and body work, understanding and working with various kinds of text and the incorporation of movement and choreography. This work continues with advanced training in all of the above, master

classes and workshops often devoted to developing a specialty. All of this creates their signature as a performer. For some actors, it is the ability to shapeshift and become the character. For others, it is an adaptation where we still know we are watching a performance. The variations are numerous, and that is what makes watching actors so exciting.

We sometimes think actors are strange with their personal rituals, such as specific warm-ups during rehearsal and even in performance. The experienced actor knows this is part of their work. This is something to learn from as a young director. Be inspired by this kind of dedication to take the journey with actors and in doing so you will find your personal journey, a journey that will one day lead you to your signature as a director.

Directors need to find new things each day of rehearsal and definitely during production. Take each step of the process, like each day of production, one at a time. Celebrate the passion for learning and what I call the "hunger in the belly" approach to exploration: how each day contributes to your understanding of preparation. It is through this process the director can be "present" and in the Now as the scene unfolds in rehearsal and in production. This should be the goal of the director: preparation to be present.

Following this path, the director is truly open and free to really be creative. They are no longer preoccupied with anything else except attention to the actor's performance: the core element of storytelling. You are on the right path to eventually arrive at a place where you've earned the right to call yourself an auteur – a director who has developed a style, a unique way of working with the actor, an uncontested signature. It is this signature that earns them the right to state in the credits, this is "a film by . . ."

If your plan is to be working in narrative production, working with actors to tell important stories, this book will be a guide for your journey. The lessons that follow will require dedication and patience. If you are willing to open yourself to new ideas and concepts about directing, you will soon connect the dots. You will see how each and every chapter is a step contributing to a deeper understanding of the work of the actor's director. You will become adept at script analysis and likewise gain a deeper understanding of the actor's process.

A word of caution: There are no shortcuts in preparation. Trust the process and follow it step by step in the same way actors do. It will work for you.

As the director, your preparation starts well in advance of rehearsal. You start to build a knowledge base, a layered understanding of the

material. The months and sometimes years of preparation to nurture your director's vision is something no one sees. This is many times a solitary act. It is called woodshedding, to coin a phrase from music, done day after day, and doesn't necessarily make for sexy copy in a magazine. It is the work the director must do to see their vision realized. Preparation allows the director to relax, to be present, to be in the Moment in rehearsal and, more important, in production.

It has been rewarding for me, with the help of my present and former students, to develop and refine the process of teaching director preparation that has led to *Becoming an actor's director*. It is heartwarming to receive feedback from students about their takeaway of learning the process of preparation. Let me share a few of their comments with you now:

"I want to thank you for being such a great professor. Now about to enter production for my BFA in a week, I definitely feel more confident as a director and I have found myself preparing with pre-pro notes for my rehearsals in a couple days. This has been one of the most educational class I've taken."

"Thank you for the amazing semester and opening my eyes to a whole other side of directing for me."

"Thank you so much for the past semester! It was an epic journey and I took away with some helpful techniques as a director."

"From the bottom of my heart, I do sincerely thank you for all the patience you've shown me. It has surely not been easy on me so thank you for giving me a chance to complete the course! Even toward the end of my last full prep I was noticing how much easier it was for me to articulate all the required information, and as a result I was able to glean more from the process of the paperwork."

Preface

When I began thinking about writing a book on directing, I had to recall my study as a student of directing at New York University. I was at that time a student of the theater. I had studied at Tufts University, which had a fairly academic program. Despite this concentration, there were some very creative and innovative students who were my classmates. I am deeply honored that actor William Hurt, studio head Peter Roth, artistic director James Nicola, and director-choreographer Donald Byrd were at Tufts during this time, to name just a few. It was a pretty exciting time to be a part of the productions performed at the Hallie Flanagan Studio Theatre.

In my final year, I was fortunate to do a year abroad at the University of Ibadan in Nigeria. Nigeria was just coming out of a violent civil war and now, with the war over, I had hoped to meet up with the esteemed playwright Wole Soyinka. As fate, would have it, Wole was still in exile when I arrived, but my year was still spent with outstanding playmakers, Ola Rotimi and Kola Ogunmola, two very important men of the theater who were unknown to Western audiences but nonetheless forces within their country.

After the time spent in Ibadan, I was fortunate to enter the graduate program at New York University with some credits from my post-undergraduate study, so I fashioned an MFA program that combined both theater and film. New York University's film program was in its renaissance, and I wanted to be a part of that, so I became this kind of "hybrid" student. On the theater side, I studied under two veteran directors who could not have been more different. Carl Weber was originally from Germany and a member of the Berliner Ensemble, so in class we talked a lot about Brecht and his style of theater and performance each and every week. Carl was very energetic in his presentations about Brechtian theater and often physicalized his teaching that in effect became "performance." Many years later, I finally visited Berlin, and the

first stop of my trip was the theater that housed the Berliner Ensemble. I wanted to finally witness what Carl had considered to be his personal Mecca. The theater had changed over the years, but inside I could feel an energy – a presence. This must have been what Carl was trying to convey to us in class.

The other teacher was Mel Shapiro, a New York theater director who was very much in his heyday with many shows on and off Broadway. Mel was famous for asking us to do a "tension scene" (those of us who were his students will remember Mel's special way of saying this). Mel believed that creating tension, or conflict, was the primary challenge for the director. Our study was aided by having access to the acting program at New York University, so in effect on the theater side we were being trained to be "actors' directors." These were great times in the old East Village of New York City. There was a good deal of activity in theater Off and Off-Off Broadway and the beginnings of the indie film movement that launched Spike Lee, Jim Jarmusch, John Sayles and many others. Ironically, my studies in the film department were not connected to acting or performance. We were not being trained as actors' directors but as "filmmakers." The focus was more on the visual, cinematography, and technical elements of making film and less about performance or the craft of the actor. I remember it was in film classes that I first heard actors referred to as "the talent" or the "talking meat puppet." I remember moving from where my film classes were held, back to where my theater classes were held realizing that I was going to have to make the connection on my own if I wanted to be an actor's director.

After graduation, I kept my feet in the theater and directed the Off-Off Broadway hit *Hail, Hail the Gangs*. It was performed in a tiny theater, but the response to the show was so overwhelming that many important people in New York theater came out to see the show. This led to more assignments in directing. Producer Woodie King Jr. brought me in to direct *Perdido* which featured two actors fresh out of college who had just arrived in New York: Samuel L. Jackson and his wife LaTanya Richardson Jackson. Sam and I would collaborate again on a production of *Do Lord Remember Me* at the American Place Theater, after he took over the role from Glynn Turman. Sam had to finally exit the role for another show, and Giancarlo Esposito completed the six-month run that initially was slated for only three weeks. Theater, where the work with the actor is paramount, proved to be the best training ground for my future work in film and television.

Itching to work in film, I got a production position on the epic *Ragtime* directed by Milos Forman. It was on this film I learned my first powerful

lesson about being clear what you want to do in this business. I initially came on board with about 25 eager young people to find locations for the movie. Finding early 20th-century architecture with 360-degree vistas (the way Milos and his director of photography [DP] wanted to do the production) was no easy task. In the end, everyone else was let go except for me and one other locations person. We both took jobs in the locations department for the duration of production.

In the early days, scouting and riding side by side with Milos, his DP, and the production designers, I witnessed a director sharing his vision with his creative collaborators. Listening to their creative contributions in response was so exciting because in many cases we found the locations that were being scouted and finally made it into the film. But once pre-production was over, being in locations meant for most of the production I was far away from camera: the place I wanted to be to observe the director–actor collaboration. It was an exciting opportunity but a clear wake-up call not to repeat this path of entry when I knew I wanted to be a film director.

A few years later, I managed to secure an American Film Institute (AFI) internship on the film *Trading Places*. Because it was AFI, and the focus was on directing, the intent of the program was to put the intern as close as possible to the director. On *Trading Places*, I had the experience of the lifetime watching John Landis work with veteran actors Ralph Bellamy and Don Ameche and then *Saturday Night Live*'s Dan Ackroyd and Eddie Murphy. John Landis employed different styles of communication with each actor. His depth as a filmmaker was based on his experiences making films in the United States and abroad. I really have to credit John's sharing about his time in Italy that encouraged me to take advantage of an opportunity abroad years later. Even though *Trading Places* was for the most part a comedy, John Landis's encyclopedic knowledge of film and film performance guided the memorable work of the entire cast. *Trading Places* emerged as a heartwarming character comedy that has become an American classic.

Following these formative opportunities, my work has since taken me all over the country and all over the world with extended experiences in Africa and Asia. Working in the industry was always combined with time spent leading workshops and masterclasses in directing and filmmaking. Most of the time, I was primarily working with film students, but finding actors to work with my film students has always been a challenge, even when there was an acting program or performing-arts department on the campus! I find it so interesting that performing-arts schools still want to keep their actors away from the filmmakers. This was in direct contrast

to my experiences at New York University. When I turned my attention to teaching, it led me to seek out an institution that by design would put actors and directors together, where in the curriculum a directing class would be matched with an acting cohort. At Emerson College, I was fortunate to find that match, a match authored by colleague Tom Kingdon. Tom worked very hard to create this much-needed course, and, since joining the faculty there, I have had the pleasure to collaborate with Ken Cheeseman, a premier actor and instructor in the Performing Arts department. In the course titled "Directing Actors for the Screen," my directing students work with Ken's advanced acting students.

Observing the work of Milos Forman and John Landis, it was clear that directors are master storytellers. If the student director is prepared, they can be present and in the Moment with the actor. One-to-one with the acting process of being in the Moment, the director and actor working together in a common language that combines directing methodology with acting vocabulary. This union can birth a creative collaboration: a delicate dance of ideas and inspiration. This is the ideal relationship between the director and the actor, but even with the most patient and careful preparation there is another ingredient that must be nurtured.

The final part of director preparation is life experience. Life experience is needed to develop the director's sixth sense, their gut reaction, their intuition. The director needs knowledge of human behavior in all types of situations. In essence, that is what we do as directors. We guide an actor in the re-creation of human behavior. We guide an actor to "be" and hopefully not to "act." Regretfully, due to the ease of technology and social media, we can all shelter ourselves from the real goings-on in the world. In the process, what is lost are the skills of observation and, most important, participation. The world is being overly guided and, worse, controlled by technology. So much of what is happening in our present world cannot be experienced via a tweet from a smartphone or by surfing the web. In addition to this book or any book on directing, you must break out of your comfort zone and experience the world around you. In a later chapter, I will discuss some ways to do this.

Having shared a bit of my life experiences that have brought me this far, let's get started.

Acknowledgments

This book is inspired by many people in film, television and theater but especially Hal Scott, whose rehearsal style and work, which I observed as an undergraduate student, inspired me to be a director. To Mel Shapiro and Carl Weber who added skills to my toolbox in grad school. To Jay Sandrich who opened the door to directing television. To John Landis for the opportunity to be a part of *Trading Places*, and to Yamada Yoji who allowed me to be the only foreign director to observe the making of *Tora-san* #43. Thank you Claire Andrade Watkins and Tom Kingdom for bringing me to Emerson and to Pratt Bennet for the TTT training.

Finally, a special thanks to Rob Sabal, for encouraging me and supporting my quest to be a better educator.

Chapter 1

What is directing and the "prose" of preparation

Before we can begin to talk about preparation, it is necessary to determine what is directing. And, after that, based on what directing is, then what does a director do? Let's start at the beginning: What is directing? Is it telling the actors what to do, how to say the dialogue, where and when to move? Now, some will say, "Yes! That is what directing is." As directors, we have to "figure it all out" in advance and then tell everyone how to reproduce our ideas. If you are working with actors who see themselves as just "talent" or "bodies in space" that need a commander of their starship, then you could be right. But this book is about being an actor's director. We are seeking collaboration, partnership, and teamwork in building characters to tell the story. If we come to rehearsal with everything already worked out, we discourage collaboration. This could alienate the actor, and the actor could end up paying no attention to anything we say as director.

In my worldview, the actor's director is a guide. The director is the leader and should create an atmosphere that someone is in charge. At the same time, setting a tone that is humble and encourages contribution encourages everyone to participate. Our job is to guide a performance not to dictate one. We come with ideas but with the humility that our ideas are just that, ideas, and therefore open to collaboration. Our direction, generally shared using verbs, should serve as "prompts" to trigger the actor to dig deeper in their exploration about the character. You may be familiar with using the term "What if?" That is also used in direction. When choosing to communicate your ideas via "What if?" this expression is an opening, an invitation for collaboration.

To emphasize guiding, I am sure many of you are familiar with the Sherpas who guide climbers up Mount Everest and many of the world's famous peaks. The Sherpas know the mountain; they've climbed it many times and with many different climbers. They have committed to deep preparation because their knowledge can mean life or death. But within

that responsibility, the Sherpas don't tell a climber what to do. Anyone setting out to scale Everest has learned how to climb. They have to have mastered climbing, accomplished more than the basics to even be allowed on Everest. The Sherpas rely on their climber's knowledge of the rules of the mountain, so if there is an unexpected turn of events, they can react in the Moment.

In the end, the Sherpa's job is to guide. To set an agenda for the day to reach the summit. When to climb and when to rest and often suggesting in a humble way "need to knows" along the way. They conduct the climb, much in the same way a conductor leads an orchestra of accomplished musicians.

Every good musician spends many hours every day just playing the scales. You may ask why. This person is part of a renowned orchestra, they perform at Carnegie Hall. Why would they have to practice? They practice because they know it all comes down to a command of the basics. You have to be able to call upon the techniques that have been proven over time. When they play the scales, they call upon their training and their experiences in music and in life. This is what they then bring to the performance, and they bring it to each concert in the Moment.

Like the musician, each climber keeps their "chops" or abilities current and flexible so that joy is experienced during the climb in the same way that a musician luxuriates in their favorite composition. They each trust their training and the steady command of an inspired guide.

Directing is no different. It means coming to production prepared but also open and ready to be in the Moment so that during the journey the director endeavors to guide the actors on a path that has the potential to be the best performance of their career. This is the work of an actor's director.

So where do we begin?

The screenwriter just handed you the final draft for the project, or perhaps you found the original screenplay for your favorite film or television show and you want to do your remake. How do you start your work?

Five formative questions that guide many creative and journalistic endeavors are the primary tools of the director. You are building a journal, a diary of creativity, compiling notes wrought from inspirations, imagination, and passions that will be the foundation of your work in preparation to direct. So, what are these first questions? I call them the Five Ws: What, Who, Where, When, and Why. Let's start with "What."

What?

What is the story about? Oftentimes I ask this question in class, and what follows is an account of the plot, the storyline for the movie or TV

show. Your What is asking much more than "What's the plot?" or "What is the storyline?" Your What in this case relates to the big picture, the larger issues and ideas that the writing is addressing. These big-picture ideas and issues connect with a broad audience, and if you are pitching your project to someone who might come on board to support it, your What needs to attract a worldwide, diverse audience.

Is this a show about power, a work that is a David and Goliath story, or maybe a fish-out-of-water story? You want to first identify these big-picture ideas and concepts, these universal themes that speak to the largest possible audience. Everyone is fond of developing the so-called "elevator pitch," when you talk about your project to seek funding. The content of your pitch always begins with the What. To the listener or the viewer, this focuses their attention on the big picture, the larger issues of life your film addresses. If your What is compelling, they pay attention, and you can continue and tell them more.

Roma is not about a wife who tries to manage life on her own after the husband leaves the family. It is about Mexico City circa 1970. It is about female empowerment in the face of machismo culture and the political and social upheavals of the period. It is also a coming-of-age story for a young woman who is not from the chosen class. *Black Panther* is not about a battle between two men to rule Wakanda, but it is about an Afrocentric view of history and technology. It is about the conflict between Africans and African Americans. It is about rising above race, ethnicity, and national identity to serve the good of all humanity. *Vice* is not a biography of Dick Cheney, but it is about politics, the dark side of politics and how individuals justify their political choices. It is also about what it means to be a patriot.

Take time to develop your What. It will start deposits to your director's creative imagination investment account, your vault of inspiration and vision. As we know from the world of finance, if your account is strong and diversified, you can withdraw from it again and again over the course of the production. Using this financial metaphor, your day-to-day work on the production will produce new ideas, which become future dividends after you reinvest them daily into your What. Now you have interested ears and you are able to continue talking. Who are the characters that will bring your What to life and explode into a compelling story? Who will represent one or more of these big issues and ideas?

Who?

Who is in your movie? Here your focus is on the major characters that propel your story. These characters are major because they have a direct

connection to the big issues and ideas you brought to light in your What. The major character's dramatic trajectory, their Objectives, the Obstacles they face trying to reach their Objectives, and the Choices they make create the journey of What the show is about. What your show is about can be as simple as Good vs. Evil. You can be sure there will be two characters representing these opposing forces. Once you begin production and dig deeper, introducing the secondary characters in your story, you will find that these characters represent the nuances of the major characters. The secondary characters are there to provide contrast that make the "good" characters not so perfect and make the "bad" characters somehow redeemable. The "tension" (going back to the mantra of Mel Shapiro) that is produced watching each of these characters navigate their way to accomplishing or abandoning their Objectives makes for great drama and also for great comedy.

Where?

Where does the story take place? Location, location, location – the mantra of realtors – is now the mantra for you as director. Carefully examine the place where the screenwriter decided to set the story. If you have a good screenwriter, the Where is never arbitrary. It is specific to bring out the angst in the characters, to underscore the issues in your What. Let's say, for example, your story is set in Los Angeles. Now, Los Angeles is a big city and a city of many neighborhoods. A story set on the west side of Los Angeles is going to be different from a story set in the Valley or a story set in the Inland Empire. You realize from these stories that Los Angeles isn't just Hollywood. There are people living in Los Angeles who are not in the entertainment business. As directors, we need this to be specific.

If the screenwriter has not been specific, the director must decide the Where. Usually good screenwriters are very clear about Where because they know their characters. They know where they live, where they eat, who their friends and neighbors are. When a screenwriter has been specific about Where, pay close attention to it. If it turns out to be place you've never visited, in order to do the project with integrity you must go there. Here is where you get to add that other ingredient to your direction: getting outside your comfort zone. You do this in order to develop your intuition, to develop your sixth sense. In this unfamiliar place, observe in a careful and detailed way the atmosphere, the mood and tone. Study the lifestyle of the people where your story takes place, and, along the way, watch how quickly it helps you understand your

Who even more. Pay close attention to the Where; it will open doors to incredible discoveries about the characters and their actions.

Thinking about Where, one of the biggest light-bulb moments for me as a director came when I visited Scandinavia during a decade I spent as an ultra-marathon biker in the United States and Europe. I was participating in Vätterrundun in Sweden, an ultra-marathon event where cyclists ride through the night, circle Lake Vatter during the time of the Midnight Sun in Scandinavia. This is also the time of the year when many of the plays and films of the Scandinavian writers and filmmakers are set. Witnessing how the people interacted during this summer season, I looked upon these works I had studied both in the theater and in my study of film with new comprehension. Many things that were baffling to me about these works began to make greater sense because of the influence of the Midnight Sun.

In the United States, unless you grow up in Alaska, you have no idea about what it is like to live in a place where the sun never fully goes down, a place where it doesn't become completely dark. It throws off your body clock. On the flip side, most of us have no idea what it is like to live when you don't see the sun for months at a time. During the summer in Scandinavia, people are without limits. They go bonkers during this time of year, and, conversely, when the sun rarely appears, they experience depression and even suicide.

We can point to works from the theater along with the stunning films of Ingmar Bergman. I also want to mention the film *Midnight Sun*, first made by a Japanese filmmaker in 2006 and remade by Scott Speer in 2018. Shaped by the sensory images of this region – what you see, what you hear, what you touch, what you smell and what you taste – during these vastly different times of year influences the behavior of people. Sensory images are something we will cover in a later chapter, but they are worth mentioning now.

This is the reason why Where is so important. Don't take it lightly with the cavalier attitude, "Oh, it takes place in a city or a midtown office somewhere, etc." The Where is specific and crucial to the work of the actor developing their character. Ebbing, Missouri, where *Three Billboards* takes place, brought a specificity to Frances McDormand's portrayal of Mildred.

When?

When the story takes place is just as powerful as Where. Your When defines the work as contemporary or perhaps set in the future. We see

this exemplified by so many works of science fiction or works about a dystopian world that awaits us in the near or distant future. Or perhaps your show is a slice of history, a chance to revisit the past and tell a forgotten or underreported story. When a story is set is often clever particularly when the What is about politics or other hot-button issues. Oftentimes, setting the story in a time removed from our contemporary world can be a more inviting way for an audience to examine the What. Looking squarely at some of the issues we face today with the rise of autocratic power points us to the recent film *Vice*. Set during a time not so long ago but far enough in the past to permit emotional distance allows for an examination of unilateral power – a particular brand of power – and the probable outcomes we might soon witness today because of it. The notion of African empowerment via *Black Panther*, set in the future and presented as part of the Marvel franchise, a comic-book-inspired series, perhaps made the politics of this bold statement of power and sovereignty more palatable for a worldwide audience.

But When can explode a budget if the story takes place in the past. How wonderful it is when a filmmaker creates a work set in the past with brilliant detail and attention. Take for instance Alfonso Cuaron's *Roma* or the television show *The Marvelous Ms. Maisel* or *Game of Thrones*.

When also pertains to the time of day. At what time do the scenes take place? Perhaps your story primarily happens in the day, with scenes early in the morning. Maybe this is a project where a majority of the work is at night. Time of day affects the life of the characters, so when working with your actors be very mindful about time of day.

As you can see, just like Where, don't gloss over When. Treat it very carefully and with as much detail and precision as your budget will allow. To create the When, things don't have to be overblown and, as a result, way over budget. Take the films, *Her* and *Ex Machina*, stories of the near future. They were successful transportations to a world that could soon await us. With careful production design and a deliberate color palette, these films brought to life a possible future orchestrated by artificial intelligence.

Why?

Probably as important as What is Why. *Why* make this movie, this TV show, this new media project? The Why is crucial because the Why gets to the heart of what makes us care about What the show is about. The Why points to the emotional, spiritual or experiential connections we

make with the material. It isn't enough that the story is Good vs. Evil but more how we identify with this age-old battle. Whose side are we on? Why does this material resonate? Looking again to *Three Billboards*, what was it about the character of Mildred that triggered a resonance, an identification, with her struggle that enchanted audiences and critics alike? Gary Oldman's portrayal of Churchill made *Darkest Hour* a more memorable picture than *Dunkirk* even though both looked at the same moment in history. What was the emotional identification and re-examination of this auspicious time during World War II that *Darkest Hour* did best? What chord did Jordan Peele strike in audiences in *Get Out* using the tried and true trope of the classic horror film, to make an even more powerful statement about race and class in our contemporary society? In all of these pictures, if we deconstruct them and identify their What, it will be clear how Why paid off the What in multiples. This is how a single film like the first *Star Wars* morphed into multiple films or how a seven-episode order in television turns into a multi-year series. This happens because of the connection these works are making with an audience: a solid unbreakable connection that lies deep within us as humans.

As you can see, finding a property with a powerful Why that cannot be denied is the core business model of the entertainment industry worldwide. A project with an undeniable Why has deep roots.

I had the pleasure of observing the making of the film *Tora-san* in Japan. *Tora-san* holds the Guinness World Record for the longest-running film series. The director is Yoji Yamada, best known by most international audiences for his works *Twilight Samurai* and *Hidden Blade*. Everyone in Japan knows Mr. Yamada for the *Tora-san* series. He made 49 feature films about the same characters' return to his family's home in Tokyo at the end of the calendar year, a time the Japanese call Oshogatsu, Japanese New Year. I witnessed the making of the 43rd in the series. (And even played a small part!) I could walk you through the What, Who, Where, and When of the *Tora-san* series, but when we completed production I still could not figure out how they could have made so many feature films from the same story. In essence, what was the Why?

On opening day, I sat with Mr. Yamada and his team in a local theater in downtown Tokyo. The area is called Asakusa, and it known by Japanese as *shitamachi*, the downtown part of Tokyo where the original "Edoko" or Tokyoites founded this famed city. Sitting with this home-grown audience who brought their own food into the theater and readily talked back at the characters on the screen, I finally understood

the Why of *Tora-san*. I suddenly became clear how this simple story could produce 49 incarnations.

The series was halted when the lead actor, Kiyoshi Atsumi, passed away, and since that time everyone has missed seeing *Tora-san* at the end of the year. It became a part of Japanese tradition and culture. As I write, after 23 years of discussions and contemplation, Mr. Yamada is completing number 50. In the storyline, the characters return to Shibamata, their hometown in Tokyo, and look back to remember Tora Jiro, their long-lost family member. Many of the surviving cast returned to reprise their roles.

The character of Tora-san or Torajiro represents "everyman," the so-called ordinary Japanese who no longer exists – a peddler of household goods with a gift for gab. He was a metaphor, a symbol of old Japan, the real feeling and spirit deep in the bones that all Japanese have about their country and their culture. Tora-san reminded them of how they worked together to rebuild Japan, returning the country from the ashes of World War II. It is an inner pride that is powerful. This was the Why that had escaped me in the beginning, but by the end of production on the day of release . . . I got it!

As you fashion your Why, look back to What, and, in fact, I recommend harvesting the big-picture ideas and issues from What and let them start off your Why. For instance, using *Tora-san*, which is about family, culture, and tradition to name just a few, I would begin my Why by stating: "*Tora-san* explores the powerful experience of family for audiences worldwide, the spiritual quality of culture identification and the emotional resonance of tradition." Your Why should be as powerful if not more powerful than your What.

To review

So there you have it: the Five Ws – What, Who, Where, When, and Why. This is the starting point for your director preparation. I recommend, in the beginning, using the outline form or bullet points to get you started on your Five Ws. Just list as many things for each, and after you have organized the Five Ws in outline form, you must then render your findings in prose.

Prose is the language of a director's vision. Prose is what gives a director's work signature. Our prose in director preparation is the same as the prose in literature that makes a novel by Toni Morrison different from a novel by J. K. Rowling or Steven King. We know that the works of these authors are powerful and visual, and, most of all, they are works

that have the distinct signature of their author. Guided by your outline or bullet points, create wonderfully visionary prose. Write as if you are creating the opening chapter of a great novel – *your* future great novel that will be rendered in visual form. It starts with lush, rich prose. Now your imagination can take flight. Your creativity can soar with passion and power. You are opening the doors and windows of creative vision. Isn't this the reason why we call ourselves directors? Because we are visionaries?

This first step takes time, so give yourself time to do the necessary "woodshedding" to experience each of the Five Ws. The emphasis here is on the word "experiential." Your Five Ws have to be deep, layered, and compelling. This is why you hear stories about the months of preparation before a modest 20 days of production for a feature. Why? Because, as director, before you can have your first meeting with the creative production team who will collaborate with you to visualize the project, you must spend precious time in the sanctity and solace of your own space birthing a clear and unrestricted vision for the project. You must do this before you can cast actors to collaborate with you in storytelling, before you can make any and all creative commitments.

I have vivid memories of riding in the van with Milos Forman and his creative team listening to his visions for the making of *Ragtime* and being guided by those visions to help find locations. Something I will never forget was watching the scene of Sarah's funeral, Coalhouse Walker's wife, in a church that I found in Harlem. I grew up in Harlem, maybe only ten blocks away from this location, but it took working on this movie to find this small period church in the middle of the city. Production Design had studied the photos of James Van Der Zee to recreate a "spare no expense" Harlem funeral of that era. I have to say I felt a real rush of pride watching as they shot the scene. The tears in the eyes of Coalhouse Walker, played by the late Howard Rollins, reminded me of the day the actor burst into the production office, with tears in his eyes, to express his gratitude for being chosen to play the pivotal role in the film. I could deconstruct *Ragtime* today based on my experiences, and the Five Ws would be so clear.

So think big and bold! Once you have composed these notes in prose and spent some time reading and rereading your ideas, then you are ready to talk with authority and command about the project to anyone, to address your cast, creative collaborators, crew, and, most of all, the producing entity. You have visualized and fully experienced the Five Ws, and you will draw from each of these creative chapters when you communicate to make your project happen.

I have created a Prezi, a visualization tool to demonstrate the Five Ws. Starting with your Five Ws, begin composing the first stage of the DNA for the project. To see the Prezi, access https://prezi.com/ye3klgxadpvq/directors-pre-pro. Just review the first seven panels. We'll review the rest a bit later in the process.

Putting it into practice

Having now explored the Five Ws, we want to see how to put it into practice. I want you to pick a TV show or a film that you really like, something that generates passion for you as a director. What are the images you see, the sounds you hear, what do things feel like when you touch them, what is the taste in the air, and what do you smell? Use these parameters to do an analysis of that show using the Five Ws.

Start in outline form with What, followed by Who, moving to Where, then When, and ending with the all-important Why? Let your creativity flow as you explore the show. Allow the passion you feel drive your efforts. Don't worry about a page count. You want your vision have complete freedom. The Five Ws belong only to you as director. No one needs to ever see them or read them. They are our creative storehouse. Once you are done, read them over and make a second pass. Get used to this phrase; it is how we work as directors. We often have second, third, and sometimes four or more passes over our preparations before we know we are ready to share our work with others. Then move from outline form into prose.

You are laying a firm foundation to be able to direct. In the next chapter, we will detail the Storyline Facts. This step, based on the Five Ws, finally leads us to "Story" driven by the Five Ws. The Storyline Facts, what the actors call the "given circumstances," are the bridge from the Five Ws to the first stage of preparation to speak to the actors.

Chapter 2

Storyline Facts
The bridge to the Three Questions to Choice

In the previous chapter, we began the preparation process with building a strong foundation via the Five Ws: What, Who, Where, When, and Why. This is where the director begins preparation, and this is not a locked document. You don't compose your Five Ws and declare, "Been there, done that." Your Five Ws are always unfinished as long as you are in production, and, oftentimes, they can be instrumental even in post-production. For that reason, you should revisit your Five Ws with each successive step in this process. As you will soon see, there are direct connections along the way back to What. Despite the tasks that you will continue to do, make it a point to revisit What.

Within the Five Ws themselves, moving from What to Who usually reveals additional big-picture ideas and issues that can be added to What. Moving forward, each new chapter in the preparation process will help you to add to the Five Ws and principally What and Why. You want to build the strongest foundation, a Fort Knox of creativity, inspiration, knowledge, and passion that you will draw upon in production. The Five Ws, unlike the steps that follow, have no limit on size and content. You want them to be expansive. To use a baseball analogy, you want a "deep bench."

Moving forward to the Storyline Facts, you will now learn how to harvest from your Five Ws. Just like the oak tree that grows from just one acorn, each process feeds the step that follows.

At the start, I mentioned that when I ask the question, "What is this movie or TV show about?" I am usually greeted with an explanation of the plot or the story. Now you know that the plot or the story are not What it is about. The plot or the story is birthed by the What in your Five Ws, and it grows richer traveling through Who, Where, When, and Why. As we prepare to move from our personal and private preparation to casting, rehearsal, and production with the actor, we need a bridge, a step that synthesizes the expansive work done building the Five Ws

to focus on introducing a scene from the story. In the process, we are revealing how the characters in the scene carry the big issues and ideas you revealed in the What of your Five Ws.

This is done by first returning to What. If you did not do so when you were composing the big issues and ideas for What, now is the time to **bold** or use CAPS to make these ideas stand out. They are the fuel for your Storyline Facts. In the actor's world, these "given circumstances" provide the backstory that carries them from scene to scene. To work in concert with the actor, you want to connect your characters to one or more of the big issues and ideas from What. Let's use an example from the series, *Boardwalk Empire*.

I like using the scene from the pilot episode where Nucky Thompson first meets Margaret Schroeder because it allows for a thorough examination using the Five Ws. In this era of streaming, I find most students and young filmmakers have online accounts so it is very easy to find this pilot episode.

Boardwalk Empire is set in a time removed from our contemporary life, and it features characters who, at times, seem larger than life. Most of all, it taps into a primal psyche in American culture, our fascination with the antihero. Let's start with What.

Set in the dawn of Prohibition, *Boardwalk Empire* is about ORGANIZED CRIME, CORRUPTION, VICES, JUSTICE, COMPETITION, POWER, GREED, VANITY, AMBITION, and FAMILY. It tells the tale of a new American frontier where money and bootlegged alcohol replaces law and order. Taking advantage of the nationwide criminalization of alcohol, America's mob bosses and politicians conspire together in smoky speakeasies filled with whiskey, jazz, and prostitutes. The nation lies disfigured and carved up into countless gang territories. Selling illicit alcohol proves extremely profitable. The mob bosses live outlandishly in mansions and drive the fastest cars, and, when their interests collide, war erupts in the streets.

Now this description that begins with the BIG ISSUES and IDEAS of What, then introduces the "story" or the "plot." This lays the groundwork for the question: Who tells the story? When you describe the major characters, you introduce them using the BIG ISSUES and IDEAS. Through the major characters, we can tell the story that is *Boardwalk Empire*.

Let's begin with the leading man of the series, Nucky Thompson. His birth name is Enoch Thompson, and he was actually Atlantic City's treasurer during this period. Born in squalid conditions among wharf rats, Nucky Thompson learned from an early age how to fend for himself. Having an abusive drunk for a father, Nucky had to work since he was

young to provide for his family. As the unspoken ruler of Atlantic City, he decides the day-to-day life of the town. He lives in two worlds. In the first, he is the respectable father-like figure, the treasurer of Atlantic City who is always there to help someone in need. The second is a shadow world, where he is able to provide for another constituency through breaking the very law that he was sworn in to uphold. His business attitude in this criminal underbelly is ruthless, cold, and calculating. The only things he believes in are those that he can physically grasp, those that make him money.

His wife, a very beautiful woman, died from consumption, so for Nucky life has taken away every pleasure, every semblance of happiness: FAMILY. He is a shell of a man who is dead on the inside. He unceasingly vies for control so that life will never again take anything away from him. In an era marked by excess and good times, Nucky stands aloof without allegiance to anyone. Everything is business, everything is transactional. Anyone obstructing his business ventures will feel the tip of a cold steel bullet in their skulls as a personal gesture from his own, smoking gun.

But the era of Prohibition has changed the game. Now his primary occupation is that of the treasurer of Atlantic City, and, like a clever businessman, he must find every opportunity to play that role and push the shadow world deep into the shadows.

Early in the pilot episode, Nucky addresses a temperance meeting on the eve of Prohibition. In the audience is another character, soon to become a major character in the story. Meet Mrs. Margaret Schroeder.

Mrs. Schroeder is an Irish immigrant. Brought up as a good, Catholic girl, she consciously tries to do good. Her husband is a drunk, and he beats her. She is pregnant with their third child, and the family does not have the means to support another baby. She came to America for a better life but now lives in misery and constant fear of a man who drinks away all their money. Her values as a good Catholic girl are choking her existence. She cannot find it within herself to ask for help. Seeking financial aid from anyone in her eyes would be beggary, and she cannot conceive of leaving her husband no matter how badly he behaves toward her – it just wasn't done during this time. She made a vow, "for better or for worse," and that is the way it is. But, like Nucky, there is a desire to control her destiny burning deep within her. Beneath her humble exterior lives AMBITION. Prompted by seeing Nucky speak, she decides to swallow her pride and ask him for help.

In preparing our bridge, composing our Storyline Facts, we want to reach back to our big issues and ideas that we harvested from What and harvest them again for the Storyline Facts to introduce the characters of

Nucky Thompson and Margaret Schroeder and preview the scene that will follow.

Starting with Nucky, here is an example: "Coming from a world of organized crime and corruption, power, greed and vanity, Nucky must wear the mask of a man of virtue and temperance meeting with Mrs. Schroeder as Prohibition has ushered in a new reality that he must now navigate."

In the beginning, as a way to build your director's preparation muscle, I would urge you to continue the practice of **bolding** or putting into CAPS the big issues and ideas: "Coming from a world of ORGANIZED CRIME, CORRUPTION, VICES, JUSTICE, COMPETITION, POWER, GREED, VANITY, Nucky must wear the mask of a man or virtue and temperance meeting with Mrs. Schroeder as Prohibition has ushered in a new reality that he must now navigate."

Now we move to Margaret Schroeder. Here is how we would introduce her: "Trying her best not to surrender to the world of organized crime, corruption, vices, justice, competition, power, greed, vanity, Margaret Schroeder forces herself to take a chance on meeting Nucky Thompson. He is perhaps the only person with the power to save her family." Following the pattern we set with Nucky, here is how it would appear if we bold the big issues and ideas: "Trying her best not to surrender to the world of ORGANIZED CRIME, CORRUPTION, VICES, JUSTICE, COMPETITION, POWER, GREED, VANITY, Margaret Schroeder forces herself to take a chance on meeting Nucky Thompson. He is perhaps the only person with the power to save her family."

To finalize our Storyline Facts, we bring together these two-character trajectories: "Coming from a world of ORGANIZED CRIME, CORRUPTION, VICES, JUSTICE, COMPETITION, POWER, GREED, VANITY, Nucky must wear the mask of a man of virtue and temperance meeting with Mrs. Schroeder as Prohibition has ushered in a new reality that he must now navigate. Margaret Schroeder trying her best not to surrender to the world of ORGANIZED CRIME, CORRUPTION, VICES, JUSTICE, COMPETITION, POWER, GREED, VANITY, forces her to take a chance on meeting Nucky Thompson. He is perhaps the only person with the power to save her family."

These are the Storyline Facts for two major characters that will launch the scene where they first meet in the series. The Storyline Facts launch the scene in the Now, in the present for the characters. It is then the responsibility of both director and actor to keep the scene in the Now. This means approaching the material with no idea what will happen during the scene.

Our Storyline Facts set up the characters to what could be called the edge of the diving board – just before the scene begins. In this way, once the scene starts, they live through the actions of the scene, staying in the Now. The story is told Moment to Moment, or, as the actor will say, from the A to the B to the C. I like to refer to this directorially as chapter by chapter.

This is what is meant by living in the Moment, in the Now, starting at a neutral point for the actor. This is probably one of the most challenging aspects you will face as a director: keeping the actors in the Now. The actors, like you, have read the script, planned a life for their character and know how this scene will end. Unconsciously, they could play the scene, and the audience will sense the end of the scene right from the start. Our work is to keep the actor from doing that. I also want to point out that in composing the Storyline Facts, notice the final paragraph in both character descriptions.

For Nucky: "But the era of Prohibition has changed the game. Now his primary occupation is that of the treasurer of Atlantic City, and, like a clever businessman, he must find every opportunity to play that role." And for Margaret: "Prompted by seeing Nucky speak addressing the women of temperance at the dawning of Prohibition, she decides to swallow her pride and ask him for help." These final thoughts will become the foundation for your Triggering Facts. We will talk about these in a later chapter.

Your Storyline Facts are now complete, and the bridge to move from your initial Five Ws to the next step of preparation – our first encounter with the actors in rehearsal – has been built.

Putting it into practice

Going back to your Five Ws for the show you chose to deconstruct via What, Who, Where, When, and Why, now compose your bridge, your Storyline Facts, for a scene from the movie or television show. Follow the template that I outlined using the example from *Boardwalk Empire*. Remember to **bold** or put into CAPS the big issues and ideas from What that you harvested to compose the Storyline Facts to introduce the characters and bring them to the start of the scene. Begin to develop the much-needed discipline of composing only what the actors need to know to be in the Now. Be mindful of this to avoid ROD.

Chapter 3

The Three Questions to Choice
Walking in the actor's shoes

We began our preparation with the Five Ws, and we just witnessed how, via the Storyline Facts, you keep your connection to the work done building the Five Ws, particularly your What. These steps are crucial before you begin to plan your work with the actors who will portray the characters in the story. As you can see, I am focusing on the character, not the actor playing the character, but the character, as if they were that person. As director, you want to be specific, you want to get in the skin of the character. Character analysis must be experiential: what the character needs and wants. The experiential journey is both observational and participatory.

At this step in the process, you are working to become what the actor must become to play the role. Like the actor, you are selfishly driven by this character's ambition. It is this kind of ambition and drive that manifests as an Objective for the character. The Three Questions to Choice are bringing you in sync with the actor's quest. You are metaphorically walking in the shoes of the character in concert with the actor performing the role. At the same time, there must be a distance. This is why the experiential journey also depends on observation. You participate in the same journey as the actor dissecting and building the character, but then you step back, back to the role as director to allow that actor to do their work. Because you have walked the walk and dived into the subworld of the character along with the actor, you've earned some political capital to guide the performance. So, where does it all begin? It starts with the Objective.

Objective is what the character is pursuing. Some actors will call it "motivation," "need," "the want," but as directors it is best to use Objective. Now, I have to point out that the most important thing to note is that the Objective is not an Action. The Objective generates an Action that is linked to the character's emotional core, something felt and experienced deep inside. If an Objective is powerful enough – and

it should be – the character will manifest an Action because of the force of their Objective. Due to this emotional drive, Objective should also "raise the stakes." This is a term actors often use so that the character's pursuit of the Objective becomes literally life or death. Also, because the Objective generates an Action, it is the source of kinesthetic behavior for the character. This makes the pursuit of the Objective physical in nature. This is where we see an actor put the character "in the body" so that the performance is from head to toe: gestures, the character's way of moving, their use of properties or other objects in the set. This is where acting stops, and the character starts "to be."

Christian Bale in *Vice*, Frances McDormand in *Three Billboards*, Margot Robbie in *Mary Queen of Scots*, and Denzel Washington in *Malcolm X* are all examples of actors who became their character. Of course there are many more performances that could be named. This list grows with each new season of films and television shows. You can tell by this impressive list of actor performances that to reach this level of performance is an awesome moment for the actor: the top of the mountain in performance when the actor ceases "to act" and steps into the vaulted world of "to be." The actor is so deeply inside of a character that the actor disappears and only the character remains.

This becomes our first task as an actor's director, to begin where the actor begins, plotting the Objective. Note that the Objective will change from scene to scene over the course of the story. Keep in mind you are doing this *before* you have met with your actors. This is our homework as directors, homework that will become collaborative when we finally sit down with our cast.

Before we get too far down the road, let's bring in some actor vocabulary because you are about to begin work with the actor face to face. The character Objective is not fixed or static. An actor will read the script and then map their character's "arc," where they start in the story to where they finish during the course of the story. This gives the actor their "spine," their vertebra-by-vertebra path of the character over the course of the show. In this way, each scene Objective becomes a stepping stone of the character's Super Objective, in other words the need the character has over the course of the story. This journey is one scene at a time, and each scene contains its own Objective.

We do the following work one actor at a time. You can see this is where the work of the actor's director becomes hard work as you are doing double duty. You are mirroring the actor's initial work to build a character along with developing the discipline as a director to be able to step back. Get out of the way of the actor to observe how this master

craftsperson – the actor – creates the character in their own way. The actors needs space and time to create their "skinship" with the character. If we can successfully navigate this first step, we can move on to discover what fuels the scene. We take the first step in building the director's toolbox with the most important tool: the verb.

When I first began teaching at the university level, one of my colleagues was a filmmaker and teacher named Alonzo Crawford. Alonzo was a very serious artist and a great talker. His office was a workshop filled with evidence of his many years as a media maker and his passion for teaching. I remember seeing students sitting with him for hours on end to listen to his stories. Alonzo decided to take a break for a semester and asked me to take over his graduate course in directing. He requested that I sit in for one class to observe how he worked with his students.

Alonzo was what I would call a Verbmaster. You notice I capitalize the "V." He could identify action verbs in an instant. In class, his way of speaking was so verb-centric that at first I could see the students were amazed how someone could synthesize all behavior into a series of verbs. It was such an eye-opening moment for me. I had always used verbs in my work, but also other techniques. Leading the class following Alonzo's example, sticking to verbs – you get out of the actor's way. Other techniques can be effective in communicating with an actor, but the most surgical is the verb. The verb becomes a prompt. It is the fuse linked to the detonator that the actor uses to explode their performance.

When I left that institution to join the faculty at Emerson, Judith Weston's wonderful book *Directing Actors* was brought to my attention. I have to again give credit where credit is due to her enduring book on directing. It is Judith Weston who introduced the concept of the Three Questions to Choice that I have adapted for this book as it relates to director preparation. One of the things I immediately point to in class is the addendum in Judith's book filled with verbs. She carefully ordered the list, so that verbs are grouped together to enable the use of a stronger verb or a softer verb to prompt an emotion (to accuse, to blame, to punish, to shame, to scold, to reprimand, etc.). In this way, you can use the related verbs from the list to dial up or dial back a performance. I will discuss this more when I introduce something I call "the Meter."

So why are we talking so much about verbs? Well, the use of verbs is to fuel the actor's Intention. But what is Intention? Intention is how the character pursues achieving the Objective. What means do they have at their disposal or what opportunities do they create in pursuit of the

Objective? Intention is powered via verbs: "to seduce," "to surrender," etc. Verbs are the activators that generate Actions for the character. Early table work with an emphasis on verbs acts as a steady guide for the actor's choices. When the actors are ready to get on their feet and begin to put the performance "in the body," verbs make it possible. When and how to move, when to make use of and how to handle properties. The power of verbs in rehearsal can also guide wardrobe, hair and makeup decisions for the characters. Because we are practicing to be actors' directors, at this stage of preparation, just like the actor, we try things out. We don't make snap judgments or fast choices about our verbs. We follow our gut, our intuition, our sixth sense about human behavior to build a list of possible choices. Then we put those choices on "the Meter" (see Figure 3.1). This is a technique I use to determine the most appropriate verb for the character at a particular moment. You simply draw a half circle, which is your meter, and you draw a line from the center to the 12 o'clock position.

Utilizing Weston's comprehensive list of verbs in Appendix C of *Directing Actors*, you will find a group of related verbs. From this list you find a grouping that would seem appropriate ("to accuse," "to blame," "to punish," "to shame," "to scold," "to reprimand"). Going with your gut, your sixth sense of human behavior, pick the verb that seems best to power the actor's Intention at a point in the scene. You are prepping as the actor would do. That verb goes in the 12 o'clock position on the meter. The remaining verbs in the group are placed at various points on the meter. The verbs that would have the ability to "dial up" the performance, or in other words intensify the actor's pursuit of the

Figure 3.1
©John Lanza

Objective, are spread out starting from the 1 o'clock position forward to 2 o'clock, 3 o'clock etc. The verbs that would "dial back" the performance or deescalate pursuit of the Objective are situated at 11 o'clock, 10 o'clock, etc. Using "the meter," we now have multiple choices, multiple verbs to employ for our direction. Clinical and surgical verbs designed to trigger Intention for the actor are deliberately brief, simple, and specific.

At this stage of preparation, be mindful that we are choosing specific verbs that will guide the actor. You want to avoid ROD (Result-Oriented Direction). This is the kind of direction that ignores the actor's work developing the character, hoping that long-winded explanations will produce the desired result. This result is the director's idea of what is happening in the scene.

Our List of Verbs, could become fairly extensive because we are thinking through each and every move we see the character is making in the scene. We must prepare ourselves to have the ability to step back as director, allowing ourselves to be open, flexible, and not rigid about only "what we want for the character." Fluid in our direction so that during the process of rehearsal and even in production we can be in the Moment, in the Now. We can journey with the actor as they discover something new and in turn demonstrates through performance this discovery about the character and the story.

This process begins as we deconstruct the major characters via Who in our Five Ws. We are building an understanding, developing a gut feeling about each character. This process is ongoing for the director. We are each and every day nurturing our sixth sense about human behavior. I like to call it "creative eavesdropping" on life because ultimately that is our task as actors' directors: to become like the Sherpas of Mount Everest, to become maestro and to help guide the actor "to be." You cannot know what it is "to be" without careful and deliberate observation each and every time you have the opportunity.

I was teaching at Emerson in April 2013 at the time of the Boston Marathon bombing. Emerson's urban campus is only a few blocks from the finish line where the first explosion occurred. As the city was on lockdown until the perpetrators were found, Emerson was closed. I had two classes that were then cancelled for the week. At the prompting of President Lee Pelton of Emerson, a man of incredible sensitivity and compassion, I emailed all of my students encouraging them to come in and talk to me if they felt alone or isolated. President Pelton's message reminded me that despite how grown up the students present themselves, the undergraduates at Emerson are young people, most of them no older

than 20, and they have all grown up in a world fixated on terrorism. This was an incredible wake-up moment for me. What it must be like for them to never know of a world where you never worried about being blown to bits in a moment.

I came downtown, and I sat in my office, thinking that despite their age and rank at Emerson no one would take me up on my offer. To my surprise, at the appointed time the first student arrived, and over the course of an hour a line developed outside my door into the hallway. They poured out their lives to me that afternoon. Their fears, their personal stories of classmates in elementary and junior high school who lost parents during the terrorist attack on September 11th. I had no idea of the personal toll that 9/11 had on their lives. I was both astounded by their frankness and humbled that they felt safe to share these intimate and personal feelings. I will never forget that afternoon.

When classes resumed, there was clearly a residual feeling of gloom all over the campus, and I wanted to find a way to demonstrate to my directing students that despite this terrible tragedy there was an opportunity to learn something: a chance to witness the aftermath of a real event and build their sixth sense. I encouraged any of them who felt strong enough to do so to walk to the corner of Boylston Street and Charles Street. The road was still partially blocked, but going to that corner you could observe the people congregating in the aftermath of the bombing.

Law-enforcement officials were still compiling evidence. Bystanders, runners who returned because they were unable to finish after the explosions, and the media were still wrapping up their coverage. I said to them, "Just take in the experience – not only what you see, but what you hear, what you smell, taste in the air – and don't forget touch!" Not all but many did venture to that corner. For those who did, their sixth sense had a very powerful lesson about the aftermath of an apocalyptical act. For many of my students, the expectations of what they thought they would witness were vastly different from reality.

I apologize for this digression, but I wanted to take every opportunity to point out that the study of directing, and principally becoming an actor's director, is about developing your sixth sense about human behavior, about the necessity to trust your "gut feeling" because you have had experiences that have informed you about life. Exploring the world around us using our five senses is often overlooked. The five senses are powerful so when the opportunity presents itself to creatively eavesdrop on life, do it, and do it using all five of your senses. This is a

skill that the director must practice every day in order to hone the craft of directing. The director is the master storyteller so to earn this position you must practice this by observing life each and every day. Using our intuition, our gut, our sixth sense, is how we shape and refine Intention for each and every character.

After initially identifying all possible verbs that will drive Intention in pursuit of the Objective, there are several steps that will take place to arrive at the Primary Verbs. These are the verbs that act as a trigger. Sharing these verbs with the actor will trigger the actor's intuitive sense. That sense organically triggers additional verbs not prompted by direction and the actor's need to play those verbs in the pursuit of the Objective. Identifying the Primary Verbs is how we stay out of the actor's way and avoid ROD. We will discuss this process more deeply in a later chapter.

We have learned about Objective and now Intention, fueled by verbs that enable the character to pursue their Objective. But life is never so easy. Called "the fickle finger of fate" – some refer to it as "Murphy's Law" – something always seems to get in the way of what we want. There is never a smooth and direct path to anything in life – at least anything really worth having. There are Obstacles: people or events that obstruct our Objective. When these Obstacles occur, a tension is created. We begin to wonder if, based on this Obstacle, the character can or will achieve the Objective despite committed Intentions powered by strong verbs.

Obstacles are what the character faces and must overcome in pursuit of the Objective. The Obstacle should be external, and it is strongest if it is the other person(s) in the scene or an immediate external event. An Obstacle is the direct obstruction to Objective. The lack of an Obstacle in a scene is often the indicator that something is off about the scene. The audience's attachment with the character, or the hero's journey, is directly related to how the hero confronts Obstacles and wins in pursuit of their Objective. In the classic film, *Jason and the Argonauts*, Jason slaying the beast to acquire the golden fleece is the metaphor I remember now. One of my elementary-school classmates' dad worked on the picture so we were treated to a private showing at their home. I discovered the film again when studying screenwriting. It is often these simple stories, fables that contain all the winning elements, that bring an audience to the edge of their seats. Think of all the incarnations of the *Star Wars* franchise. In practically every scene the hero confronts an Obstacle, wins and moves on. When an Obstacle can be used as cliffhanger then we get the most from the power of the Obstacle.

I want to emphasize that an Obstacle needs to be external, created by another character, and, to be most effective, it exists in the Now. Characters do not create Obstacles on their own, based on their personal behavior. Not many people deliberately sabotage themselves to thwart achieving what they want. The external character's pursuit of their Objective can reveal a flaw, an "Achilles Heel," in the other character, and in the process an Obstacle is triggered for that character internally. This is what I mean about an external force be it human or a naturally occurring event. Good drama and good comedy rely on this age-old battle between Objective and Obstacle. If you examine the films or television shows on your favorites list and deconstruct the stories, you will find at the core there is an ongoing confrontation of Objective vs. Obstacle.

In *Black Panther*, the character of T'Challa must face the Obstacle in the form of Erik Killmonger who wants to rule his kingdom. In *A Star is Born*, Ally must confront the Obstacle in the character of her lover, Jack, who could destroy the career she wants so bad. In *The Favourite*, Abigail must overcome the Obstacle of Lady Sarah's relationship with Queen Anne to ultimately take her place. Finally, in *Green Book*, Tony Lip has to face the Obstacle of race hatred and segregation to fulfill his job driving Dr. Don Shirley. The Obstacles referenced here are large and resonate throughout the movie, but in each scene we are reminded through the actions of the characters pursuing their Objectives that these large Obstacles driving the story are what birth the Obstacles that occur in each scene.

Obstacle brings us to the penultimate moment in an actor's preparation and in turn the character's journey: the Moment of Choice. The character has an Objective; they have assembled a powerful lineup of verbs to power Intention; and now, finally, they confront an Obstacle to their quest. This is the Moment of Choice and how each scene builds to the next scene and on and on, all the way to the final frame. At Choice, generally one character achieves their Objective and wins, while the other must surrender their Objective and perhaps lose. The delicate dance between characters in a scene, each one trying to achieve their Objective and confronting Obstacles along the way, finally brings the scene to the Moment of Choice. This is the moment-by-moment, play-by-play interaction we want to orchestrate with our direction of the characters. This is where our preparation is put to work to guide the actor's journey and tell a powerful story.

Let's look back for a moment to the scene between Nucky Thompson and Margaret Schroeder in *Boardwalk Empire*. Nucky and Margaret

meet, and their connection to the "old country" creates a genuine friendliness rarely seen from Nucky: a friendliness that assists his masquerade as the treasurer of Atlantic City. Suddenly, Ms. Danziger emerges from the back room, a room where Nucky was in bed with her before Margaret arrived. Ms. Danziger becomes an Obstacle at this moment for Nucky. How does this look when you are the treasurer of Atlantic City? A man who just 24 hours ago spoke of tolerance and virtue. Her appearance and Nucky's quick dismissal becomes a Moment of Choice.

He and Margaret both have Objectives, but it is Margaret who seizes the moment and drops the small talk to get to the matter at hand. Some may argue that Nucky Thompson would have just patted Margaret on her head and sent her on her way had Ms. Danziger not appeared. I think not. This moment becomes an opportunity, even for Nucky. He quickly peels off what appears to be three to five $100 bills, a tidy sum in 1920, and presses it with authority into Margaret's hand. She just hoped Nucky might give her husband a job, get him out the house and back in the working world. This action is more than she bargained for.

This is the Moment of Choice. Margaret succeeds in her Objective. It also ushers in a new Obstacle for Margaret, as she will have to explain this large sum of money to her husband, when she isn't even supposed to be out of the house. Nucky gets to save face as this "donation" until tourist season will mean Ms. Danziger's untimely appearance will soon be forgotten. Here is how you would do your preparation for the scene between Nucky and Margaret.

Nucky:

Objective: Uphold his public persona.
Intention: **to charm**, to decipher, to recognize, to demand, **to comfort**, to distract, to confess, **to accommodate, to insist**, to diffuse/disarm.
Obstacle: Ms. Danziger could expose him.
Choice: to uphold his public persona, he helps Margaret financially.

Margaret:

Objective: To ensure the survival of her children.
Intention: to pretend, **to cower, to compose, to confess**, to relate, to conceal, to plead, to refuse, **to oblige**.

The Three Questions to Choice 25

Obstacle: The threat of Nucky's refusal.
Choice: To accept the money from Nucky to ensure the survival of her children.

Notice that Choice and Objective should work together. The best way to test this is to harvest Objective when you compose Choice. If you have chosen the right Objective and the right Choice, they will work seamlessly with each other. See the example below:

For Nucky
To uphold his public persona (Objective) he helps Margaret financially (Choice).

For Margaret
To ensure the survival of her children (Objective) she accepts money from Nucky (Choice).

This key final step in composing your Three Questions to Choice is crucial. It is so easy to choose a strong Objective but find when you compose the character's Choice that the two fail to pay off the scene. After you compose Choice, look back to Objective.

I also want to point out that certain verbs in Intention are **bolded**. This highlighting is also a very key step in the preparation process. The explanation for this is in the next chapter.

In review, you begin preparation for the scene starting with Objective. You then move to determining the verbs that power the Intentions. Identify the Obstacle and finally compose Choice for each character in the scene. You need to experientially follow their journey from beginning to end. Do this in the same way the actor would – selfishly as if they were the only person in the world. When an actor makes this kind of life-and-death commitment to their Objective, powers it with the verbs for Intention, confronts the Obstacle, and makes a life-or-death Choice, be it drama or comedy, sparks will fly!

Putting it into practice

Using your same show, prepare to direct your actor's using the Three Questions to Choice. It is best to pick a two-person scene to get started with this process. You can progress after a few scenes to a three- or four-person scene, but starting with a two-person is best. Walk in each

of the character's shoes, starting with Objective and moving all the way to Choice. It is imperative that you do each character separately and be sure your Objective is not an Action. This is a very common error, so test that what you have chosen is truly the character's Objective. If what you have chosen has emotional resonance, raises the stakes in the scene, and has kinesthetic potential, then you have chosen the character's Objective. Also be sure that your Obstacle is external and that it is an obstruction to Objective.

Chapter 4

The Five Tools
Bringing the ensemble together – Part I

To quickly review, you started the process with the Five Ws, revealing the What, Who, Where, When, and Why. This led to the Storyline Facts, keeping the connection to the Five Ws with each scene and the characters, and we just completed composing the Three Questions to Choice for each character. As you will see moving through each step of our director's preparation, everything flows from the Five Ws.

At this stage of the process you are still preparing for rehearsal. Now it is time to add some more tools that will be instrumental in orchestrating the scene and bringing the ensemble of actors together. This next stage of the process will also synthesize your preparation so that your direction is, as Weston says, "simple, direct and playable." In *Directing Actors*, Weston shares five powerful tools to shape a performance: verbs, facts, images, events, and physical tasks. Her work inspired me so much that in my teaching I have adapted these for director preparation, and in this chapter we'll look at the first three tools.

Let's begin by looking at the verbs you have chosen. We don't want to come to rehearsal with too many verbs, finding a new verb for every line of dialogue in the scene, and that we end up micromanaging the performance. That is just as bad as ROD. There is no way that an actor changes their Intention with every line. The work to be done now is to synthesize this selection. Starting out with a long List of Verbs, you end up with just the few Primary Verbs that will power the character's Intentions for the entire scene. We look for verbs that will prompt. Verbs that will trigger specific places in the scene allowing the director to get out of the actor's way to connect the Actions and the Moments in their performance. This is how we plot the verb that propels the Opening Intention, the place where the actors begin the scene in the Now.

Verbs

We first introduced verbs in the Three Questions to Choice. If you remember after we completed plotting our verbs by walking in the actor's shoes, we ended up with probably a long list. This is because we are figuring that the actor in navigating the scene is employing a number of tactical changes, and at each change they use a new verb to power a new Intention. Our first step is to harvest (an old term given new meaning in the digital age) the verbs we picked to power Intention in the Three Questions to Choice. In this new section, the Five Tools, this is now your List of Verbs.

The List of Verbs is in what I call "Arc Order," which means you are tracking, as the actor would say, the A to B to C of Intention changes. This begins with the Opening Intention and goes all the way to the last Intention change in the scene. This is key in order to proceed to the next step, composing Two Sentences, sentences that briefly and specifically describe what happens in the scene. Arc Order, or chronological order, allows us to see the action or reaction between the characters: the kind of call and response in human interaction. A character makes a move, and the other characters respond to it. Arc Order sets up a visual way to see how these Intention changes ping-pong off each other.

Having harvested all the verbs in Arc Order for each character, here is what it would look like if you return to the scene from the pilot of *Boardwalk Empire* where Nucky meets Mrs. Schroeder.

> Nucky: to charm, to decipher, to recognize, to demand, to comfort, to distract, to confess, to accommodate, to insist, to disarm.
>
> Mrs. Schroeder: to pretend, to cower, to compose, to confess, to relate, to conceal, to plead, to refuse, to oblige.

This is a fairly long list of verbs, a long list of Intention changes. From this long list we want to determine which verbs are really needed to propel the scene. These verbs will become our Primary Verbs, so now the hard work begins.

Using the verbs for both characters, you want to compose two verb-driven sentences that describe as Tom Kingdon quotes Harold Lang in *Total Directing*, "What am I doing? In order to do what? Against what resistance?" What should result after multiple passes designed to eliminate all the descriptions and unneeded explanations – essentially all of the potential ROD, will be two verb-driven statements of Action, two sentences driven by Primary Verbs. These are the verbs that should

propel all the Intentions of the scene. Here is a demonstration of the multiple passes that need to be made to determine the Primary Verbs. I have bolded the verbs so that you can see the process clearer.

First pass
Nucky **charms** then **comforts** Margaret as she **cowers**, until she **composes** herself and **confesses**. Nucky **accommodates** her needs but Margaret **refuses**. Nucky **insists** until Margaret **obliges**.

This is really a bit too wordy. We have eliminated a number of verbs from the original list but we are still attempting to use too many so this needs to be thinned out.

After a second pass
Nucky tries **to charm** Margaret as she **cowers**. Nucky **comforts** and Margaret composes herself and **confesses** she wants a job for her husband.

We have cut down the number of verbs, but these sentences are filled with a bit too much description and information that are part of the given circumstances (getting the job for her husband) known by both you as director and your actors.

After a third pass
Nucky **charms** then **comforts** Margaret as she **cowers**, until she **composes** herself and **confesses**. Nucky **accommodates** her needs and **insists** until Margaret **obliges**.

The third pass finally yields Two Sentences – two statements of Action – and in the process the Primary Verbs are identified for both characters. Once the Primary Verbs are identified, you **bold** them.

Nucky: **to charm, to comfort, to accommodate, to insist.**

Mrs. Schroeder: **to cower, to compose, to confess, to oblige.**

Having determined these Primary Verbs and to keep your direction consistent with the actors at all stages of the rehearsal and in production, the first step is to go back to the List of Verbs at the start of this Five Tools section and BOLD these verbs.

Nucky: **to charm**, to decipher, to recognize, to demand, **to comfort**, to distract, to confess, **to accommodate, to insist**, to disarm.

Mrs. Schroeder: to pretend, **to cower, to compose, to confess**, to relate, to conceal, to plead, to refuse, **to oblige.**

When you begin rehearsal and you call up your preparation in the Three Questions to Choice to begin your work with each individual actor, you also **bold** these verbs in Intention for both characters. In this way, from day one of your interaction with your actors, you are introducing your Primary Verbs.

Nucky: **to charm**, to decipher, to recognize, to demand, **to comfort**, to distract, to confess, **to accommodate, to insist**, to disarm.

Mrs. Schroeder: to pretend, **to cower, to compose, to confess**, to relate, to conceal, to plead, to refuse, **to oblige.**

Also, note that by determining the Primary Verbs you are also identifying the Opening Intention for both characters to keep them in the Now.

Nucky: **to charm.**

Ms. Schroeder: **to cower.**

Now your Primary Verbs are set to steer your direction. Remember the meter that I mentioned previously? These Primary Verbs would occupy the 12 o'clock position on the meter, but it is also good to have a verb to dial back the Intention and one to dial it up. Using the verb "to charm" in the 12 o'clock position, at 10 o'clock might be the verb "to entertain" and at 2 o'clock the verb "to enchant" when we are working with the character of Nucky. For Margaret, if "to cower" is at 12 o'clock, at 10 o'clock we might use "to hide" and at 2 o'clock we might use "to bow down." I think we have chosen well, but always have a backup.

Verbs are the engine, the propulsion for Action, in the scene, and these same Primary Verbs will make an appearance again when we create our Marked Script. This is your Director's Script, the primary document in rehearsal and during production to guide our work with the actor.

Looking back to our initial plotting, there were other verbs that we found but ultimately did not identify as Primary Verbs. They include for Nucky "to decipher, to recognize, to demand, to distract, to disarm" and for Margaret "to pretend, to relate, to conceal, to plead, to refuse."

Examining these verbs you might wonder why they were not used. The answer is fairly simple. If you look closely at these verbs "to decipher, to recognize, to demand, to distract, to disarm" and for Margaret "to pretend, to relate, to conceal, to plead, to refuse," these verbs lean more toward a specific Action as opposed to verbs that are more open, that charge the actor to use the verb as a point of exploration and investigation. They are verbs that inspire creativity. Still, do not erase or in any way delete the other verbs that we didn't bold. Keep these verbs just in case. It is always good to have additional verbs at the ready if you need to make a change in direction.

With the Primary Verbs chosen and revisions made to the List of Verbs and to Intention in the Three Questions to Choice, we move to the next tool: the Triggering Facts.

Triggering facts

Earlier, we composed the Storyline Facts for *Boardwalk Empire*, and in doing so we talked about how later we would determine the Triggering Facts. Let's review the final sentence of the Storyline Facts.

For Nucky
But the era of Prohibition has changed the game. Now his primary occupation is that of the treasurer of Atlantic City, and, like the clever businessman, he must find every opportunity to play that role.

And for Margaret
Prompted by seeing Nucky speak, addressing the women of temperance at the dawning of Prohibition, she decides to swallow her pride and ask him for help.

The events described above for both Nucky and Margaret Schroeder are leading to the Triggering Facts. These facts happen in the Now to bring Nucky and Mrs. Schroeder together for their initial scene in *Boardwalk Empire*.

Take note that the Triggering Facts only launch the scene. They do not describe anything that happens once the scene begins. To mirror the actor's process, the Triggering Facts are what is prompting the character to enter the scene. The Triggering Facts keep us in the Now. They keep our direction away from saying anything about what happens in the scene, away from results, away from ROD. We set the characters up to enter the scene and then watch what happens.

32 The Five Tools, Part I

If we have planned our work well from the Five Ws, to the Storyline Facts, to the Three Questions to Choice; then identified the Primary Verbs using the Two Sentences, the Triggering Facts will act like a detonator to launch the scene. The Triggering Facts propel the Opening Intention, and this is crucial to keep the actors from playing the end of the scene at the beginning of the scene. We have all read the script, we all know how the story ends, but the journey must be made moment by moment in the present, in the Now. This is what creates tension and keeps an audience on the edge of their seats with the anticipation of "What will happen next?" As directors, this is where we want the viewer to be: never ahead of the story but moving with it – taking the journey in real time with the characters.

If we look back again at the episode from *Boardwalk Empire*, the Triggering Facts can now be composed by focusing on the most immediate Now moment for both Nucky and Margaret.

For Nucky
But the era of Prohibition has changed the game. Now his primary occupation is that of the treasurer of Atlantic City, and, like the clever businessman, he must find every opportunity to play that role. **It is morning on New Year's Day, and his valet announces there is a woman waiting to see him – and she is pregnant!**

And for Margaret
Prompted by seeing Nucky speak, addressing the women of temperance at the dawning of Prohibition, she decides to swallow her pride and ask him for help. **She has waited an hour in the waiting room for his office. Margaret knows that leaving the house for this long will arouse suspicion from her husband.**

The closer to the Now you can determine the Triggering Facts, the more they will help support the Opening Intention for both characters. This sets the stage for the actors to play the scene moment to moment.

Having arrived at the Triggering Facts, then the Dynamic Event has to be identified. There are the unique happenings within the scene that the characters must respond to, but . . . the Dynamic Event is different. Actors sometimes will refer to it as "the Turn," that place in the scene that often triggers Choice. The Dynamic Event is sometimes clearly evident because it is an external incident, but often it is the introduction of new information, a secret

revealed. We see this in the pilot from *Boardwalk Empire* during the scene between Nucky and Margaret. Just as Margaret coaxes a moment of tenderness from Nucky as he reminisces about his late wife, Ms. Danziger appears from a back room. Nucky is caught off guard, something Nucky Thompson does not experience too often. Margaret shyly looks the other way, but it is clearly the turning point in the scene. Margaret knows that knowledge is power. Margaret seizes the moment to press Nucky to hire her husband and help her family to survive. Nucky may have attempted to placate Margaret and send her on her way, but the Dynamic Event, the appearance of Ms. Danziger, is the game changer. Margaret's Objective is to help her family survive, so this turn in the scene places her at the Moment of Choice and she uses it to succeed in her Objective.

The Dynamic Event is not always this dramatic and obvious. Sometimes it is more subtle: a small bit of information shared, a subtle gesture or perhaps something out of the ordinary occurs. Look for it! It can be a wonderful moment directorially.

In the next chapter we will move to Part II of the Five Tools and probably the tools closest to directing because they tap into and nurture the sixth sense.

Putting it into practice

Using the scene you've been working on from a film or a television show, continue your breakdown employing the Five Tools. Start by identifying the Primary Verbs using multiple passes over your List of Verbs from Intention in the Three Questions to Choice. Determine the Triggering Facts for the scene that launch the characters. This is also a way to test your first Primary Verb. This verb should correspond to the verb that the actor would play at the beginning of the scene. Finally, determine the Dynamic Event. The Dynamic Event may not be so evident as it is in the example from *Boardwalk Empire*, but there will be a Dynamic Event. A well-constructed scene generally contains a Dynamic Event.

Chapter 5

The Five Tools
Bringing the ensemble together – Part II

These two remaining tools are probably the most important of the Five Tools. The first of these two are the Sensory Images, the most powerful in your toolbox. The Sensory Images are what you see, what you hear, what you smell, what you taste and what you touch. When you are connecting with the Sensory Images, you are utilizing your sixth sense, your "gut," your intuition. The Sensory Images are the keys to the inner world of the character, the place where the actor wants to be in pursuit of the Objective. Sensory Images produce Kinesthetic Behavior, the fifth and final tool. Kinesthetic Behavior are the physical gestures and tasks that happen in the world of Sensory Images. This is where "acting" becomes "being." Via the Sensory Images the actor can dive deep into the subworld of the character and embody the character from head to toe. How the character moves in the scene, handles properties, their body posture, gestures etc. This is where we "see" their choices via physical behavior. When an Objective is strong, life or death, the stakes are raised, and the kinesthetic possibilities for the character increase.

I shared a bit about my experience in Scandinavia as an ultra-marathon biker as it relates to my recognition of the power of Sensory Images in a previous chapter. I want to dig a bit deeper in this section, Part II of the Five Tools, to illustrate how this particular tool is uniquely qualified to help the actor put the performance "in the body."

In addition to my work in film and television, I still direct for the theater. As far back as I can remember, one thing that stands out in my mind during the rehearsal process is that moment when we go into technical rehearsals for a play. This is the time when all the design elements including the set, costumes, hair and makeup, lighting, sound and special effects are added. This is "tech" for the production. It is a magical time because up until this point, all the work with the actors has been in a rehearsal hall, usually a very nondescript room with the floor taped to mimic the ground plan of the set and perhaps a few necessary rehearsal

properties for the actors to incorporate into their character development. Even with the best sketches or, even better, color renderings of the costumes and an accurate color model of the future set, the sterility of the rehearsal room doesn't lend itself to the feeling the actors will soon experience when they actually walk onto the set to perform the production. In the performance space, the world of rehearsal furniture, props and tape on the floor suddenly becomes three-dimensional and above all, sensory.

A richly upholstered couch with a fine wood trim can be held, clutched tightly, and sat on. This gives the actor the sensory experience of *touch*. The doors of the real set, which have weight when opened and closed, are also part of this experience as well as a carpeted floor that absorbs the sound of footsteps and provides a soft surface underfoot. Absorbing the sound of footsteps is part of the sensory experience of what you hear. So too are the voices of the characters now reverberating off the walls of the set and the environment of the theater. What about smell? Are we in an office with the smell of office machines, paper and that industrial odor of dividers between workspaces? Perhaps it is a home in a wealthy part of town and some potpourri left on the dining table perfumes the air. On the other hand, maybe we are in a poorer section of town, where an apartment is filled with well-worn hand-me-downs and the garbage is not regularly taken out or picked up. The setting could be a place where food is served – perhaps the sensory experience of smell is present as food is cooked during the performance, heightening the sensation of taste. Something we might vicariously experience when the actors are eating. All of these represent the experience of our five senses: sight, sound, touch, taste and smell. The Sensory Images when shared with an actor in rehearsal and in production can tap into a part of the character that has not yet been mined by the actor, a part that triggers a revelation in the performance.

I directed a play in Washington DC many years ago called *Hambone* by Javon Johnson. The play took place in a diner, so we built a portion of a real diner with a fully working kitchen on the stage. While the show progressed, the actor playing the owner of the diner actually cooked food that was served to the other characters during the course of the play. The sensory experience of taste, the taste of an old-fashioned Mom-and-Pop-style diner, was so effective. It helped to bolster the audience's attachment to the characters and the diner whose future was in jeopardy. It was such a tantalizing experience for the audience that the concession stand in the theater sold more things to eat and drink during the intermission than they were used to doing. That was how the

sensory experience of smell and taste in the air could move not only the characters during the action of the play but also the audience. Add to all of the above the lighting. Lighting can control not only time of day and seasons of the year but also mood and tempo within the play. The lighting for the production is also a contributor to what you see.

Sensory Images are powerful. Working with very creative designers, we were creating a sensory experience for the characters that would in turn bring a tactile reality to the play. It is exciting on the first day of tech when all of these elements come together and you watch the actors suddenly leave the world of rehearsal and enter the world of performance. No more scripts in hand, they had clothing that touched their bodies and gave them something to embrace as part of their characters. Wearing makeup changed what each actor would see when they looked at their fellow actor. Now fully in character, the actor has been transformed. My greatest delight was directing period pieces with elaborate sets, costumes, makeup, and hair, supported by dramatic lighting and sound. What you hear also has a magical effect on the characters and as well for the audience.

During my years at university, we were always inside a theater. Whether it was the Hallie Flanagan Studio Theater at Tufts or the Loeb Drama Center in Cambridge, these were traditional theater spaces, and every element to create the sensory world of the play had to be brought in. It was not until I traveled to Nigeria to attend the University of Ibadan as a study-abroad student that I finally had the opportunity to experience a participatory form of theater – a theatrical style practiced by traveling actors, musicians, and dancers, a style of theater like commedia dell'arte – theater performance that made full use of the Sensory Images.

I mentioned previously my time in Nigeria where I witnessed the work of two other prominent dramatists at that time: Ola Rotimi and Kola Ogunmola. Rotimi was from eastern Nigeria, the part of Nigeria that had broken away to become Biafra during the civil war. Rotimi's troupe was very popular all over Nigeria at that time. Their form of outdoor, topical theater had become a way to comment on the way Nigeria was being rebuilt following the civil war. They were famous for their production of *The Gods Are Not to Blame* which was an adaptation of the Oedipus myth. The noted actor Jimi Sholanke performed the lead character, and this production, or I should say pageant, moved from area to area all over the country. The troupe traveled on open-bed trucks, or lorries, over Nigeria's treacherous and infamous roads.

When they performed in a town, Rotimi wanted to bring the audience into the world of the play. They rarely performed in an indoor theater,

and I think Rotimi liked it that way. The stage was just an open space, sometimes the town square or in front of the main market. Torches were used to light the action along with some very rudimentary theatrical lighting powered by a generator. Some of the audience – the dignitaries of the town – had chairs, but most of the audience sat on mats, stood on their feet, or even climbed on top of cars or trucks to watch the performance.

I was not aware of the concept of Sensory Images at that time, but I witnessed Sensory Images during the performance. The power of the play was in the way Rotimi harnessed the Sensory Images of each venue. You would see elaborately costumed men and women passionately performing this drama. You would hear drums playing, traditional singing, chants, and shouts. You could smell the paraffin from the torches along with the perspiration of the audience and the performers, mingling with the moist tropical air. The air also had a taste, a rich flavor. It was a combination of local food that was being prepared and served to the audience along with the remnants of palm wine. This alcoholic drink made from palm trees was always available.

Perhaps the most sensory experience in those performances was touch. It was very crowded so you would be right next to the person on either side of you. People were in front of you and behind you. We were all pressed so close together that you felt you were part of the action. The audience didn't only respond verbally to the highs and lows of the play, but they also responded with their bodies. The audience were physically engaged with the action of the play so when the character played by Jimi Sholanke theatrically plucked out his eyes, the gasps and screams from the audience were at times deafening. Some audience members even fainted. The theatricality was visceral and all encompassing, so much so that when an invitation to journey as an observer with another theater troupe led by Kola Ogunmola on one of their tours to smaller villages, I could not pass it up.

Ogunmola was known for a musical form of theater called "Yoruba Opera." His productions were massive, and, like Rotimi, the outdoors was the venue where his troupe performed. Ogunmola was always the lead actor surrounded by dozens of singers, musicians, dancers, and supporting players. When I recall this time for the purpose of sharing Sensory Images, what vividly comes to mind is the experience of riding the lorries from one place to another: the darkness of the roads, the sounds of voices speaking Yoruba excitedly about the performance that had just been completed, and the upcoming performance in the next town. You see, local events were often incorporated into

the performances, so in effect I was witnessing a story-development meeting taking place on board these lorries. Stories that were not being written down or scripted in any way shape or form. Stories that would later be improvised as part of the next performance. I clearly remember the smells and the taste of local food, often purchased from roadside vendors, and, of course, Ogogoro. This was another alcoholic drink, a kind of Nigerian vodka, a very strong brew made from the cassava plant. No one knew the alcoholic content, but if you drank more than a few sips your head would be spinning. Lastly again was touch. The feeling of being pressed so close to people you experience a kind of skinship. Careening over bumps and large potholes, the floor of the lorry was very hard, and something to hold on to was never easily located. While listening to the sounds of the lurching truck, mixed with talk and laughter, I can remember staring up at the moon and wondering if I would ever be able to share this magical time with anyone back in the United States.

I became so attached to the work of Ogunmola that when he passed away I traveled to his family home in a small village for the funeral. This was probably one of the most telling experiences witnessing Sensory Images. The going-home celebration took place over multiple days, but I could only journey there for the final day as the casket was carried to its resting place. "Rest in Peace Sun Reo" was emblazoned on the side. The members of his troupe, the actors, musicians, and dancers, performed to send him off. The sights, sounds, smells, tastes, and touch of that day are still very present in my mind. This kind of send-off to the next world is evident in many cultures around the globe. These experiences were planting seeds in me as a director, seeds that were nourished through my understanding of the power of Sensory Images.

These are moments from my past. I call upon them when working in the theater, film, and even in television. I learned at this tender time of youth the power of Sensory Images. The memory of these experiences propels me as technical rehearsals have evolved into opening nights. But it wasn't until I began to work in film that Sensory Images became even more important.

About seven years after the experiences witnessed in Nigeria, I was in the Barlovento region of Venezuela. Barlovento was one of the *palenques* in Venezuela. These are areas in South America where runaway slaves from what is now the Republic of the Congo and Angola hid during slavery times. Barlovento is east of Caracas. I had gone there at the conclusion of a film festival in Caracas with an Afro-Venezuelan poet who wanted me to see this evidence of African culture in her home. It was

an arduous trip by bus from Caracas, and when we arrived my guide was astounded that the town was completely quiet. All the way there she kept telling me how the town of Curipe was a very crowded, active, and busy place. The residents were all descendants of the runaway slaves and proud of it. The town was famous for its drummers. They played a very distinctive rhythm that was thought to be one of the last connections to their African roots. Yet when we arrived the whole town was silent. Then suddenly, out of nowhere, we heard the sound of feet, not stepping but dragging. The feet were shuffling, one step at a time. Then around the corner came a procession of men carrying a casket on their shoulders. The poet inquired and learned that the oldest man in the town had passed away recently, and today was his going-home ceremony. This man had also been one of the chief drummers in Curipe, so all the drums were silent that day in his honor.

I am a filmmaker, so of course I had my camera ready to shoot traditional drumming in the town. Without my knowledge, the poet began talking to members of the old man's family, convincing them to allow me to document the event. They surprisingly agreed, so I began to film. It was completely on the fly so I acted from my gut, from a spontaneous urge to shoot those elements that could tell the story of the celebration of this man's life. The town is in the rainforest so everything was moist. With the high humidity, it was tough to film quickly. Once he was in the ground and they began to dump soil on top of the casket, singing erupted. The drums I had traveled hours to see and hear were played at a deafening volume.

Later, when it was all over, I sat in front of the family home eating local food and being introduced to family members young and old. One of the youngest, probably a grandson or great-grandson, presented me with a replica of the drums of Curipe. It was a miniature version of their drums, and I was overwhelmed by the family's kindness. I carefully brought it all the way back to the United States. It still sits in my living room as a reminder of that very special time in Venezuela. The Sensory Images I witnessed on this trip live with me to this day. As filmmakers and specifically as directors, we must recognize the power of the five senses.

My work in documentary film happened in a serendipitous way after I finished my degree at New York University. Armed with a film education, my first forays with the camera were spent not only documenting life in Nigeria but also retracing my steps after leaving Nigeria all the way to Ghana. These early documentaries are what led to an invitation to attend the festival in Caracas.

My time in Nigeria stayed with me once I returned to America. I produced and directed the play *Song of a Goat* by the Nigerian playwright J. P. Clark. I knew that combining my theater and film training in narrative filmmaking was what I ultimately wanted to do. Ten years after the time in Caracas and with my life firmly focused on narrative film, I had the opportunity to realize a dream.

We had a film house in New York City during this time called the Elgin. They showed all-day retrospectives of the best foreign films. It was here I first saw the works of Fellini, Truffaut, Bergman, and many others. But my fascination centered on the Japanese masters of cinema. The mise-en-scène of Japanese films were driven by the Sensory Images. Their films were also about detail. I later learned that Yasujiro Ozu had his actors drink real sake in barroom scenes. The scenes he shot in restaurants had a working kitchen so that the smells and flavors wafted through the set. I wanted to witness this world up close and personal.

I wrote a proposal and received a grant to spend six months in Japan. This is how I came to observe the work of Yoji Yamada, the man behind the *Tora-san* film series. While I watched the making of the 43rd in the series, his use of Sensory Images was evident every day. On location in Kyushu at a hot spa, the smells of hot sulfurous water were everywhere. Outside the cities, Japan is lush with steep mountains alongside plains of rice fields. The buzzing of cicadas is always evident. There is a particular taste to the air: a mixture of soy sauce along with the essence of cooked daikon root common in many Japanese foods. These were the Sensory Images of Kyushu, but a good portion of the movie was made on the streets of Tokyo in an area called Shibamata. This is the eastern side of the city, the area many regard as real Tokyo or Edoko. Here you find the smells of urban Tokyo, buses and cars mixing with cooking from local restaurants and drinking places. The streets are clogged with traffic, of course, but organized, and, despite the sprawl, few honking horns or loud voices. There is an overall cleanliness to Japan that makes touching everything feel safe.

We were not allowed to stop the progress of the city during production, but there was a scene that needed to be filmed as the lead character, Tora Jiro, boarded a bus to head for the train station. I have just described the Sensory Images around the area of Shibamata, and all the residents know the very street that was the inspiration for the series. To see Atsumi Kiyoshi who played Tora Jiro, a legend in Japan, just stride down the crowded street and board the bus like any other citizen was astounding. The crew kept filming as if this was just a part of life. There were no extras on the bus, just normal passengers who once they

were aware that another *Tora-san* was in production, just acted naturally. Unbelievable!

The way Ozu used Sensory Images was adopted by Mr. Yamada (who was an assistant to Ozu) when we filmed in a traditional Japanese ryokan, or inn. Basically there are no beds in the rooms, just a futon that is rolled out on tatami mats for sleeping. These mats are then tucked away during the day when the room functions as a meeting place. Mr. Yamada is not a drinker, so there was no real alcohol used when we staged a dinner scene in the room, but there was real food that the actors consumed. Mixing with all the smells and tastes in the air coming from Japanese food, along with the smell of tatami, accompanied by impromptu singing and lots of laughter, the Sensory Images did their work.

When *Tora-san* was completed, I joined Mr. Yamada and his team to complete another film that had been started in the previous spring. Titled *Musuko*, which means "son," the seasons of the year played an important role in the story and, thus, the making of this film. A winter scene was needed to complete the filming, so we boarded a train for the sea coast city of Hachinohe in Iwate prefecture. This is the northern part of Japan, so the climate here is challenging. They can get snow like Alaska. This was clearly going to be a new experience in the world of Sensory Images.

Ozu was Mr. Yamada's mentor so I could see one of his many takeaways was not only Ozu's sense of detail and accuracy, it was also the use of reality. Whether Ozu articulated it or not (something tells me he did), he employed full use of the Sensory Images in all his work. So here we found ourselves not in the port of Hachinohe but on the outskirts of town on a real working farm, and it was winter. Snow covered the roads and the houses. The houses in this region have thatched roofs, the original method of construction dating back centuries. On this particular farm, the area where the animals stayed was in close proximity to where the farmer and his family lived. During in winter, the snow is so high you cannot afford to travel far to feed and care for the animals and for your loved ones. The smell of the animals was strong, so strong some members of the crew who were real Tokyo folks could not wait to complete these last days of filming.

Inside where we filmed was the *kotatsu*, a kind of fire pit in the middle of the room. In winter, you gather around the *kotatsu* to keep warm because even up until the time I first visited Japan in 1990, there still was no central heating – even in cities!

We staged our scene here, and, along with the smell, all the other Sensory Images were powerful: the sound of the fire and steam that

arose from a kettle, the taste of smoke in the air in a room that was dimly lit. The scene was about home, about a place in the home where people gather and call themselves family. There was something so tender and warm about this room, this farm. I clearly understood Mr. Yamada's decision to complete the filming here. The title of the film, *Musuko*, and the conclusion of the film produced in this location was the high point of my time in Japan. It cemented the power of Sensory Images for me as a director.

I shared before my first experiences in feature film were connected to location work, finding places where the scenes would take place for the Milos Forman film, *Ragtime*. Milos Forman was also a director who clearly understood the power of Sensory Images. He also directed *One Flew Over the Cuckoo's Nest*, done almost entirely in a mental hospital in Oregon, and portions of *Amadeus* were filmed in the Count Nostitz Theatre in Prague where 200 years before *Don Giovanni* debuted. While working in the locations department for the film *Ragtime*, which was set in 1903 in New York City, we had to recreate an ethnic neighborhood of that period. We used an area that was once known as "Alphabet City" or "the Lower East Side," and today just the "LES." Back then, people who lived on 11th Street were Jewish. They were first-generation immigrants from all over Europe. They were marginalized during this period so they congregated in this part of New York City.

Milos Forman and the production-design team spared no expense or limit to their imagination. We transformed what was then a dangerous street known for being the crossroads of the New York City drug market (11th and Avenue B) into a packed and crowded street of primarily Jewish businesses of the period. What you would see were signs in English and some in the language of the birthplace for the immigrant population. We had horse-drawn wagons and carriages that navigated a crowded street of shoppers and vendors. What you would hear were snatches of English blended with foreign tongues such as Yiddish. We built stables for the horses, and, horses being horses, they would leave traces of themselves all over the street. So, along with some vegetable and fruit carts, what you would smell was quite distinctive.

The vegetables and fruit on the carts were real, and some of the extras who provided background action would be tasting as they bargained, so what you taste could be experienced by their actions as well as the taste of the air in the city laced with animals and urban pollution. Finally, what did you touch? This was a time of real metal, real wood, that tools were made from. You would touch wooden modes of transport and feel the sensation of various fabrics: some gentle to the touch, representing

wealth and privilege and others rough and coarse, representing the poverty and struggles faced by these first-generation immigrants. This was the Sensory World of *Ragtime*. When the principal characters of the film appeared in scenes at various times during our production on 11th Street, they stepped into this complete sensory world of New York City circa 1903.

I remember on the first day of production when the character of Tateh, played by Mandy Patinkin, discovers that his wife Mameh, played by Fran Drescher, has been cheating on him with one of the shop-owners on the street. The scene was staged with the street completely filled with atmosphere players from Avenue A to Avenue B. Atmosphere players, both male and female, along with children, all in full 1903 wardrobe. Carts, horses, and animals packed the street as Mameh emerged from a building, caught by her husband, and walked through the crowd, ostracized by everyone in the community. I had never seen production of this scale before. Up until now in the production office there were only drawings and storyboards depicting what was later to be filmed. These images in no way compared to what I was seeing now. All of these sensory elements worked together to put these actors into the world of 1903. Tateh navigating his way through the crowded street and then watching his wife force her way past stunned neighbors and strangers: It was a believable experience for all, most of all for the actors who could fully immerse themselves in their characters. This is how Milos Forman provided the actors the opportunity to "be" not to "act," and to put the performance "in the body" from head to toe. The Sensory Images generating the Kinesthetic Behavior of the moment.

We were on this street for almost a month, if my memory serves me, probably one of the funniest moments was a scene where Evelyn Nesbit, played by Elizabeth McGovern, comes down to 11th Street. Evelyn Nesbit was a socialite of the time, a woman of means. Her clothing, hair, and makeup were in stark contrast to the denizens of the Lower East Side. As she strolled down the middle of 11th Street, navigating what horses left behind and other materials that were used the dress the street, a neighborhood guy, circa 1980, came out of one of the buildings completely to our surprise. He casually walked up to the character of Evelyn Nesbit and gave her a once-over look reminiscent of something from a Mel Brooks comedy. It was hilarious at first. Milos called "Cut!" and the first assistant director (AD) who was also the line producer, Michael Hausman, tried to coax this guy back into the building and out of the action – but he wouldn't budge. He hoped his unexpected cameo appearance in the movie might lead to something

more, so he kept playing the scene in the movie that he was seeing on the inside of his forehead. The best part of this encounter was watching Elizabeth McGovern as Evelyn Nesbit not miss a Beat as she strolled down the street. She kept playing the scene, the real scene, and would have strolled right up to her mark if Cut had not been called. Talk about an actor "in the Moment" – but again, all of this is due to the 360-degree sensory world that had been created on 11th Street.

One of the most memorable moments for me personally, and for Carol Cuddy, another member of the production staff and now a celebrated producer, was cleaning out the horse stalls at the end of each day of production. As part of the agreement to use this location, we had to return 11th Street to the business of 11th Street by 6 P.M. each day. The business activities on 11th Street during this period were "sketchy," but that was the arrangement we honored. This was my first lesson in working in an urban center where not only is a permit needed but also the cooperation with the local community and local businesses, whatever those businesses might be. There is a film office and a mayor of New York City, but neighborhoods have their own hierarchy. They really control the streets.

My second experience of the power of Sensory Images in film came with the film *Trading Places*. *Trading Places* is about money, old patrician money, power and class. I was the AFI intern. Philadelphia is an old city, and it is a city filled with the architecture, atmosphere, and lifestyle – a city that fit the profile of Duke & Duke, the fictional brokerage owned by the Duke brothers portrayed by veteran performers Ralph Bellamy and Don Ameche. Louis Winthorpe III, played by Dan Aykroyd, is a young man from old money and class who works for the Dukes. His ambition is to continue the tradition of wealth, status, and power he has grown up with and marry the love of his life, Penelope Witherspoon, played by Kristin Holby.

The Dukes stage a bet that they have the power to make anyone rich. They create a scheme where Billy Ray Valentine, played by Eddie Murphy, trades places with Louis and assumes his role at the brokerage. Louis is ultimately disgraced and kicked out of the firm. He loses his beloved Penelope. In the end, Billy Ray and Louis team up with the help of Ophelia, played by Jamie Lee Curtis, to turn the tables on the Dukes.

In contrast to the seedy urban world of the Lower East Side for *Ragtime*, *Trading Places* needed the Sensory Images of money and power. A stately bank building on Market Street in Center City was turned into the Duke & Duke brokerage. In this grand palace of a bygone era of banking, what you see consisted of polished marble, old staircases,

and lots of brass. The building exuded old money, original wealth in America. In this sensory world, when someone spoke, thick carpeting absorbed everything. It was like being in a formal library. What you touched was experienced via old oak desks and heavily padded office chairs. Every detail, even down to the $1,000 attaché cases that Eddie Murphy and Dan Aykroyd carried, made sure that you knew you were among the haves in life. The clothing was all top-of-the-line classic conservative wear. The air was crisp and clean, and the taste cleared your palate – the taste of wealth and success. So for Billy Valentine, who had spent his life as a street hustler, he was at first a fish out of water in this world. He soon began to realize that the people he was working for were hustlers too, just in a bigger more lucrative game.

Watching Eddie Murphy morph into this role was a delight. John Landis, who directed, wanted Eddie to become Billy Valentine, not just his *Saturday Night Live* character who had now turned up in a movie. They worked hard together to craft the character of Billy Ray Valentine, and if the saying "clothes make the man" is correct, it was evident in the movie. When Murphy donned Billy Ray's Brooks Brothers' inspired attire and strutted around Duke & Duke like a top trader, he was a winner. Billy Ray's world of Sensory Images produced the appropriate Kinesthetic Behavior. Dan Aykroyd, in the beginning, was equally convincing as Louis, totally at ease in this upscale environment. The change for Louis occurs when he is duped and kicked to the curb. He ends up on the other side of tracks, the low-end neighborhood of Philadelphia, where he meets Ophelia.

Louis was confronted with a new world of Sensory Images, and his Kinesthetic response matched that world. Seeing the other side of America was devastating. The sound of police sirens every few minutes, the smell of garbage and bodily fluids overwhelmed him. Everything he touched was peeling. He risked injury if he held onto a railing too tight. The sour taste of poverty was always in the air. This previously confident character, who had attended private boarding schools and frequented private clubs, was reduced to a common street urchin. He found himself forced to wear ill-fitting clothes associated with the African-American ghetto. He became ashamed and broken. When he meets his beloved Penelope on the street in this condition, her response to his pleas to take him back is "Louis, you smell!" Returning to his new home, he had to walk up flights of stairs in Ophelia's tenement building. Ophelia, who worked the oldest profession, and you know what that means, eventually takes Louis in and helps him rebuild himself. But for Louis, seeing this other side of America is at first devastating.

As an observer to the making of this very funny character comedy, featuring two very different worlds of Sensory Images, it was clear from the start it was going to be a huge hit. The environments were faithfully recreated by the production-design team. *Trading Places* remains a favorite for audiences even to this day. The power of the Sensory Images in this film and how they shaped each and every performance is really unforgettable. Don Ameche's rant "Turn on those machines!" as the Dukes' fortune is evaporating was one of the most stellar moments during production. Don Ameche, a true old-school Hollywood star, nailed the line and the Kinesthetic Behavior that went with it all in one take.

The making of these two pictures were very influential to me when I had the opportunity to helm my own productions. They taught me the power of Sensory Images and how they can turn an ordinary performance into something extraordinary. I directed *The Story of Barboza* about the infamous Mafia hit man. It was a drama that was part of a news series and so we were bound by certain journalistic parameters. We had to, whenever possible, use the actual locations where the real story took place.

When you go to the actual places, places where crimes were committed or people were incarcerated, the concept of Sensory Images reaches another level of importance. Even in the casting session, the producers wanted look-alikes for the principal characters. We chose an actor who very much resembled the real guy to play Joe Barboza. When he put on the mobster's signature sunglasses, you thought the real Joe Barboza – "The Animal" as he was called – was seated across from you at the audition table.

On our first day of production, we traveled to the actual jail in Hyannis, MA, where Barboza was kept. It was where he waited to meet with the FBI agents who would later convince him to join them in taking down his former boss, Raymond Patriarca. We were led to the actual cell where Barboza was kept. Because he was known as "The Animal," Joe was kept in a part of the cellblock all by himself. He had attacked other inmates and guards when he was held with the regular jail population. While we were setting up camera and lighting, I was rehearsing with the actor playing Barboza and his jailer who comes to get him. We dressed the actor in clothing just like the real Barboza wore in this very same cell, and I watched as this actor, based on photos and some research footage we gave him, walked hunched over in the same way the real Barboza did as he paced around the cell. He was taking on the Kinesthetic Behavior of the real guy.

We did a final rehearsal of the scene with Barboza and his jailer for our camera moves. We were ready to shoot when one of the real jailers

at the Hyannis cellblock spoke up. It was the guard who helped us pick the actual cell where Barboza was kept. It turned out he was working at the jail when the real Joe Barboza was locked up. He pulled me to the side and said, "Regge, if you really want to do this right, then I have to show you something."

Our actor playing Barboza was a smoker, and so he wanted to smoke in the cell as we did the scene. He was planning to just mash the half-smoked cigarettes into an ash tray on a table we placed in an interrogation room for the next scene. This guard showed us how the real Barboza would stack his cigarette butts on the horizontal bars of the cell, stacking them almost like spent shell casings from bullets. This was a Joe Barboza trademark wherever he was locked up. He'd leave these stacked butts behind as if to say "the Animal was here." So, following a great tip, I asked our actor playing Barboza if he could perform this delicate task of stacking the butts side by side when we did the scene. The guard was astounded by the actor's diligence to get this right. In the act of getting it right, he manifested another Kinesthetic Behavior of the real Joe Barboza. He had to pay attention to this action and find a way to incorporate it into the scene along with the dialogue. The producers, who were old-school network-news people, were delighted. I found the whole thing fascinating as this simple action became a window for the actor playing Barboza to become Joe Barboza, to become "the Animal."

One of the places Joe Barboza was kept while awaiting his time to testify was an island off the coast of Rockport, MA. It is a rocky place with a single lighthouse accessible only by boat. It was the perfect location to hide Barboza away with his family and to protect them. We went there to shoot this portion of the story.

We rented a helicopter for aerial views of the island and shot the moment when Joe and his family arrived. The real Barboza family had to stay on this remote island as they waited for him to testify. Barboza considered it a double cross. He had expected to be somewhere nice, maybe in Florida or the west coast, but no, it was this rugged stretch of earth. The Sensory Images in this location were striking. What did you see? Just acres and acres of rough terrain. What did we hear? A howling wind from the Atlantic Ocean and the nearby bay. What did we taste? The salt air and an acrid aftertaste produced from the spray when the Atlantic pounded the soil and rocks. The smell of the place was equally unwelcoming: a dank, putrid smell. Finally everything we touched was wet, moist, and most of all cold. I talked with the actor playing Barboza and the family about the reality of this world, even though we were just going to be there for a day and half. I wanted them to picture what it

must have been like to stay there for as long as the real Barboza family had to as they waited for him to testify. We even positioned armed guards at high points on the island just as the FBI had done. They did this so that Barboza, his wife, and child could walk around without fear of a sniper. Patriarca's people were looking for him. We were there in the early spring, but the remoteness of this island and the cold ocean were enough to make everyone realize how disenchanted Barboza and the family must have felt being stuck there for months.

The final scene of the film was set in the actual courthouse in Boston where Joe Barboza finally identifies Raymond Patriarca. We had to go through a lot of red tape to get use of this location. It was still a very active courthouse, but we had to use the actual location whenever possible. Old courthouses have their Sensory Images too. The high ceilings, the cold marble, curtains long overdue for cleaning. There is a kind of mustiness in the air that you realize will dry the throat and act as a real obstacle to someone who is testifying and not telling the truth. Everything feels cold and hard, like the law of the land. Voices seem to reverberate when prosecutors and defense attorneys cross-examine witnesses.

We packed the courtroom with extras because at that time this was a very high-profile case. We sat our actor playing Joe Barboza in the same area where the real Barboza made his damning testimony against Raymond Patriarca, who sat at a table about 20 yards away. In our scene, when Barboza finally points out Patriarca as the guy who ordered the killings that Barboza carried out, the actor playing Patriarca flashed an ethnic gesture at our actor playing Barboza. The gesture translates in a derogatory way: "You're a dead man." I didn't know about this gesture, and it was not something indicated in the script. The actor playing Patriarca knew it, and on our first take of his coverage he did it.

The actor playing Barboza, off camera at that time, reacted instinctually to the derogatory gesture. I saw his reaction firsthand. It was a stunning gut reaction to a real insult, something that in or out of character he could not ignore. So when we changed our coverage to get Barboza's dialogue and this reaction, because I had witnessed the actor as himself react, we shot it in this way and also in a way that I would call a bit over the top for the producers who wanted a bigger reaction.

In the final edit, we used the bigger reaction that the network liked. I had learned long before that when you are directing and you aren't the producer as well it is better to lose a battle so you can ultimately win the war. What was important to me as director was to be sure to get the shot I wanted. You never want to be in a position during the edit where you don't have another choice.

In this instance, I had inadvertently "Creatively Eavesdropped" on a very real moment, the way people in a particular ethnic group react, not on the surface to a slur but in a deep, subworld way because you have insulted them deeply. I wanted to shoot that instinctual gut reaction. This was a really important day for the film, and it was my time spent observing *Trading Places* in those marvelous cavernous rooms of Philadelphia that I was reminded of that day in a Boston courtroom.

This story would not be complete without another adventure that we took in the making of *The Story of Joe Barboza*. As I mentioned before, this was a fact-based movie. Joe Barboza was the man who created the now famous Witness Protection Program. We were guided every step of the way by our veteran network news team. We wanted to find the original locations for the story and use all of its Sensory Images to shoot the scene. We were in preproduction and research when our producers sought out the actual FBI agent who convinced Barboza to flip on Patriarca in exchange for protections. We made a plan to meet. The agent wanted us to meet in the Providence, RI, area.

We took the train to Providence. We were met by some of the agent's friends and driven to a bar and grill on the outskirts of town. I felt like I was in a Raymond Chandler novel. It was like being on location for a film-noir movie. We were ushered inside. The agent was a great guy, open and wanting to share his stories about Joe Barboza. He also wanted to share a series of tragic stories describing what happened to the family when the Witness Protection Program did not go well. Seated in this small, cozy restaurant, I took in the Sensory Images hoping that this might be the actual location where Barboza met the agent for the first time. The low lighting made this restaurant almost too dark to even see a menu. There was the smell of alcohol, beer, and spirits that had been spilled on many a night on the floors and the bar. There were only a few other customers in the club that night, and they spoke in soft voices, private conversations at each table. The furniture had seen better days, but the worn quality was homey and in a strange way comfortable. People could still smoke in bars during this time, so the air tasted of the grease from the kitchen mixed with the cigarette smoke.

As the agent shared story after story, and I was already visualizing how we would set up production in this wonderful location, I was told this was not the place where they met. The real place was no longer in operation and had been torn down. Still, the evening was a goldmine of information from the agent and wonderful Sensory Images to remember from this local establishment. I didn't get to use the experience of these Sensory Images in *The Story of Joe Barboza*, but I did get to use them

in a production of excerpts from the celebrated novel, *Native Son* by Richard Wright.

The production was part of the *Great Books* series and the focus of the scenes to be shot from the novel were scenes from the book that had been altered to permit publication in 1940. Wright wanted the novel to be published by the prestigious Book-of-the-Month Club, so some critics say he sanitized some of the racial and sexual overtones in the story. Wright wanted to be sure the book was published and his fame as a writer ensured. *Native Son* was republished in 1991, and I worked with a team that developed a screen treatment for these omitted scenes.

We had a scene that takes place in a pool hall on the South Side of Chicago, where the lead character Bigger Thomas meets friends, other men of color trapped in this part of the city. As we imagined the location for this poolroom, that was also a bar and a restaurant, the Sensory Images from the bar and grill in Providence guided me in our location scouting. There is a similarity in these kinds of meeting places in ethnic communities. They are a safe zone, a place designed for informality and comfort. Of course the bar and grill in Providence was a place for people of another ethnic hue, but the lighting, the smells, the sounds, the taste and the touch of these watering holes bear a sharp resemblance to each other. I wanted the Sensory Images to welcome the viewer into this Chicago South Side world. I wanted them to find comfort just as the Sensory Images in that small bar and grill had welcomed me in the search for Barboza's story. This too is another facet of "creative eavesdropping" as an actor's director, immersing yourself in worlds that one day you will need to recreate for television or film.

In another scene, we needed to shoot was the key moment in the story when Bigger Thomas is cornered and arrested by the police. In the novel, this takes place on a rooftop, so we searched for a building that would allow us to film. For me, the Sensory Images in my imagination were seeing the lights of the city of Chicago in the background. I wanted to feel the wind from Lake Michigan on the rooftop that would make a hand railing cold to the touch as Bigger climbed a fire escape to safety. There should be a smell in the air from small industrial factories and the sound of approaching sirens as more police arrive. We found such a place on the North Side of town. It was perfect, and we were given a permit to film.

On the night we arrived, my first AD, who was monitoring the weather, informed me that we had better move things along. It was not yet spring in the Midwest, and Chicago, sitting right on the lake, is known for suddenly being blanketed with snow. We moved quickly, and what worked

in our favor was the wind. The wind I had visualized and imagined when I was preparing the scene erupted off the lake. The cold hawk, as they call the wind in Chicago, became inspiration to the actor playing Bigger Thomas as he hunkered down to make his escape. I saw him use the cold wind to propel himself up the fire escape and then, in the end, that same wind cornered him as the flashlights of the police tracked him down.

We got our last take and were hustling into the building when the first wave of snow fell on the city. Within a few hours, more than 18 inches had piled up, but we got what we needed. The scene was, as they used to say in the world of film, "in the can."

With regard to specific Sensory Images, I would like to share the filming of one final scene of *Native Son*. It was the portion of the novel that had been changed back to Wright's original text in the 1991 publication. Mary Dalton's chauffeur Bigger is driving her home after a wild night with her boyfriend Jan. We rented a period Cadillac and, for the Dalton home, access to a mansion in a community north of the city. The Daltons were part of old-money America, so the Sensory Images had to be right. As they drive up to this elegant home you must see, hear, taste, touch, and smell wealth and privilege. As Bigger opens the door to help Mary out, the remnants of a bottle of alcohol crash to the payment. Mary stumbles out, stating, "I sho am drunk" as if to treat Bigger as an equal.

When we enter the home, we follow Bigger as he carries the inebriated Mary to her room. We pass through elegantly furnished rooms and up an ornate staircase to a part of the house that is off limits to the help. Bigger has never been past the Dalton study on the first floor, where he met Mary's father and was hired for the job. Being inside her bedroom is a totally different and forbidden world. The smells of alcohol mixing with expensive clothes, the feel of fresh linens on the bed, the quiet of the home in the wee hours of the morning: this is the pivotal moment in the novel and the most controversial part of the story. It is why Wright altered it for the 1940 publication.

Bigger's presence in this world of Sensory Images is so different and foreign from anything he has ever known. He is ultimately trapped when Mary's blind mother arrives to pray at the bedside of her wayward daughter. To ensure that Mary does not reveal his presence in her room, Bigger is pushed to do the unthinkable. Later, he shoves Mary's lifeless body into the furnace of the home. One can only imagine the Sensory Images: the heat emerging when Bigger fumbles to open the furnace door too hot to touch, the raging fire that quickly consumes Mary, the smell of burning flesh and the crackling sounds that suddenly grow

louder when the fire is fed with her body. I shared these Sensory Images with the actor as we shot this final scene at the Dalton mansion.

As Bigger goes on the run, the section of the novel Wright called "Flight," we shot one additional scene where sound, one of the Sensory Images, becomes almost too much to bear. Bigger is escaping, but his girlfriend Bessie is slowing him down. He fears if he leaves her behind she will expose him. In the novel, Mary's death might have been an accident, but what he does to Bessie is no accident. Bigger deliberately kills her. We needed to add a sound effect in postproduction to replicate the sound of a skull being crushed. I won't reveal what we used to do it, but the sound accompanying the action is chilling. You never see Bigger actually commit the act, all you have is the sound, and that is powerful enough.

As demonstrated by these two productions, Sensory Images are some of the most powerful tools available to a director. They create the world of the scene. A world where the characters in pursuit of the Objectives are either aided by the Sensory Images of this world, or the Sensory Images provide an obstruction. The Sensory Images become an Obstacle to achieving the Objective. In any event, Kinesthetic Behavior is produced.

I always like to use the Sensory Images in both ways, first suggesting how they aid achieving the Objective as well as the potential to derail. I think from the examples I have shared from *Ragtime*, *Trading Places*, *The Story of Joe Barboza*, and *Native Son*, it is clear how powerful and useful these final two tools can be.

We've been using *Boardwalk Empire* to practice our tools of preparation, so let's now apply Sensory Images and see how they influence Kinesthetic Behavior. Here is a description of Nucky's Atlantic City office from the perspective of Margaret as she enters it.

When Margaret comes to Nucky's office, she enters his world. The room smells of rich walnut. This is not the barroom of Nucky's night club, a place where hooligans get drunk and fight: it is pristinely maintained. It is a place of power where the elites of society dissociate themselves from the common riffraff. The ceiling is high, echoing the power of the elite. Calliope music plays in the background from the merry-go-round on the boardwalk. You can taste the remnants of pipe smoke mixing with the smell of walnut, adding to the rich allure of the room. A great wooden desk sits at the end – it is grand and stately, not unlike the Resolute Desk found in the Oval Office. Touching the wood you know it is real and that the furniture makes everyone sit upright. The taste in this room is a mix of cigars and the soon-to-be-forgotten remnants of good scotch.

This is Nucky's world as the treasurer of Atlantic City. He is comfortable here, and someone from Margaret Schroeder's world is out of place. As a director, you can remind the actor of the Sensory Images that ground the world of the scene. How this world affects the five senses can shape a performance. Note that you describe the Sensory Images of Nucky's office without anyone there. Just an office empty of people. When Margaret finally enters, the Sensory Images trigger the Kinesthetic Behavior. We witness how both Margaret and Nucky react to this sensory world and from that reaction how they put the performance "in the body" and not only in their head.

The Kinesthetic Behavior, the physical gestures and tasks that happen in the world of Sensory Images, is the place where acting becomes being, how the character moves in the scene, handles properties, their body posture, gestures, etc. This is where we "see" their choices via physical behavior. When an Objective is strong, making the task a situation of life or death, the stakes are raised and the kinesthetic possibilities for the character increases. Using the scene from *Boardwalk Empire*, here is an illustration of Margaret's kinesthetic response:

> Margaret enters the room as if she is entering a new world. She is careful not to disturb anything; everything is too beautiful. The tall ceiling looms over her like some great, cold god that is looking down upon her, judging her every movement. It frightens her, and she adjusts her position in the chair to protect herself and her baby from the unknown. Nevertheless, she is a woman on a mission, a mission to save her children for the coming winter. Despite feeling small in this grand world of wealth and power, her Objective will manifest via her Choices.

For Nucky . . .

> The grand desk and the rich aroma of the room remind him of how he escaped from a life of misery. This room, this ornate building, and his position in the world of Atlantic City invigorate him. He will never go back to a life of squalor. The memory and any indication of that world are what keep him fighting. In this world, the office of the treasurer of Atlantic City, he glides across the room with ease and flair. This is his dance of an exquisite life. He revels in meeting the ordinary citizens of Atlantic City and dazzling them in this lair. This is something he will do with Margaret Schroeder as he has done so many times before.

When you are composing this final section of the Five Tools, first harvest the character's Objective and keep that in the forefront. It will help you shape your ideas how the Kinesthetic Behavior will be triggered via interaction with the Sensory Images and most important to remember – in pursuit of the Objective.

Margaret: **To ensure the survival of her children.**

Even though she feels small, her Objective is strong, and it will help her hold up her head.

Nucky: **To uphold his public persona.**

Nucky must maintain his image, so his Objective is also strong. He will use the elegance and comfort of his status and position to frame the masquerade for Margaret's benefit.

When you arrive in our preparation at the Kinesthetic Behavior, your toolbox is now complete. You are ready to transfer all of the preparation: the Five Ws, Storyline Facts, Three Questions to Choice, and the Five Tools to your Marked Script. Your Marked Script now becomes your Director's Script. That is where all of your work is recorded in a neat and clear manner. With your Director's Script in hand you are ready to meet your ensemble. With each step of this process, take your time in rehearsal so that you fully explore all possible answers to the questions of the text and the human responses that tell the story.

The preparation you have done up to this point allows you to walk in the actor's shoes as they begin to build their character. In addition, we have discussed the tools needed to bring the ensemble together, to merge the independent trajectories of each character in order to tell the story and move the journey forward.

In the next chapter we will talk about Moments and Beats. How each scene must be laid out with the Intention changes for all the characters. Where Intention changes occur, there is the possibility that this is also the place for a Moment. A Moment is a powerful marker between characters in a scene. Moments build tension, and create Choices, Choices that lead to one or more characters achieving their Objective. Characters having achieved their Objective mark the end of a Beat. Moving the story forward begins with the start of a new Beat and the pursuit of new Objectives. This process moves the work from scene to scene to the finale.

Putting it into practice

Using your chosen show, now apply the remaining tools, Sensory Images and Kinesthetic Behavior, to your Five Tools. Review your work from the previous assignment. Did you harvest the verbs from Intention to start off the Five Tools? Did you identify them with their characters and kept them in a chronological or "Arc Order"? Arc Order helps to identify the verb that powers the Opening Intention all the way to the final Intention.

Review your composition of the Two Sentences, your Two Statements of Action. Here you determine your Primary Verbs. Primary Verbs of Action that describe what happens in the scene. Triggering Facts are crucial because they launch the Opening Intention for the characters, keeping everyone in the Now. If it is not completely transparent, determine the Dynamic Event, the game changer, "the turn" that usually forces Choice in the scene.

Dive deep into the world of your scene and experience the Sensory Images. Truly imagine how all five of your senses would be affected by the world of your scene. Drop your characters into this world. Actors know what to do, they are in touch with their senses, but just in case, devise a way to reference this world to the actor in pursuit of their Objective. Small hints to arouse their imagination and creativity are all you need to have at the ready. Share them if needed and only if needed. Trust the actor. They know how to make their way.

Chapter 6

Moments and Beats

After completing the Five Tools and transferring our work to our Marked Script, we have prepared the foundational work to direct. In addition to this thorough preparation, our work as an actor's director is guided by our sixth sense: our knowledge of and sensitivity to the human condition.

The study of human interaction in conversation, conflict, joy, and sorrow is the work of a director. We need to always be students of the human condition and the diverse ways that people interact – not only in the country of our birth but all around the world. The entertainment industry is global, and many of the stories that are being told by media-makers happen in places that used to be considered far away. Technology and social media have turned distance into a thing of the past. We as media-makers have to realize that our audience is global. We are not making media just for the United States, with principal locations of production being New York or Los Angeles. We are telling stories that need to have worldwide appeal and impact. The Why of our Five Ws reemerges at this step because we want to produce work that will have a worldwide appeal. You want to tell stories that will resonate in New York, Tokyo, London, Mumbai, and Johannesburg to name a few. How we create Moments in our storytelling gets to the heart of producing work with the potential for worldwide impact and resonance.

If you remember, we developed our Intentions in the Three Questions to Choice by relying on our sixth sense. We walked in the actor's shoes and imagined ourselves in the scene and what tactical moves (Intention changes) that we would do to reach our Objective. Now we want to explore how that comes into play when we bring the ensemble together. Using the example from *Boardwalk Empire*, let's harvest the Intentions again for Nucky and Margaret.

Nucky: **to charm**, to decipher, to recognize, to demand, **to comfort**, to distract, to confess, **to accommodate, to insist**, to diffuse/disarm.

Mrs. Schroeder: to pretend, **to cower, to compose, to confess**, to relate, to conceal, to plead, to refuse, **to oblige**.

Looking at the list, you can begin to see how one character's change of Intention seems to trigger a change of Intention for the other character.

Nucky: to charm; Mrs. Schroeder: to pretend.

Nucky: to decipher; Mrs. Schroeder: to cower.

As director, we do not want to use all these verbs to guide a performance. That would be micro-management. We want to uncover which verbs are really needed to propel the scene. These we determined in the previous chapter are the Primary Verbs.

Nucky: **to charm, to comfort, to accommodate, to insist.**

Mrs. Schroeder: **to cower, to compose, to confess, to oblige.**

When we were working to identify the Primary Verbs, there was a demonstration how Intention changes take place when characters are pursuing their Objectives. The character reaches a point in the interaction where they realize that to achieve their Objective they have to make a tactical change. They have to find a new path, via a new verb, to power Intention. A new How to achieve their Objective. This is what actors call the A to B to C in the scene. I like to refer to this from a directors' point of view. That means composing the "Chapters" in the scene.

Each actor enters the scene with an Opening Intention powered by a verb, and if there was no Obstacle Intention would take them straight to their Objective. But there is always going to be an Obstacle. In a two-character scene, the other character's pursuit of their Objective could certainly provide an Obstacle. Without something to obstruct Objective, there would be no conflict, no tension to provide an emotional payoff for the scene.

In the case of Nucky and Margaret, Nucky would like to meet this constituent who has been announced with a "growing issue." Nucky's valet informs him that she is pregnant! Nucky would like to dismiss her as soon as possible and get back to his leisure, but there is an Obstacle.

58 Moments and Beats

Prohibition is now the law of the land, and playing the role of the treasurer of Atlantic City triggers his need to see Margaret Schroeder.

For Margaret, her need is far more important. Her Objective "to provide survival for her family" is a matter of life and death. She knows meeting a man of Nucky's stature is a gamble. She is terribly out of place in City Hall. She is a commoner and at this time in America truly the forgotten. Pursuing and achieving her Objective is not going to be simple. To save her children, she is willing to go toe to toe with a man who she considers decent, God-fearing, honest, and above all not a victim of the demon alcohol. Nucky's stature is her Obstacle but an Obstacle she is willing to face in order to win.

When an Objective is life or death, it raises the stakes. It heightens tension and, as we discussed in the Five Tools, fuels the kinesthetic possibilities for the character.

The scene begins. Nucky enters with his Opening Intention **"to charm"** and for Margaret **"to cower"**, her attempt to be humble. The conversation is polite and respectful. Nucky even tries to make an "old country" connection with Margaret. This is a typical political ploy, and, in doing so, he notices something on Margaret's face: a bruised eye, the clear sign of an abusive situation. An abused woman who is with child is the sign of a bad marriage. This is the first real Moment in the scene. Margaret tries to hide her injury, but it is clear that Nucky has seen it. Time stops as this information is registered.

This is what distinguishes a Moment during the scene. A clear exchange of emotion, an energy passing between individuals becomes a marker. So when we arrive at this unexpected Moment, tactics must change. Nucky's desire to be quick about dealing with Margaret and grease the rails that ushered her into his office has to change. He must change his Intention from **"to charm"** now **"to comfort"**.

For the actor, this is the A to B in the scene, a portion of the "through line" of an actor's pursuit of their Objective. Now here is probably one of the first places where the vocabulary of the director is a bit different from the vocabulary of the actor. Many actors will call the A to B to C "Beat changes," but as a director, I prefer Intentions, tactical changes in pursuit of the same Objective. A Beat for a director is a major marker in the scene. In my definition, a Beat is where the character chooses a new Objective after the Moment of Choice determines the outcome of the scene. We will discuss Beat changes in detail later.

Margaret on the other hand, reacting to Nucky's change in voice and approach, also makes a change from **"to cower"** to **"to compose"**. She calms down a bit to explain what brings her to Nucky's office. This

is what we want to monitor as the director. We want to be sure once we begin rehearsal, that these Moments, these markers of human interaction, are clear and honestly played. This is where we are finally putting our preparation to use, coupled with our sixth sense about human behavior. Directing is the craft of preparation working in concert with the sixth sense. With Chapter 1, or the actor's "A" Beat behind us, let's move forward to Chapter 2 or the "B" for the actor.

Using our Primary Verbs to guide Intention, the next change for Nucky would be **to accommodate** and for Margaret **to confess**. Examining the text, these verbs seem more appropriate for the latter part of the scene, and are verbs that would come into play after the Dynamic Event when Ms. Danziger emerges from the back room. This analysis would be correct. Nucky's Intention **to comfort** and Margaret's Intention **to compose** allows the scene to proceed in an unexpected way for both characters. For a brief time, seated with Margaret, Nucky is able to think about family and remember his departed wife. For Margaret, she witnesses a man who has a soft spot for children and family, a man who loved his wife.

This is a very important part of the scene, and to allow it to happen with honesty and clarity, as actors' directors, we get out of the way. We do not try to micromanage every twist and turn by insisting that Nucky play "to distract" and "to confess." All of this leading up to Ms. Danziger's appearance or to insist that Margaret play "to relate" and "to conceal." As an actor's director, we trust that the actors realize both Nucky and Margaret temporarily put Objective on the back burner. That is why this part of the scene is something you don't want to micromanage. The Primary Verbs are determined to leave space to allow life to happen between the characters. So, be an actor's director, and let it happen.

In the Five Tools, we talked about the Dynamic Event. In this scene you won't find a better one. Suddenly when Nucky relaxes to lovingly recall his late wife, Ms. Danziger appears. This is also a Moment clear and simple. Nucky is knocked off his game, and Margaret is suddenly presented with an image of Nucky in complete opposition to his character at the temperance meeting. Disheveled, and probably reeking of alcohol and sex, Ms. Danziger suddenly becomes the poster child for Obstacle. Nucky attempts to comfort and discreetly dismiss Ms. Danziger, who has no intention of being so easily dismissed. This failed attempt does not go unnoticed by Margaret. She remains composed, and in a rather coy fashion retreats to her previous shyness. She is not going to assist Nucky in cleaning up the matter at hand. Once Ms. Danziger has been

sent on her way, Margaret changes tactics. Fueled by her new Intention "**to confess,**" she returns to her Objective that has been helped by Ms. Danziger's unexpected appearance. Nucky too must change Intention now "**to accommodate,**" because Margaret's silence about this incident is crucial to upholding his reputation.

Notice with this change in Intention for both characters there is no Moment, no emotional marker. These changes are a result of the Moment created by Ms. Danziger's appearance. You will also notice that even though Ms. Danziger's appearance is the Dynamic Event of the scene and likewise a Moment, we don't indicate an Intention change to micromanage the performances of Nucky and Ms. Schroeder. We let them play in the Moment. They can rely on their sixth sense that is part of their actor training to make it happen. Actor's will say they "drop into" this Moment, reacting intuitively to the situation.

As Nucky peels off large bills from a wad in his pocket, Margaret at first refuses. This is only proper despite how much she needs help. It is this response that triggers Nucky's final Intention "**to insist.**" Nucky's need to uphold his reputation matches Margaret's need to feed her family. The change in Intention is accompanied with a kinesthetic action: Nucky presses the money in Margaret's hand. He touches her. A touch at this time in history between a man and a woman is significant. Margaret can feel the smooth hand of a man of means. The crisp bills that he is pressing into her moist palm. Nucky rarely has to use physical force to make a point anymore in life, he has minions for that. Pressing these bills into Margaret's hand has a special meaning for him. Touching her, hand in hand, is a way to say "Hush now." The force of this action, something Margaret never anticipated, catches her by surprise. This triggers her Intention change now "**to oblige.**" Searching for words to say as a demonstration of her thanks, she promises to name the child after Nucky. Nucky response is so memorable "Enoch? You wouldn't be so cruel."

Structured by the tools of preparation and the sixth sense, you have all the elements to create Moments. Moments that are crucial to our Marked Script, our director's script, the blueprint you bring to rehearsal. Using the Five Tools to focus your work as director, you are able to guide and prompt the actor's work performing the character.

This approach may feel minimal, but it is in fact collaborative. As an actor's director, you expect the actor to also prepare and come to rehearsal with solid ideas about the character. You don't have to feel responsible for everything, and you should not expect to do everything. Be prepared to guide and to make creative suggestions inspired by your

preparation. Preparation that first began with the 5 Ws and has grown step by step to create the Marked Script, your Director's Script.

In the next chapter, we will learn to build your Marked Script. The Marked Script represents all the preparation we have done up to this point. It is also, to use a musical metaphor, your score – your orchestration for rehearsal and capture. Like the conductor's score for a major work in classical music, each scene is laid out with the Intention changes for all the characters. These changes usually result in Moments. A Moment, as you can see from our work in this chapter, is a powerful marker between characters in a scene. Moments build tension and create Choices: Choices that lead to achieving or being forced to abandon Objectives.

Putting it into practice

Using the scene you have been working on, find the Moments and note at each Moment if there is an Intention change. In the Three Questions to Choice, from Intention for each character, harvest the Primary Verbs. Guided by these verbs, note how they move the scene forward for your characters.

Chapter 7

Marking your script

Let's again review where we are in the process. We created our Five Ws, revealing the What, Who, When, Where, and Why. Next came the Storyline Facts to keep the connection to the Five Ws (primarily What) for each scene and the characters. We then plotted the Three Questions to Choice for each character independently and learned how the Five Tools bring the ensemble together. We determined the Primary Verbs with the help of Two Sentences that focus the action.

The Triggering Facts bring each character to start of the scene. Once in the world where the scene takes place, we experienced the power of Sensory Images: what the characters see, hear, taste, touch, and smell. We realize how they aid or obstruct the characters from achieving their Objectives and what kinesthetic activities and tasks are put to use in this sensory world.

We have prepared well up to this point. What remains is plotting how to document the ensemble's journey, creating a roadmap, a clear plan that incorporates each character's trajectory and that results in tension. Tension is produced by the twists and turns from colliding Objectives producing Obstacles and the Choices each character ultimately will make. This roadmap, this director's blueprint, is called the Marked Script.

Tom Kingdon introduced this practice in his book, *Total Directing*, and it is the inspiration for how I teach marking a script. You work in pencil when you are formulating ideas, when you are drafting, but your final Marked Script should be typed and carried in hard copy. Even in this digital world, somehow holding paper for a director is a tactile experience I still wish to experience.

To begin to build the Marked Script for each scene in your show, you must first harvest the Two Sentences you created when determining the Primary Verbs for each character in the scene. Using our scene from *Boardwalk Empire*, we would have:

> Nucky **charms** then **comforts** Margaret as she **cowers**, until she **composes** herself and **confesses**. Nucky **accommodates** her needs and **insists** until Margaret **obliges**.

To begin the Marked Script, you want to place this at the top of the page, like a headline from a newspaper, so that you are reminded right from the start what happens in the scene.

Clarity is very important to the director in rehearsal and in production. You want to be able to easily refer to your Marked Script. A messy, disorganized script usually makes for a messy, disorganized rehearsal and, heaven forbid, a messy, disorganized shoot.

To prevent this, we designate the left and right margins of our script for different duties. At this time, we are just going to concentrate on the right margin. We'll get to the left margin in a moment.

We start by dividing your script page horizontally into thirds. Under your heading created by the Two Sentences, using your tab, move your cursor to what would be two-thirds to the right of the page. Type the words, Beat 1. Here is a good time to define a director's Beat. Earlier I spoke about unique vocabulary that I ascribe to for the director that is a bit different from the vocabulary of the actor. As directors we are always looking at the big picture, the total world of the scene including the characters, the setting, the costumes, etc. For the director, a Beat defines the start of and completion of an Objective by one or more characters in the scene. In the scene between Nucky and Margaret, you could argue that both achieve their Objectives, but perhaps it is Nucky who gives a bit more than he first anticipated. The point is, in the encounter when Nucky's Objective is to "Uphold his reputation" and Margaret's is to "Provide survival for her family," that is all this scene or this Beat is about. If during the scene either Nucky or Margaret chose a new Objective, then that action would be the beginning of a new Beat.

This methodology is used so that the director can properly orchestrate the tone of the scene. Tactical changes in the character's quest for the Objective are noted by Intention changes, whereas as an Objective change is major, a new Beat begins.

In episodic television, most scenes have only one Beat as a new Objective usually signals the start of a new scene, but nothing is set in stone. Put your sixth sense to use to be sure. Oftentimes, as a director, finding a way to create a Beat change in a scene can raise the stakes. A Beat change can heighten the tension by taking predictability out of encounter, thus producing a stronger impact on story.

So far on the first line, you have Beat 1. Now on the line below it, you want to compose a name for your Beat. Now here is the place as a director, I like to have some fun. Directing is hard work, and, as you've seen, preparation can be challenging. When the opportunity to have a little fun presents itself, take it. Usually my "nickname" for the Beat will be derived from looking back at the Two Sentences, which became the headline for this scene.

Nucky **charms** then **comforts** Margaret as she **cowers**, until she **composes** herself and **confesses**. Nucky **accommodates** her needs and **insists** until Margaret **obliges**.

This is a pretty serious scene, except for the moment when Ms. Danziger spoils the party. To have a bit of fun, but also to keep focused on my What, here is my penname for the scene:

"**Nucky's new clothes.**"

Now this is my name for the Beat. You can make up your own, but this gets me focused on What this scene is about: this new world called Prohibition that Nucky is coming to terms with, and his place in it. Nucky's realization that life now could be challenging. So we have Beat 1 and underneath, "Nucky's new clothes." What becomes important now is having right up front each character's Objective and, equally important, their Opening Intention. The How they are pursuing their Objective at the start. This is how the characters "enter the scene," based on the Triggering Facts. For Nucky on the line below "Nucky's new clothes," I write, "To uphold his reputation" and on the line below Objective, I write "To charm" for his Opening Intention. On the next line, I write for Mrs. Schroeder's Objective "To provide survival for her family," and on the next line, underneath Objective, her Opening Intention "To cower." Therefore our right margin Opening Header at the start of the scene would look like this:

Beat 1

"Nucky's New Clothes"

Nucky OBJ: "To uphold his reputation"
Opening INT: "To charm"
Margaret OBJ: "To provide survival"
Opening INT: "To cower"

One of the things you usually need to do to make this kind of formatting possible is converting the script you are given to a Word document or some format that you can manipulate. It is pretty much now industry standard to have a script delivered electronically, but you want to insist that the script be written in Word. A PDF, even when converted to a Word document, can be problematic.

The initial List of Verbs was the result of your sixth sense about human behavior. You trusted your "gut feeling" about what each character was

Marking your script 65

doing to achieve their Objective. For the study of directing and principally to become an actor's director, it is a necessity to rely on your sixth sense: to use your intuition about human behavior to plot the character's tactics in the scene. Prepare to mark the script with Intentions using the Primary Verbs as a guide.

To start, harvest your Primary Verbs that were revealed using the Two Sentences. Using our example from *Boardwalk Empire* for Nucky and Mrs. Schroeder, here is what that would look like:

Nucky: **to charm, to comfort, to accommodate, to insist**

Mrs. Schroeder: **to cower, to compose, to confess, to oblige**

Print these out on a separate piece of paper or paste them under the Opening Header before the start of the scene. You can cut and paste them as you build your script or later delete these after the Intentions are placed.

Wherever there is an Intention change we have a unique way of marking it. Tom Kingdon in his book, *Total Directing*, developed this system of marking the script, so with Tom's permission I adapted this system a bit for this book. You choose the last word of the character's speech or sometimes it can be a moment of action in the scene. Underlining the last word, or a moment of action, you draw a line of dashes over to your right margin, ending with the word Moment or just the letter "M":

--MOMENT or (M)

As a matter of procedure, when you first mark your script before rehearsal, use dashes instead of solid lines to denote Moments and Intention changes. When you and your actors have come to agreement about the journey of the scene, then you turn these dashes into hard lines.

In the script below, we make note of where Nucky's Intention changes.

```
                    NUCKY
          Ah but we're all immigrants, are
          we not?

She nods smiles. Nucky notices - - - - - - - -MOMENT

a bruise under her left eye, poorly concealed
by makeup

A few Beats then . . . - - - - - Nucky - to comfort
```

Marking your script

> NUCKY
> Tell me how I can help you? - - - - MOMENT
>
> Margaret - to compose

Notice how Nucky and Margaret's Intentions change from the Opening Intention to the next Primary Verbs. Our sixth sense, our gut feeling about how they wish to navigate this encounter, can be seen clearly when you mark the script in this way.

 Now the next place where Intentions change comes after Ms. Danziger's exit. Margaret "**to confess**" and Nucky "**to accommodate.**" This is pretty straightforward and there is no Moment. Let's move to the end of the scene where the Intention change is more dramatic after Margaret explains her family situation.

NUCKY reaches into his pocket and pulls out a wad of cash.

> NUCKY
> However this should see you through
> winter.

He goes to press 300 dollars into her hand.

> MARGARET
> I couldn't no. I am not here looking
> for charity.
>
> NUCKY
> I insist. - - - - - - - - - - - -MOMENT

She looks at the money in disbelief, grasps his hand.
 Margaret - to oblige

> MARGARET
> I. . . . I don't know what to say,
> how to thank you.

MARGARET thinks a moment and then . . .

> I'd be honored to name my child
> after you.
>
> NUCKY
> Enoch? You couldn't possibly be so
> cruel.

This is how both characters' journeys are composed and subsequently marked in the script. You can see where the Obstacle of Ms. Danziger's entrance drives the change of Intention and ultimately Choice that brings the scene to a conclusion.

Now here is where we need to unpack Moments.

As I mentioned in the previous chapter, a Moment is a powerful marker between characters in a scene. Moments build tension and create Choices. Choices can result in achieving an Objective or lead to new Beats and the pursuit of new Objectives. This moves the story from scene to scene and to the finale.

To determine Moments you must trust your sixth sense, your gut feeling. Is there really an exchange of energy, of emotion creating a Moment at this time between the characters? Is this an emotional marker? If so, you have found a Moment, and perhaps at this Moment there is also an Intention change. You must examine this closely.

Notice in the scene from *Boardwalk Empire*, when Nucky's Opening Intention of "**to charm**" changes "**to comfort**" and later changes to "**to accommodate,**" Margaret's Opening Intention of "**to cower**" changes to "**to compose**" and later "**to confess.**" Nucky sees Margaret's black eye, a sure sign of an abusive husband, and this Moment causes him to want "**to comfort.**" Moving through the scene to where Margaret's Intention changes from "**to cower**" to "**to compose**" comes directly after Nucky's Intention change "**to comfort.**" This exchange between characters drives the A to B to C for the actors in the scene and likewise for the director. These are the Chapters that create the storytelling.

There are also times where there is an Intention change but without a Moment. We witness this as Ms. Danziger leaves and Nucky and Margaret restart their conversation. You want to be very specific about Moments in a scene. Too many Moments can lead to melodrama. If Moments are carefully orchestrated, your audience becomes part of the journey of the character. The emotional tapestry feels natural, not forced, so they go for the ride. They become part of the journey.

The clear and concise marking of your director's script provides you with easy access to all of your preparation. When you see the word Intention, you know what that change is and what it means for the character and how it was arrived at from your preparation.

If you have a scene where there is a Beat change, then script marking must make this totally clear. Because a Beat change is a complete change of Objective, it is not only for the character who causes it but for all the characters in the scene. To indicate a new Beat in your script, you draw a solid line from the left margin all the way to the right margin. By drawing this solid line you are creating a boundary. This line of demarcation separates pursuit of the first Objective and the start of a

68 Marking your script

new Objective. You must also create a new header: Beat 2, along with a pen name in addition to new Objectives for the characters and new Intentions. Below is an illustration of a brief scene courtesy of Tom Kingdon's *Total Directing* that demonstrates a scene with a Beat change. Notice that because our Intention changes and Moments are now set, the dashes have become hard lines to the right margin.

Hubert and Elena

```
Int. Office,               Day
```

Hubert, 65 years old and of Greek origin, is a salesman and Elena, age 24, is his niece. They have recently met for the first time. Hubert was separated from his sister Elena's mother during the war.

He is studying a family photograph she has given him.

Beat 1

"Do I Know You?"

Hubert OBJ: Should I reconnect?
Opening INT: To investigate.
Elena OBJ: Persuade him to reconnect.
Opening INT: To entice.

> ELENA
> It was taken a few years ago. You can see my brother. They named him Hubert, after . . . you.

> HUBERT
> And he lives in Greece too . . . ?

(ELENA nods)

> HUBERT
> You must miss <u>them.</u>————————MOMENT

> ELENA
> I met my husband in a village in Thessalonika — it took a long time for him to persuade me to come and try living here.

 HUBERT
 If you hadn't . . .

 ELENA
 But I did. And now I know I have
 some family here, it might make it a
 little easier for me.

 HUBERT
 You are so like your <u>mother</u>——MOMENT

They sit smiling at each other for a <u>moment</u>———

 Elena – to conclude
 Hubert – to speculate

 ELENA
 I should be getting back.

 HUBERT
 Of course.

(They get up.)

 ELENA
 There is just one thing we haven't
 talked <u>about</u>
 ———to close the deal

 How are we going to break the news
 to Mama?

 Do you want to be the one to call
 <u>her?</u>———MOMENT

 HUBERT
 The thought <u>of it</u>! ———to confirm

Beat 2

 "We Are Family"

 Hubert OBJ: To reconnect with his sister.
 Opening INT: To make plans.
 Elena OBJ: To bring everyone together.
 Opening INT: To celebrate.

> HUBERT
> Just picking up the phone and hearing her voice! I don't know if I'd be able to get the words out.
>
> HUBERT (cont)
> Maybe you better prepare her first?
>
> ELENA
> I'll do it as soon as I get back. I am sure she'll call you straight away.
>
> HUBERT
> I'll be waiting. Though I don't know where we'll begin, there's so much to talk about.
>
> ELENA
> The first thing she'll want to know is when you're coming over for a visit.
>
> HUBERT
> You try and stop me!

So there you have it. Your Marked Script is now your Director's Script. Your work in preparation from the Five Ws all the way to the Kinesthetic Behavior is complete, and you are ready to meet the actors and start the rehearsal process. Before we begin to discuss the steps that carry you through rehearsal and into production, the next chapters focus on one-to-one work with an actor doing a monologue. Perhaps the best way to experience being an actor's director is to collaborate on a monologue; and the first collaboration is a monologue that comes from your own experience.

Putting it into practice

As demonstrated using excerpts from *Boardwalk Empire* and *Hubert and Elena*, create a Marked Script, your Director's Script, based on the scene you have been working on. Remember to be sure that an exchange between characters is really a Moment. Moments are special and arrived at carefully. Also be on the lookout for a Beat change, a place where the character decides to change Objective.

Chapter 8

The Improvised Monologue
Exploring collaboration through personal experience

When you examine great moments in theater, television, and film, you realize there are special times when a character gets to express more than what is revealed in the dialogue. Monologues where characters express themselves for upwards of five minutes or more and the audience is transfixed. Monologues are more common in the theater, but if you examine current works in television and film, there are times when one of the major characters has an opportunity to tell the story via a monologue.

In the film, *Mary Queen of Scots*, Saoirse Ronan, in the role of Mary, finally gets to confront Margot Robbie, in the role of Elizabeth. Mary's world has been turned against her, and it is only Elizabeth who can intervene. In this final moment that sets up the actions Elizabeth must ultimately take against Mary, Ronan delivers a powerful monologue. Elizabeth only listens, her reactions preparing the fatal response. Ronan's performance at this moment in the film, rendered as a monologue, is a unique opportunity for the actor. She alone must weave her presentation, changing Intentions to facilitate all the twists and turns, creating the Moments all by herself, which will resonate for Elizabeth and for us as the audience. One of the best ways to experience this process as an actor's director is via the "Story Exchange." This is an exercise that actors do with each other to practice telling a story. The actor who listens to the story, the scene partner, experiences listening and being present. Here is how it works. One actor chooses a true story from their life experience. The story can be dramatic or it can be humorous, the only demand is that it be heartfelt. The story should be about an incident that stays with the actor and will probably be remembered so it has resonance. The actor listening to the story, who will prepare a monologue based on the story, will ask questions to gain valuable information needed to shape the character and the situation. The actor will usually take some time to prepare, a few days or even up to a week to fashion an Improvised Monologue of the story. When they are ready, the actor performs the monologue.

The original raw story has now become content. The actor who is improvising has complete creative control. Sometimes the story is nearly identical to the original, and sometimes they take the original story and spin it in a different direction. The takeaways are numerous. First of all, collaboration is experienced for both the actor delivering the monologue and for the scene partner who told the raw story. Second, the actor who told the story gets to experience "letting go" of something private and personal and watching it turned into content. Using the template of the Story Exchange and applying it to collaboration between the actor's director and their acting partner, as director, you have the opportunity to mirror this experience.

The first step for you as director is to dig deep and find a story from personal experience that you are willing to share. Pick a story that is heartfelt but also a story you are willing to make public. Ultimately, it will be shot and posted online for all the world to see it. To give you an example, here is a story from my personal life during college. It is for me a story of friendship, trust, and a reminder of the importance of taking chances when you are young.

> I was a sophomore at university in Boston. Every spring we would have a break from classes, the iconic "Spring Break" where most students would take this time to journey somewhere. For the more well-heeled students, they might spend the week somewhere in Europe or Asia, but for most of us, perhaps a trip to New York City would be the way to spend this time off. I am not sure who suggested it, but myself and three other classmates, Claude, Victor, and Tamio. decided we would go to Montreal during the break. We had a vision of springtime in Montreal, similar to springtime in the northeast as temperatures were beginning to climb, announcing the end of winter. So we packed spring-like clothing and climbed into Claude's VW and headed north. As we left Massachusetts and crossed through New Hampshire and a bit of Vermont on the way, we all noticed a good amount of snow still evident as we neared the border with Canada. We convinced ourselves that when we got to Montreal all this snow would be gone – well, how wrong we were! We crossed the bridge from Longueuil into downtown Montreal, and the streets of Montreal were snow-covered. The VW skidded around trying to navigate the road conditions. Our primary destination was Mount Royal, but when we got there, sleds were doing better than cars. And it was cold! So cold our spring-like leather jackets were no match for the subzero temperatures. We were a sight to the Montrealers. I guess they saw us dressed for warmer weather and wondered, what are these guys thinking? We finally found a small B&B in downtown Montreal where we decided to stay

and, thankfully, warm up. Next door was a bar and kind of meeting place called "the Boiler Room." And I think that is what it must have been before someone turned it into a business and made it a place to hang out. It was warm, and I remember we spent most of our time eating and drinking there because to be on the street was painful.

What I do fondly remember was getting to know my three classmates in a way I had not known them before. It was a time of political upheaval in America, so all too often relationships with fellow students tended to be based along lines of ethnicity. Tamio was Japanese American and a good friend of Claude's but prior to the trip I only knew his face in passing on campus. We bonded that weekend, and I learned things about the Japanese American experience I had never known. Claude and I were friends, and we had hung out many times. Claude, who was also African American or a Black American, that was the term of the times, was one of the few people who had a car on campus. He had a personality that prompted relationships with everyone on campus regardless of ethnicity. I knew Victor because he too was African American. Prior to this weekend, I had always found him quiet, reserved and staunchly independent on a pretty polarized campus. This was a time when, if you were a person of color on a campus with predominately White Americans, you walked lockstep with your classmates of color. This weekend also allowed me to get to know him better. His background growing up in the central Midwest and how the experience of ethnic enclaves on a university campus was new to him. In his town he was used to being the only person of color in all his classes. I could identify with this because it had also been my experience, but in a much more urban, East Coast environment. Over the course of this weekend, we huddled together in the Boiler Room and back in our B&B. We were trying to stay warm physically but realizing that most of the warmth came from the bonds of friendship that developed. To this day, Claude and I are friends. Tamio has become a minister but sadly, Victor, who became a prominent person in the television business, has passed on.

As I have just done, directors share a personal story and then give the actor time to work on an Improvised Monologue. The action of telling this story, something true and resonant for me, is my demonstration of trust and of "letting go." I surrender to the actor something important to me and in doing so I agree to accept the actor's creativity. My truth has now become content. As directors, we want the writer to surrender the screenplay to us for interpretation. We also want the actor to surrender

themself to our direction – and we now agree to do the same. We allow someone else access to our deep and personal truth. This action is intended to be the start of a powerful bond between actor and director.

So now as the actor goes to work improvising a monologue based on, or driven by your story, take off your hat as the writer and put on your director's cap. As director, put into practice your preparation, starting with a breakdown of your original story using the Five Ws. We identify the What to start off. It might be the first time you've thought about the What for the story you have shared. Don't be surprised as you discover the powerful issues and ideas contained in your story. The Who is usually pretty obvious but even a portion of your breakdown can turn into an aha moment when you remember your story and someone who was there. When and Where are also usually straightforward, but here again you might experience a glad surprise. Probably the most impactful, the reason why the story stays with you, is the Why. Why has this moment remained a prominent part of who you are today? Why did it mean something then and remains powerful in your life now? The Why is usually a wake-up call. Oftentimes it is life-affirming, but sometimes it can also be unsettling. Remain open to whatever comes up and document it. What you are doing is also part of your training and building your sixth sense.

When you meet again with your actor, the first step, and maybe the scary step, is to let them perform the monologue. Now you get to see what they have done with your story. Did they keep it the same? Maybe your story was simply a jumping-off point for an entirely different story in their monologue. Whatever it is, this is now content. It is their story, and it will become the script for the collaborative work you and your actor will undertake.

Because this is a class assignment and presentation time is limited, I ask students to limit the improv to two to three minutes maximum. This usually means that actor and director have to prune down the original monologue rendered by the actor. Perhaps the first time the actor performs it you record it to your phone or another device. Using the class guidelines of three minutes maximum, you prune away as many minutes needed to get to that time. Here is where the Five Ws come in. If the story has radically changed, ask the actor What the new story is about for them. Identify the Who: Any new characters? Plot the Where and When and use the Why to help select the portions of the monologue that really resonate, the portions that you as director know can be turned into Moments. A monologue with Moments communicates to the audience. A monologue without Moments is like watching paint dry.

Be judicious in your selection, but be clear and concise so that the Chapters in the story, triggered by the Intention changes, manifest into Moments that will enchant your audience.

Once you have pruned the monologue down to the appropriate time, put to use the Three Questions to Choice. If you feel the need, clarify the Objective. Find stronger verbs for the Intentions, and make sure the Obstacle is a powerful obstruction to Objective. This work will strengthen Choice in the monologue.

When the actor performed my story, I wanted it to be clear and concise in the way he shaped the Moments: how he described how we all dealt with the cold, the Moment where it occurred to all of us that this time was a bonding opportunity. That realization was the Choice, the Choice I made and the Choice we all made. Looking back at the monologue, to chart the Moments I just outlined and make them clearer, it might look like this:

I was a sophomore at university in Boston. Every spring we would have a break from classes, the iconic "Spring Break" where most students would take this time to journey somewhere. For the more well-heeled students, they might spend the week somewhere in Europe or Asia, but for most of us, perhaps a trip to New York City would be the way to spend this time off. I am not sure who suggested it, but myself and three other classmates, Claude, Victor, and Tamio, decided we would go to Montreal during the break. We had a vision of springtime in Montreal similar to springtime in the northeast as temperatures were beginning to climb announcing the end of winter. So we packed spring-like clothing and climbed into Claude's VW and headed north. As we left Massachusetts and crossed through New Hampshire and a bit of Vermont on the way, we all noticed a good amount of snow still evident as we neared the border with Canada. We convinced ourselves that when we got to Montreal, all this snow would be gone. Well how wrong we were! ———————————————————————— (Moment)

We crossed the bridge from Longueuil into downtown Montreal, and the streets of Montreal were snow covered. The VW skidded around trying to navigate the road conditions. Our primary destination was Mount Royal, but, when we got there, sleds were doing better than cars. And it was cold! So cold our spring-like leather jackets were no match to the subzero temperatures. We were a sight to the Montrealers. I guess they saw us dressed for warmer weather and wondered, What are these guys thinking? We finally found a

small B&B in downtown Montreal where we decided to stay and, thankfully, warm up. Next door was a bar and kind of meeting place called "the Boiler Room." And I think that is what it must have been before someone turned it into a business and made it a place to hang out. It was warm, and I remember we spent most of our time eating and drinking there because to be on the street was painful. ——————————————————————— (Moment)

What I do fondly remember was getting to know my three classmates in a way I had not known them before. It was a time of political upheaval in America, so all too often relationships with fellow students tended to be based along lines of ethnicity. Tamio was Japanese American and a good friend of Claude's, but prior to the trip I only knew his face in passing on campus. We bonded that weekend, and I learned things about the Japanese-American experience I had never known. Claude and I were friends, and we had hung out many times. Claude, who was also African American, or a Black American, that was the term of the times, was one of the few people who had a car on campus. He had a personality that prompted relationships with everyone on campus regardless of ethnicity. I knew Victor because he too was African American and prior to this weekend. I had always found him quiet, reserved, and staunchly independent on a pretty polarized campus. This was a time when, if you were a person of color on a campus with predominately White Americans, you walked lockstep with your classmates of color. This weekend also allowed me to get to know him better. His background growing up in the central Midwest and how the experience of ethnic enclaves on a university campus was new to him. In his town he was used to being the only person of color in all his classes. I could identify with this because it had also been my experience but in a much more urban, East Coast environment. Over the course of this weekend, we huddled together in the Boiler Room and back in our B&B. We were trying to stay warm physically but realizing that most of the warmth came from the bonds of friendship that developed. ——————————————————————(Moment)

To this day, Claude and I are friends. Tamio has become a minister, but, sadly, Victor, who became a prominent person in the television business, has passed on.

As you can see, the story has been broken up into Chapters: Chapters for us as directors and for the actor the A to the B to the C, and so on;

Chapters that if examined closely are triggered by a different Intention, a different verb.

If at this time you and the actor are comfortable with the results and the monologue is "in time," then shoot it all in one take. No editing please. You don't want to manipulate the storytelling by piecing together the best takes. This is not about the best takes; it is about improvising. Encourage the actor to take a chance and fly solo with your story, free to let their imagination soar. You don't want them to worry about saying the right lines or memorized dialogue. You want to keep the performance as raw as possible, spontaneous and in the Moment. The focus is on communicating a story that clearly resonates for the scene partner and for the audience. The emphasis is on retaining the intimacy and relaxed atmosphere you both created in rehearsal when you bring the monologue to the world of production. The introduction of technology can manipulate and sterilize a performance. Production should be conducted to mirror the intimacy that is felt when someone is sharing a private and personal story in person. This approach dictates attention to the all-important eyeline.

We are jumping to bring up the subject of eyeline, but this is an assignment. You are creating your first collaborative work with your actor partner so we need to talk a bit about cinematography.

One of the things I emphasize in the first class of the semester, "Directing Actors for the Screen," is that it is a class about directing actors. It is not a class in filmmaking or, to be specific, in the work of a DP. Unfortunately, camera expertise is thought to be film-directing by some students. Directing Actors for the Screen is not a class primarily focused on lenses, f-stops, or aperture settings. In order to shoot something live and then position it in a rectangular box, an actor's director must know something about visual composition. There are basics that most film students learn in introductory classes. Because they are basics and part of the canon of best practices, I consider them rules – rules you should follow because they make sense to the human eye and to our sense of human behavior.

The study of cinematography will take you to museums to study paintings, the works of the great masters. Why? Because of composition, lighting, details in the foreground and background to name a few areas of attention. These are also good to know for the actor's director. The one rule I find most applicable is the Rule of Thirds. If you divide your rectangular screen into thirds, it defines where to position your character when in conversation with another character. This is something you must be familiar and comfortable with as an actor's director. We can all applaud the cinematic approach in works like *The King's Speech* and

The Danish Girl as both challenge the Rule of Thirds. These are feature-length works, and an aesthetic decision was made to tell the story in this way. As directors, we will all at some point have our opportunity to work with a cinematographer who knows how to bend the rules and still tell the story. Starting out, I emphasize a healthy respect for the works of the great masters of art and the great masters of cinema who embraced and celebrated working with the Rule of Thirds and other cinematic constructs.

My suggested composition for the Improvised Monologue, a personal intimate story, is to place the camera "over the shoulder." This is normally the shoulder facing the camera of the scene partner. We want the look of the actor speaking the monologue to be close to the "line," that is, the imaginary line drawn between two actors facing each other. The closer you can bring the look of the character to this imaginary line, the more intimate the experience.

I must digress here because a brief description is needed for those who may not know what "close to the line" means. There is an imaginary 180-degree line between two characters in a scene. It can be expressed like in Figure 8.1 below. You want to stay on the same side of the line so that in a two-person scene the character who appears on the left side of the screen (Rule of Thirds) remains always to the left and the other character to the right. You can cross the line, which means flip the left and right orientation of the characters, but to keep from driving the audience crazy, it is best to do it only once. After you cross, stay on that side to allow the audience to adjust to the new geography.

Staying close to the line, the audience is witnessing the sharing of the story in the same close proximity as the scene partner. The audience member's line of sight is right next to that of the person who is listening intently. In this way, when Moments happen, the scene partner usually responds kinesthetically. A nod or some other primal physical affirmation that says "I hear you," "I understand," "I am with you."

Figure 8.1 This is the eyeline between two characters that determines the 180 degrees for camera placement.
©John Lanza

We as audience members should have the same response watching the performance of the monologue. We too should respond kinesthetically when Moments occur.

If the work is done well, and expressed chapter by chapter with authenticity, it does not matter whether the story is still faithful to the original raw material, or an adaptation. The story has become something else. The creativity of the actor orchestrating Moments within the story is what's most important. In the final analysis, does the story resonate for the audience ensuring that they might be touched? Will they remember this final performed story just as you remember the original story you shared for the rest of their lives? That's the challenge of the Improvised Monologue.

When Improv Monologues are presented in class, it is fascinating to watch the faces of the directors. As they observe the actor's performance of the monologue, they learn something new and intriguing about the actor and themselves. When both actor and director are proud of the final product, it is a sign that a bond has been created: a trusting bond between an actor's director and an actor. Great work can be built from this place, and that is the reason I highly urge those who are planning a career as an actor's director, to experience this first step: the experience of digging deep inside yourself to discover a personal and powerful story. Once you discover it, surrender your story to an actor and be open to embrace the product the actor creates.

The Story Exchange allows us to release a part of ourselves much in the same way that actors do for each other in their preparation and training. The actor wants their scene partner to be present, to be with them in the scene. They want them to be in the Moment, so they expect the same from an actor's director. They depend on the actor's director to be there, to be present with them as they do the work to bring honesty to the scene. Some filmmakers who go by the title of director may or may not be trained or emotionally, psychically, or spiritually interested in the actor and their process. They just want to see that movie playing on the inside of their forehead so that anything else is really a bother. These individuals usually find the idea of participating in the Story Exchange workshop a waste of their precious time, but in doing so they miss out on the opportunity of bonding with their fellow actor(s).

There is nothing to fear in sharing a part of yourself. It is a necessary step in the pursuit of building a creative bond with the actor and carving a path to a superlative performance. Actors rave about certain directors they have worked with that brought out their best performance. The rehearsal and production time is filled with moments of sharing, of

giving and of surrender. Performing the Story Exchange for my students is a joy for me. Taking the time to look back and recall my college years, years filled with the hopes and dreams of a 20-something American, is precious to me. Through memory, I realize how I have become the person I am today. Given the opportunity to participate in the Story Exchange every semester, I celebrate the twists and turns, the ups and down, the struggles and the triumphs of life I continue to challenge and celebrate. I know clearly that all of what I have experienced has contributed to building my sixth sense and, to coin the phrase I share in class, to develop my practice of creative eavesdropping.

Creative eavesdropping is having your senses on full alert so that you are open to witness the moments of human behavior that are happening around us all the time. Being a witness to the serendipitous way that life just happens but most of the time goes unnoticed. If you are a director or aspire to be one, you have to be open to creative eavesdropping at any moment during your day.

That is what I try to do each and every day: to place myself where I can listen and observe the unpredictable moments, the world of spontaneous human behavior. Learning about the Story Exchange from my colleague Ken Cheeseman was a lightning-bolt moment. I remember immediately desiring to find a way to incorporate this practice as part of my teaching. It was an icebreaker into the world of being an actor's director, and, for a few, a window into the private and often secret world of their favorite filmmakers, the women and men they regard as auteurs. In screenwriting, the mantra is "to be successful, write what you know." I think for many of my directing students, the mantra becomes "to be successful, direct what you know." This is how individual creative visions are born. Examine the first films of most contemporary directors. Films often birthed from personal life. They are stories that had to be told because they were banging on the door of that director's soul to get out, stories that needed to be released: seen and heard. As a result, the vision of these filmmakers is singular and original, not a piece of work that is a remake of something someone has already done. Here again is where the Five Ws plays a part: What is it about? Review this over and over again because when the What is personal and deeply felt, it cannot be imitated. It is a vision that has signature.

Don't retreat from the opportunity to experience the Story Exchange. The Story Exchange is a necessary step in learning how to structure a monologue. Through the Story Exchange you are learning the basics and foundation of storytelling, and, remember: as director you are the master storyteller.

The biggest takeaway for this assignment is focus: "Where is your focus?" Your focus should be on the actor, on the performance, not on the equipment. Look at all the wonderful black-and-white photos of cinema's great directors from the past. Notice their proximity to the actors. They were always up close and personal. Always focused on the nuance of performance. So, forget "video village" or what we used to call "the tap." Dare to sit close and witness it all live. That is the front-row seat you want to have.

Returning to the example I shared at the start, the scene from *Mary Queen of Scots*, you will see they placed the camera over the shoulder of Elizabeth. Mary can deliver her plea as close to the line as possible, making this monologue a candidate for cinema history.

To review, here is a workflow for the Improv Monologue Story Exchange. Before meeting with your actor, tell the story to yourself using your smartphone so that even in telling it to your actor you can limit your original story to between two and three minutes.

At the first meeting with your actor, share your story. Then allow your acting partner five to ten minutes to process the story and come up with questions. Your acting partner will then ask questions that you should be able to answer, completely guided by the Five Ws of your story. The actor may ask questions that will cause you to take a detour into some uncharted territory. Trust your partner, share without reservation. Your acting partner needs this. These deep images are from the Sensory Images world.

Right after meeting without your acting partner, do your Five Ws for *your* original story. You know the What, the Who, the When, the Where and most important the Why. You've picked a story that resonates, a story that defines who you are today.

Allow your acting partner whatever amount of time they need to work on their version of your story. Some need a day or two, and some may need more. The most important thing is don't depart from this initial meeting without first setting the schedule to meet again.

When you meet again, let the actor first perform their version of the story. Don't time it the first time. After the first time, compare how your story has changed via the actor's creativity. You will need to document this in your original Five Ws via **bolded** type, *italicized* type, another color, whatever you choose, but what is important is that you document how your story has now become "content." Most of the time your acting partner will stick fairly close to your original story, but be prepared for something completely new. The story could now be placed in another set of given circumstances and will be told as a monologue in those

new given circumstances. (Some examples: Two guys work together at a bar, and one tells the story. A romantic couple getting more deeply acquainted over dinner or just hanging out. Two siblings seeing each other over a semester break back at the family home.) The objectives and intentions that are part of the story now relate to these new Triggering Facts: Are they telling it to impress their co-worker? To tantalize their new lover with their adventurous spirit? To one-up their sister with their accomplishments at college?

Before production, put on your director's hat and make "adjustments." Compliment the actor on their initial rendering of the story and then ask, if it was not crystal clear, "What do you think the objective is?" not *was*, *is*. Keep the story in the Now. Here is where collaboration begins. Discuss Objective, which will open the door for you to make adjustments via the Intentions. Maybe there are places in the story you want to adjust, so share a verb. "What if before you talk about _____ How about trying to coax?" etc. Use language like this, polite, respectful but at the same time encouraging the actor to try your direction. Use this opening in dialogue between yourself and your acting partner to also talk about the Obstacle and ultimate Choice. Look for pauses in the actor's story or places they take a breath. These are usually the places that you can mark as Moments. You may find that the actor might use these phrases every time they tell the story.

Use these tools as a means of collaboration, developing the story the actor has created. It is no longer your original story even if similar; surrender it to the actor, but as director help guide their presentation. Take note of the verbs decided upon and any other information that you will need to complete your Three Questions to Choice. If time permits with the actor, identify the Triggering Facts and the Dynamic Event in their version of the story. Hopefully you are already planning to shoot in a location that supplies all the Sensory Images, but if not, talk about these images using your five senses to trigger the same from your actor. It will probably be subtle (sometimes not), but observe how the actor adds the Kinesthetic Behavior during production.

With this work done collaboratively, now shoot the story on location. Don't forget, the actor needs a scene partner, so that is why it is best to work in groups of four: two actors and two directors. Your actor will tell the story to the other actor so you can observe the performance as director and the other director will operate the camera. Let the scene partner hold the microphone. It may take a few passes to get something both of you are happy about and also conforms to the maximum time (three minutes). Remember: One take. No editing. The assignment is

about the flow of story that creates Moments and maybe even a Beat change.

Once production is done, thank your acting partner so they are released, and you begin transcribing the audio portion of the selected take to create your script. After you have your script (double spaced), look at it, and identify the Moments: the places where your actor shared energy and emotion with the listener. Now you are marking the script.

Chapter 9

The Scripted Monologue
Prelude to directing a two-person scene

With the Improvised Monologue project completed, you want to move forward to new material, scripted material, by an established screenwriter. This material could have also been adapted from a true story – many great screenplays are. It's your chance to interpret one of these great scenes as the actor's director. It is always nice to ask the actor you worked with on the Story Exchange Improv Monologue to again be that person you work with. You have created a bond and a trust with them. Choose a monologue from a published screenplay or even a work from the theater or television. Usually the actor will have a number of monologues that they have worked on and prepared for the purpose of auditioning. Choose one that has creative and visual potential. While the actor polishes up their performance, you begin your work.

You know the process. Starting with the Five Ws, break down the What, Who, When, Where, and Why not only for the scene but for the entire movie or television series. The homework increases because if it is a film you need to read the entire screenplay. If it is a television show, you need to find the scripts for a few episodes to really get a sense of the Five Ws. Finally, if the actor has chosen a play, you need to read the entire play. Try your best not to watch the prior finished work. What you are watching is someone else's rendering of the scene. You want to start from scratch with your vision, your ideas, your creative impulses – your signature.

After you have mapped out the Five Ws, the Three Questions to Choice, the Five Tools, and created your Marked Script, find a time to meet with the actor and talk about the monologue and the character. The actor could be rigid about how they have prepared this piece and not open to change. The most important quality to demonstrate is being humble. When you begin, ask questions and listen. Let the actor take the lead, especially if this monologue is their choice. They have probably lived and worked it for a long time, so honor the fact that they

may know a bit more about this character than you do. They want to be granted the freedom to have agency over the character and be respected for Choices. They know the performance needs to be captured for the screen, so create an atmosphere of collaboration that allows the actor to relax and polish the live performance.

Building trust and a comfort zone is the order of the day, the kind of trust that will only manifest if a bond was made during the Improvised Monologue. Understand this kind of bond is not automatic. We earn this as actors' directors. We earn the right to have to skin in the game so that we are welcomed and can be there to guide the actor during rehearsal and capture.

The Scripted Monologue is also the time to encourage the actor to get on their feet. You want them to put the performance "into the body" and experience the Kinesthetic Behavior. For some reason, it is hard to get actors off the furniture, out of the chair, off the couch. They seem to want to "block" themselves from one piece of furniture to the next. We are always nurturing our sixth sense so observe how people really behave in a room with furniture. Human beings either plop themselves down somewhere and remain in that place for as long as they can, or nervously negotiate where to move, studying their options of seating choices. It may seem strange, but it is hard to get people to just stand, to hold their ground and talk to someone.

Using a Scripted Monologue, we want to examine and explore the Kinesthetic Behavior, how the character physicalizes pursuit of the Objective. This is how you build the character's physical roadmap. This is how you get away from "blocking" the scene just to have convenient marks on the floor for production. Let your story drive the physical, drive the Kinesthetic Behavior for the character while they perform the monologue. For the Scripted Monologue, along with physical movement give yourself the challenge of helping the actor find an independent activity that is generated by movement.

If you have been honing your sixth sense, if you have an idea of physicalizing, trust your gut and share it with the actor. This is possible and often expected because you have created trust so the actor is open to you for collaboration. You both want to be brave and bold. Take chances and try multiple ideas about the physical life of the character in the monologue. You will discover what works best to tell the story.

Like the Improvised Monologue, you definitely need a scene partner because to add to your visualization practice you will shoot the reactions of the scene partner to the actor performing the monologue and edit these reactions into the final piece.

One of the first things you may have to do is reformat the script. Most of the time, scripts are sent out as PDFs, and the same is true for monologues. As a director you want to be able to manipulate spacing in your script. You didn't have this issue with the Improv Monologue because it was transcribed and you could set it up any way you wished. Now with a published or previously captured work this conversion must be done. I prefer creating a Word document, but whatever works for you, take this first step.

You should bring all the other elements of preparation with you, but at this time, the Marked Script is the top sheet. Each marking has roots that go all the way back to the Five Ws, so trust your preparation and let your Marked Script be the guide. Keep in mind this is still "your" preparation, your homework, and now with the actor, your work together begins. Be completely open to the collaboration that is about to start. A portion, or perhaps a good deal, of the work you have done and marked will need to be revised. So, as I said before, in our tool belt we always carry a simple ruler, a good old #2 pencil, and, of course, a sharpener! As you work with the actor, particularly when you come to places you prepared to be Moments or perhaps places where Intention changes, now is the time where all this is tested.

Once the actor begins to work the monologue, there are new places to be marked. You may find that places you were certain were Moments or places you were sure were Intention changes, never manifest. With your ruler and pencil, note these places. Each time you go through the monologue, check to see if these changes are consistent with the actor's performance. If the story is being told effectively, with honesty and authenticity, the new places may in fact be where the Moments really are in the scene. This would also be the case for Intention changes but for now keep it all in pencil.

There is another side to this story, and that is one where as director you strongly feel that the actor is glossing over a potential Moment, where the actor is completely missing what is for you an obvious Intention change. Here is a way to approach this. While performing, actors fail to breathe. They start doing their work and completely neglect to do the one thing that gives us all life and for the actor, puts life into a character: the breath. Reminding an actor to breathe at certain places (politely of course) is a way to usher in a Moment.

Looking back at my story, if I would remind the actor to take a breath after "were" in "how wrong we were" or after "cold," a Moment could be achieved. Taking the breath would initiate a new chapter to the story. Reminding an actor to breathe is probably the kindest way, but also a

very necessary way, to shape the storytelling and create Moments. Based on the level of trust you have built with your actor, you can always use "What if . . .?" at a place where you sense there is an Intention change. This is a way to keep your direction respectful of the actor's performance. "What if . . .?" "Could we try . . .?" "I have an idea . . ." are ways to voice your direction so the actor will respect your suggestions and not feel you are criticizing their performance or judging them. You are once again the viewer, helping to guide the best work.

Another lesson learned shooting the Scripted Monologue that has movement is also guiding the scene partner, the listener. Do they remain seated or still during the monologue? Even though they do not speak, that does not mean they remain still throughout the storytelling.

In the recent film *Beautiful Boy*, Maura Tierney, who plays Karen, wife of David, played by Steve Carrell, spends much of the film silent. David rants on and on to his son Nic, played by Timothée Chalamet, turning much of his dialogue into a series of unexpected monologues that Karen just witnesses. She stands for the most part, supporting both her husband and her stepson, reacting humbly to their deteriorating relationship. It is a brilliant example of a scene partner for a monologue because her silence is not static. She is actively listening, and the expressions on her face speak volumes about What this film is about. We as viewers watch Carrell as David put his character "into the body," causing him to rarely sit calmly. He is in constant movement because that is how the story ends up being told.

When the performance goes into the body like this, the actor oftentimes changes positions so frequently that the position of the scene partner determines "the line." So with this kind of movement, the line is also constantly changing. To remedy this and not give the audience motion sickness, composition has to take all this into account. The camera usually cannot rest on the tripod but it is up and moving to stay with the action of the scene, always remembering the Rule of Thirds when composing the frame.

There can be a lot of moving parts with the Scripted Monologue, and it is for that reason you give the actor and their performance your undivided attention. The director of Cinematography is in charge of the visual, and if you have any question, just ask to see the composition. Don't be too shy to request it be changed when it isn't the way you saw it, but here again, trust your DP. They are part of the collaboration too.

What becomes evident via the Scripted Monologue is that this monologue is really not about capturing a single character. It is in effect a two-person scene: a crucial part of the shoot are the reactions of the scene

partner. As I pointed out with *Beautiful Boy*, we witness most of the dysfunction of this tortured relationship through the eyes of the silent but powerful performance of Maura Tierney. She is so present in each and every scene. Her eyes, her kinesthetic responses to their frightening interactions are captured brilliantly.

After you and the actor are satisfied with how you've captured their performance of the monologue, now the camera turns around and you capture the scene partner. It is their reactions that will knit together each chapter of the story. Here again your sixth sense plays an important and powerful role. Witnessing life makes you realize that real life is very nuanced. It is never what we think it is, and if you don't get out and experience life you will never know what it is. Just as I urged my students who were comfortable to visit the site of the Boston Marathon bombing, I myself had made the trip a day or two before when the tragedy was still fresh.

I remember standing at the corner of Boylston and Arlington Streets because that was as close as you could get to where the first bomb went off; watching people who were still in shock. I remember how quiet it was despite vehicles moving and law enforcement keeping people away. I remember watching one of the local news anchors during a break between standups, leaning against the side of the news truck with tears in his eyes. The truly human side of this tragedy that grips everyone was clearly evident. There was not a lot of screaming or yelling – it was quite the opposite. It was tense, quiet the day after, when no one could be sure if it was really over. It was so much like what I felt a few days after 9/11 when I had to go down to the World Trade Center area and see and feel this incident for myself.

When I was a student at Tufts, I managed to find short-term jobs during winter breaks, and one of the places that offered these short assignments was a company called Western Electric. They were the makers of all the telephone equipment back in the days of rotary dial phones and thick hard cables. Their offices were in downtown Manhattan and at lunch we would all watch a massive big dig going on next door. This was the site for the future Twin Towers.

A few days after 9/11, I remember getting off the subway at Chambers Street, and people were selling face masks for $5 each because the dust was still so heavy. I remember seeing the shards of steel sticking out into the air that were all that was left of the towers. People were still moving about in the area struggling and trying to get on with life. This is New York City, the city that never sleeps and will not be shut down. I remember it was very noisy with machinery and the normal hustle and

bustle of this part of the city, but it was the faces of the people that stuck in my mind. Everyone was still frightened, traumatized. Everything was different now. America had been violated, and no one was ever prepared for that.

Colleagues question me about this curiosity, but I go to these places and I feel you must go into the dark and sometimes dangerous places of the human condition to absorb what these catastrophic events are really like. Then you will know, really know, how people react in these situations.

I cannot say I know how Maura Tierney prepared to play the role of Karen in *Beautiful Boy*, but I do know her performance was moving in its simplicity and authenticity. Let that be a guide to you when directing the scene partner. Yes, the scene partner is directed when it comes to their participation in the Scripted Monologue. You will notice this person is not just a listener; they are actively part of story. The key here is matching their participation with the work of the actor telling of the story. The ideal places where the scene partner should be seen are those places you designated as the Moments in the monologue. This is what I mean by authenticity. If at those places marked as Moments in the storytelling, you insert the scene partner and the Kinesthetic Behavior of the scene partner is not in sync with the Moment, then the Moment will be diminished. The scene partner's addition represents us as the audience. At those places of resonance where we can read emotion on the face of the scene partner, that recognition heightens our attachment to the story. As the scene partner nods in the affirmative, or looks to the ground in anger or embarrassment, as observers and willing participants, we mimic those same kinesthetic reactions in our own way. They become places of connection, places where we too are in the Moment. So even though it is the actor's monologue, be clear about orchestrating the work of the scene partner. You have done your work, you have a gut feeling, a sixth sense about where the Moments are. At those places where you know you will be asking us to participate in that Moment, make sure the kinesthetic response of the scene partner is in sync with the actor's performance.

Sometimes it is actually best that after you map out the Kinesthetic Behavior for the actor performing the monologue, that the first pass of production is of the scene partner. Instead of preparing to point the camera first at the actor performing the monologue, you should direct it toward the scene partner. Why? Because their responses are still fresh. They have not yet begun to "act." They are still listening and responding, and the honesty of their participation is what you want. This is so important

because without this meticulous attention to the scene partner, when you get into the editing room, you end up "wallpapering" the scene with unneeded reactions. In effect, placing reactions arbitrarily anywhere and everywhere just to use them for editing your best takes. This becomes so evident in a finished work when a scene partner is inserted correctly. The kinesthetic response from the audience is spontaneous, primal, and immediate. It is spot on. On the flip side, when wallpapering occurs during the edit, the impact of the monologue is clearly diminished. This is how editing reactions into a scene can interrupt or even spoil a performance. There is a presence between two actors, be it in a scene or a monologue, and it is that presence, that energy between the two of them that drives the action. The actor needs a scene partner, and the scene partner needs the actor to generate this energy creating a presence that links them to the story.

In doing the Scripted Monologue, we experience joy just being the director and working with the actor and the scene partner. To take the words off the page and put them into the body to explore the kinesthetic possibilities of the character. We use our sixth sense not only to guide the actor performing the monologue but also to guide the scene partner in their participation. We have put to use all of our tools of preparation and find excitement during the act of revising our work to create a true collaborative piece.

Putting it into practice

When working on the Scripted Monologue, follow all the same steps in the Improv Monologue workflow since this work is already scripted. Use your initial meeting to ask the actor questions about the monologue guided by your complete preparation (Five Ws all the way to a draft Marked Script). As the actor performs the monologue, make notes in pencil, on a hard copy of the script, about where Moments occur, and, using your sixth sense, note where you sense Intention changes, making note of the places you see that actor has decided are Intention changes.

After this meeting, revise your draft Marked Script so it is ready for use during your next rehearsal, or, if you both feel confident, during production. Remember, for the Scripted Monologue it is sometimes best to capture the scene partner's reactions first. In that way you maintain spontaneity as they are listening to the first pass by the actor. This work should be fluid so go with ideas that might suddenly happen in the Moment.

For the Scripted Monologue, along with physical movement, give yourself the challenge of helping the actor find an independent activity that is generated by the movement.

Once production is done, edit the best takes and reactions to package your Scripted Monologue for presentation. You will be surprised, with the reactions added, what would at first appear to be a monologue becomes a two-person scene.

This monologue is also an opportunity for composing an opening and closing master shot. You want to encourage movement and an independent activity by the actor to "put it in the body," so beginning the monologue in a master shot and ending it with another master, is an excellent way to create visual variety and also prepare for visual transitions between scenes.

Chapter 10

Presenting and responding to the monologues

Response to the work is important because it is how we grow as directors. Response is constructive analysis that should be part of the process because, as directors, we are always honing our tools. The task is to structure the response to be an encouragement even when addressing missteps in the process. To inspire better work in the future, do not tear someone down. We all know how hard it is to do work that appeals to an audience, work that can reach a large audience and be celebrated. It is up to those of us who call ourselves storytellers, makers of media, to honor our work and support everyone else's efforts as well.

Responding to the Improv Monologue from the Story Exchange

Because the emphasis of this monologue is improvisation for the actor and for the director, who began the process as the author of the original content, the work of this monologue is about orchestrating Moments. This is done via Intention changes by the actor, so it is best if you can arrange a team response: one instructor who can focus on the directing while the other focuses on the acting and performance. This is how we do it where I teach. I focus on the director's work, and my colleague, Ken Cheeseman, focuses on the actor. We don't draw hard lines to define our territory, who gets to say what. We attempt to reinforce each other's work, which means sometimes my comments cross over into his comments about performance, and likewise Ken will need to make references to production. Here are some of the points that Ken likes to focus on.

"One of the first things I ask students to do is to sit as directly in front of the screen as possible. No lining up along the walls or at oblique angles to the screen. This gives me the opportunity to talk about framing and aspect ratio. I remind them that someone has made an effort to get

this right, and when they sit along the sides they are not honoring those efforts. Also, after so many of years of watching films, TV, videos and class work on screen, I make the effort each time to take a breath. I want to clear my mind and begin watching without expectation. I encourage the actors to do the same. Be ready to be surprised, to discover something, to learn something, to feel something."

He goes on to say: "When the video is finished, I am careful not to rush to turn the lights on or start speaking. Leave time for some resonance in the room. How much of a 'sustain' do we feel after the notes were played? If there is resonance, it is obvious; if there is nothing, it is obvious too."

Like myself, Ken uses music as a reference to the work of the actor in the same way I see the work of the director as "maestro" leading the ensemble. In this way, the director is no different than a conductor who leads an orchestra. Let's continue with Ken's comments: "Tempo, rhythm, and intention: What was driving the scene? What need was at work? Were the natural rhythms of human speech and interaction alive in the work? Did the tempo change? Did it feel rushed and ahead of the moment? Did it feel plodding and behind the Beat? Jean-Louis Barrault described acting as 'the pursuit of the ever-changing present moment.' Was the actor in pursuit of that moment? Was the character? Were they behaving, as Sanford Meisner said, 'truthfully in imagined given circumstances'?"

For me, as the directing instructor, I want to see if my directors were able to recreate the intimacy when a person decides to share something personal and special to them. That translates to putting the camera close to the line so that the audience feels they are part of the action. They are "in the room" too – not observers from the bleacher seats but witnesses to the moment because there is a big difference because of proximity. The shot needs to be in one take, reminiscent of a moving master. In that way, Moments are created solely by the actor's performance of the monologue. There is no cutting to a reaction to affirm a connection with the audience. The actor's pacing, breathing, and eye contact with the scene partner are the only tools they have. The monologue is most successful if at the appropriate times, the actor conveys the intended message and then breathes into the next chapter of the monologue. Just like the markings I did with my own story in the previous chapter to indicate where I wanted moments to play. The actor finds moments in their Improv Monologue that match the initial story or they reveal alternative places in the story where moments occur. Here are Ken's thoughts: "Now I, hopefully, bring an awareness of 'feeling'

into the room. Did you feel anything? What did you feel? Did you laugh, cry, get angry? These questions correlate to the Improv Monologue Story Exchange process. Actors need to write down impressions, sensual and visual images after the storyteller has shared their story the first time. So, my first responses are in the category of senses and feeling. Narrow down to the specifics: What moments stood out? Was it a turn of the head? A lifting of a finger? A particular word or phrase? A sigh, a breath, a look? A specific image created through language or the actor's thought process or some mysterious amalgamation?"

I ask directors to keep two versions of the final monologue for comparison: an initial version, that is like the Marked Script for my monologue, indicating the places I wished for moments to occur, and the final Marked Script, transcribed from the selected improv take, marked with the actor's performance moments and intention changes. Before I give any response, these two versions should motivate the first response for the director: a self-critique noting where they and the actor were in sync with the placement of moments. This is a wonderful affirmation of their initial storytelling. The director can be proud that their sixth sense, their intuition, was codified by the actor's performance. They also have the opportunity to broaden their knowledge and intuition when they can see where the actor found a more advantageous place to orchestrate a moment in the monologue. That is what makes this introductory monologue a marvelous learning experience.

When presented in class to me and an audience of their fellow directors and actors, they witness how the group interacts with the final performance by the actor. It becomes so clear when the moments resonate and you see the class kinesthetically react to what is on screen. The nod, a laugh, a gasp, something that affirms a connection, a primal response to another person's sharing. When it works, it works! Here are Ken's comments: "With respect to the narrative: What story got told? Was it mythical? Personal? Psychological? Political? What was this piece 'about'? Did we get it? Was any one changed or altered in the piece? How? Were we as viewers changed or altered? What were the 'Beats'? How was the narrative structured? In the Improv Monologue Story Exchange, how did our natural, innate ability to construct the narrative create Beats or Chapters? How did this correlate with the structure used by the writer in the Scripted Monologue? Did the story resolve as an 'up' (Hollywood) ending? Was it ironic or unresolved? Was it a tragic downturn?"

In many respects, most of my response is about connection. It centers around did the monologue successfully provide the opportunity for an

intimate experience with the actor performing the monologue. Were I and the audience moved, touched, and changed by the journey?

The transformation of original raw story material to a work for the rectangular box signifying television or the cinema is a wonderful learning experience for both actor and director. It gives the director a solid example of collaboration with the actor. They learn that via surrendering something sacred and personal to the actor they open a door to trust. This trust can be built upon when they move from this first monologue to a scripted monologue and future projects.

I generally encourage the director regardless of the work on this first monologue. My focus is on what went really well, and I treat things that were not so terrific with a constructive response so that it becomes a teaching moment. I want to help solidify the bond that is now incubating between director and actor and help the director with their own sense of confidence.

Sending the directors and actors out in teams is another way to build trust and cooperation. As one director works with their actor performing the monologue, the other director acts as DP, shooting the performance. The other actor serves as scene partner, and, if they are willing, sound recordist for the actor performing. It has been my experience that actors, because they are trained in this way, are always willing to help each other, to support each other's work. The dynamic cooperation that comes from these teams working together helps to build community between directors and actors.

I believe in the basics, so I comment on composition if I feel that the director or their chosen DP got a bit carried away with the production. As I talked about earlier, films like *The King's Speech* and *The Danish Girl*, with their obvious composition choices, are more an exception than the normal rule. These approaches are very tantalizing to the young director and the young DP. To keep everyone focused on the work of actor's director and the actor, I encourage simple capture so that our attention is on the actor and performance and not the cinematography. Practicing the rule of thirds will never diminish the work of the actor's director or the work of the actor. It will provide the proper forum to witness the performance as close to what it would be live. Here are Ken's thoughts: "Camera placement. Lighting. Sound. Frame. Eyeline. Most of this is out of the actors' control but how might you have suggested alternatives at the time– especially given that this is class work. What are the parameters of collaboration in film production? Are those flexible? Might they be different as you're all learning or if you are cast in a big feature with experienced professionals?"

So, in a two- to three-minute monologue, we hope that the magic of one-to-one communication happens onscreen. The good news is that it generally does.

Responding to the Scripted Monologue

Moving from an improvised work to a scripted work, a published and more than often a work that has already been captured and released, we raise the bar a bit higher. There are important things at play here for both director and actor. First of all, both my acting colleague and myself try to discourage the director and the actor from watching a previous version of the monologue, whether from a film or a television show. There is a tendency among young actors and directors to feel that by imitating performance styles or production styles, it ensures that they will get it right. They consider these versions on television or in the cinema to be the gospel truth. We do our best to convey that these versions are just that, versions, someone else's rendering of the monologue. What you are seeing is their signature, how they chose to interpret the work. Now is the time to render the monologue and capture the monologue with the signature of our students, both actor and director.

Another factor that needs to be responded to is movement. Unlike the Improv Monologue, which is generally done while sitting, a more static presentation, the Scripted Monologue needs to be on its feet to encourage a kinesthetic performance. This is very good for the director because now there are possible issues of eyeline and – an even more important menace – crossing the line. Crossing the line is something that was discussed. This is something that the director has to pay close attention to because it is very easy to suddenly find the camera on the wrong side of the line. This leads to confusing your audience, and, with the short attention span of the average person, you could lose them for the rest of the show.

When the monologue is presented in addition to the moments, I am watching for the technical imperfections that would make the work unacceptable to use on a director's reel: eyeline issues and, the big one, crossing the line. Another addition I request when shooting the Scripted Monologue are reactions from the scene partner and an independent activity motivated by movement. If you remember, the Improv Monologue was done all in one take. No edits, no scene-partner reactions. Now, if you had a successful Improv Monologue, you should be very aware of building and delivering moments with your actor. Those places where you have established a Moment are the places where the director should

first look to place the reactions of the scene partner. The scene partner's reaction should coincide with our primal reactions as the viewer. Our engagement with the performance of the actor is heightened by the scene partner's engagement. These are also places where movement should occur.

The actor reaches a Moment in the story and perhaps here is where they make a tactical change, a change in Intention. The body is now kinesthetically inspired, and it wants to move. So let go! Move! When the actor moves, getting out of the chair, or changing positions in the room, this is the place to encourage the actor to find an independent activity. Now picking up a property is motivated and not just added on arbitrarily. Everything now feels organic and natural. Not rushed or made up for the sake of acting or for the camera.

It is worth noting that here is where things get very tricky because you can make the mistake of what I call "wallpapering" the scene. As explained earlier, what that means is that the director, during the edit, will insert the scene partner arbitrarily without regard for the Moments. This is where a wonderfully performed monologue could be diminished in impact. It can turn the monologue into a melodrama. This is similar to what happens when too much music is added at emotional points in a scene to force a reaction from the audience. This was one of the criticisms against *Beautiful Boy* despite the stellar performances that didn't need an overly indulgent score.

Editing is clearly the time where your intuition, your sixth sense is needed. Be very spare and judicious about where to add a reaction and be guided by the Moments in the monologue you worked long and hard with the actor to create.

To review, what to look for in the Improv Monologue is all about the Moments. Does the actor's performance accurately deliver the Moments during the storytelling, so that the A to B to C (actor's vocabulary) or in the director's vocabulary the "Chapters" of the story are clear and succinct? You also want to check where the camera is placed. Over the Shoulder (OTS) is preferred because that helps the actor's eyeline, keeping the performance close to the line. And the final observation, overall: Do you see a collaboration of director and actor in the finished work?

When you review the Scripted Monologue, look at how the director and actor collaborated to shoot the work of the actor. Does the presentation feel like an actor monologue or is there a feeling that they worked on it together for the shoot? Did the actor find places to move so that the director, along with the DP, had to make adjustments in composition? Were they able to maintain eyeline and manage not to cross the line?

Were the reactions of the scene partner carefully placed to make them most effective when coinciding with the moments created by the actor? Was there an independent activity prompted by movement?

Capturing the monologues completes the prelude to real scene work that will be discussed in the next chapter.

Chapter 11

Scene work
Conducting the full rehearsal

Up until now has been a warm-up to the real deal: conducting a full rehearsal with multiple actors. This of course means moving from simple preparation for one actor doing a monologue to two or more actors performing in a scene. Now, as director, you have to do your preparation for each actor. The Five Ws will still ground and fuel your work. Storyline Facts have to be composed to introduce the characters and in the process connect them to the Five Ws. Each character will receive a separate Three Questions to Choice. The Five Tools will be used to bring everyone together, and the Marked Script will act as your Director's Script, your "score," enabling you to orchestrate the work of the ensemble.

We begin the rehearsal process by reading the script. Because production is normally out of chronological order, more or less controlled by location instead of scene by scene, a full read through will provide the "through line." It will allow your actors to track their characters from start to finish in the screenplay. In the rehearsal room, the actors can talk about their character's arc, the Super Objective that carries them throughout the entire story. This is their "spine," and knowing and understanding the spine of the character not only from their point of view but from the point of view of the other characters is very important.

Let this time reading the script be open, free, and nonjudgmental. As the director, you want to establish an atmosphere where everyone can share and comment. A full read-through like this is not a given and in fact is sometimes impossible based on actor schedules. But when you can do it take advantage of the opportunity. Many actors have had theater training, and, because of that training, a read-through is a natural part of the process. They are so grateful when the director insists and is granted time to rehearse when working on a film or television show.

While the actors read, listen carefully as director and make notes based on hearing the words now read aloud. I always find that a first read like this triggers my sixth sense, my intuition, and there are always wonderful takeaways, aha moments that never occurred when I read the script on my own. Note these feelings, ideas, imaginations, inspirations in the margin of your script, and if you are able to make a day of it and get in a second reading, use a different color ink for your notes from the second read. Keep track of your creative vision.

Generally actors want to get on their feet as soon as possible. They are used to the process we experienced doing the monologues so they know that getting started putting the performance "in the body" is best done slowly and in conjunction with learning the text. Muscle memory helps them remember the dialogue so don't spend too much time around the table, but also do not get the production on its feet too soon. Take the temperature in the room from your actors to be sure everyone is ready to move from table work to getting on their feet.

To aid the process of rehearsal, it is appropriate to have the floor of your rehearsal room marked like the location where the scene will ultimately be captured. Rehearsal furniture that approximates the sizes of the furniture in the actual location or on the studio set is also enormously helpful to the actor. If you are working in a rehearsal space prior to moving to the studio set or on location, the actor is able to experience the distance. Distances between doors and windows, placement of furniture and other large items could have a profound effect on kinesthetic activity. Are the floors hardwood or is this meant to be a carpeted space? All of these considerations are helpful to the actor. Remember in the Five Tools we talked about the Sensory Images? At this time of rehearsal what you experience from all five senses even now in rehearsal space can be very useful.

Let the actors "play" a bit saying the dialogue and moving in the space. If they have suggestions about hand props that are not already indicated in the screenplay, have your assistant director or a staff person locate them or find substitutes. You will notice that I don't advocate adding properties, even those indicated in the screenplay immediately in rehearsal. I am a firm believer that the actor needs to develop a kinesthetic life with the character and that kinesthetic life will dictate the properties that need to be on the set. Doing it the other way around tends to obligate the characters to make use of the properties whether they are motivated to do so or not. They might even completely ignore them or complain they are in the way of the work. All this is to say: integrate the properties as the tempo of rehearsal dictates.

Running the scene a number of times will usually lead to the actors finding their way in the world of the scene through the eyes of their characters. In this way, the scene is mounted organically by the characters. You will notice I avoid using the word "blocking." I find that if you block a scene you add a layer of artificiality to the character's physical life in the world of the story. Don't block, allow the text and the actor's commitment to the text interpreted by their character to chart their physical life in the space. The dialogue and their sixth sense will generate kinesthetic activity, so let any movement happen via the life of the characters.

Here is where and when based on your plotting of the Three Questions to Choice, you can work with the actor to craft a performance. Watch each character during the scene and see if the pursuit of the Objective is clear. Are the "Chapters" (the actors A to B to C) clearly rendered? Do you "feel" the Intention changes, the change in tactics, as they pursue their Objective? Be aware of the Obstacle and where a character(s) finally make a Choice. All of this is done in a humble, self-deprecating way so that for the actor you are like a scene partner, a director as a guide they can trust. Following this method, you will find that your suggestions will more than likely be incorporated into their performance.

Always compliment the actor on their work. This is key: a compliment must precede a note. Following a compliment about their work, then if you have note to share, voice it beginning with "What if . . .?" or "How about . . .?" and "Could we try. . . .?" You notice that all of these comments are voiced as suggestions, not commands or dictates, just a note that the actor try something new. If you have their ear and their open cooperation, try the scene again. If what you shared works, the actor will be delighted, and if it proves not the fix the situation as you had hoped, don't let your ego get tied up in being right. Seek another way to try the scene. Perhaps you need to come up with a new verb.

Using the Five Tools can fine-tune the performance, starting with the verbs. I spoke about this earlier, but here is also where the Triggering Facts play a huge role. One of the most important things to do as director is to keep the actor in the Now. Keep the actor from playing the end of the scene at the beginning of the scene. I cannot tell you how many times I have encountered this working in film, television, and the theater. It just seems to be one of those primal things. We as humans know where the story ends and so unconsciously we portray that in the beginning. Sometimes it is in the way we say the dialogue, but most of the time it is in the kinesthetic – our bodies, how we move, how we gesture – that gives us away. Use the Triggering Facts to set up the scene,

Triggering Facts that were harvested from the Storyline Facts, which in turn were harvested from the Five Ws. This helps to keep the actors in the Now, in the present. The Triggering Facts lead them to the precipice, the edge of the scene before the action begins. Now here is where we begin to put into play the craft of our preparation.

We take a second look at our Three Questions to Choice and specifically Intention. The Opening Intention is the first verb the actors use to begin the scene. Is this verb prompted by the Triggering Facts? This is key in scene work, the importance of the Opening Intention for all the characters.

As you can see, now in rehearsal, the borders that used to exist between the steps of preparation have now become soft boundaries. In fact, the process of rehearsal removes the need to monitor each step independently. To employ a musical reference again, we first played the notes carefully reading the music, now we are letting the music play itself. We then look to the Dynamic Event in the scene to be sure it manifests as it should, as the game changer, as the "turn" (as actors say) generating the Moment of Choice. Add the Sensory Images so that they can take their place in the process, and the actors will realize how powerful these images can be.

Think of Guillermo Del Toro's *The Shape of Water*, Ryan Coogler's *Black Panther*, or Alfonso Cuaron's *Roma* and the power of the Sensory Images is more than evident. What do you see? In *The Shape of Water*, the underground headquarters where Octavia Spencer and her fellow characters work is a slightly wet and humid world of spy catchers. In *Black Panther*, we drop into an Afrocentric cultural world mixing with the highly technological world of Wakanda. In *Roma*, it is the energetic streets of 1970s Mexico City with its sights, smells, sounds, tastes, and the touch of a discarded leather jacket held so tenderly by Yalitza Aparicio as Cleo. What do you hear? The echo of voices and the clanging of doors in *The Shape of Water*. The sounds of wild animals in the bush mixed along with the high-tech vibrations of Wakanda in *Black Panther*. The noisy crowds of people, cars, and aging machines of industry in *Roma*. In *The Shape of Water*, everything has a slippery, slimy feel to it. In *Black Panther* there is the difference between holding a traditional weapon and moving the dials of a delicate control mechanism. The experience of the grit of the city in contrast to the touch of fertile earth of the countryside in *Roma*. The moist taste of the air in *The Shape of Water*, contrasting with the taste of the air in tropical Wakanda. So different is the taste of car and bus exhausts in Mexico City and the taste of ocean while seated on a Mexican beach. Finally, the dank smell of the underground in *The Shape*

of Water, to the smell of the rainforest in *Black Panther* and the smell of food being prepared in the kitchen of the family home in Mexico City.

All of these have a profound effect on the behavior of the characters, so as director you must talk to the actors about the Sensory Images during the rehearsal period. It is rare when you are able to bring the cast to these places on day one, so describe the world where the scene will take place via the experience of the five senses. Watch how sometimes your inspired descriptions will magically transform a performance.

It is at this time you observe the Kinesthetic Behavior, how the characters have put the performance "into the body." Using current films, you look to Christian Bale in *Vice*, Saoirse Ronan and Margot Robbie in *Mary Queen of Scots* or Viggo Mortensen in *Green Book* as examples. In the case of Bale and Mortensen, putting on weight to experience a new center of gravity playing their characters. This brings back memories of Robert De Niro in *Raging Bull*, Denzel Washington in *Roman J. Israel Esq.*, or the startling transformation of Charlize Theron in *Monster*.

Finally, all this work in rehearsal has to be reflected in the Marked Script, now your Director's Script. It is always best to work from a hard copy of the script. As you are working with the actors, mark your script as we did working on the Scripted Monologue using a ruler and pencil. Chart whenever Intentions change, when Moments happen in new and sometimes unexpected places, and, of course, when you find them, new Beats. This way as the work grows, you have immediately made note of them in your script. When you finalize all the changes during the period of rehearsal, you will bring a printed script with you to production. But prepare yourself, and keep your pencil and ruler handy, as many times it is in production when things really change.

Even if you have rehearsed theater style before production begins, it is always best to find time to rehearse every scene before you shoot. How much rehearsal is not an easy question, but, as a rule, you should rehearse only enough so that everyone is comfortable and can still be fresh when you get to the set. In this way, the performances will not lose spontaneity, the actors will still be "present" and in the Now. This is exactly where you want them to be.

Once staging is consistent but not routinized, with your DP by your side, begin to map out how you will shoot the scene. Prior to this rehearsal period, you and your DP should have met and created draft storyboards that will indicate how you both plan to capture the scene. This advanced planning is now regarded as previsualization, which I will discuss in the next chapter.

Now that you are in rehearsal and you and your DP have previsualized the scene, you can see if your planning makes sense. Oftentimes the way you planned for the characters to move in the space does not occur. So your plans and the storyboards will have to be modified, but this is part of the process so get used to it. I will often use a simple DSLR camera to capture stills of the final physical scene as a reference for storyboarding. If you are using technology to storyboard, revisions are made at this time and with some programs you can also determine if additional lenses or other gear will be needed for production. I will go into greater detail about this in the upcoming chapter on previsualization and capture.

Last but not least, we still have that left margin of our Director's Script that remains untouched. We have waited this long to set up the physical environment of our scene, so now, using the left margin, you can draw simple but clear and concise ground plans for the movement of the characters in the scene. Pencil in your principal furniture from the set, the chairs, tables, anything that the characters might use or might obstruct their movement in the space. As the character makes a move to sit or to cross, you document it in the left margin.

I find that actors generally move when the Intention changes. They take a breath at the end of a "Chapter" in the scene and move to a new location in the space. This is not a rule or something to be counted upon each and every time. Nevertheless, this is one of those primal traits, something in our nature as humans that manifests when we are in interaction with another person. So, we can use this as part of the rehearsal process.

The actors are now on their feet, and you've allowed them to "play," to let their instincts and intuition move them around the space. The more confident an actor feels about putting the character "into the body," the more variety they will find using the space. With this kind of actor, "adjustments" are all that is often needed so that performance can be shot without crossing the line. But what about the actor who seems frozen, who cannot seem to get off of the furniture or figure out when and where they should move during the scene? The actor that seems to pace back and forth, never really going anywhere? Here is how we again bring in our preparation as a starting place for turning the Kinesthetic Behavior into movement.

When we marked our script, we were in effect, transferring the Primary Verbs we identified in the Five Tools to our script at each place where Intention changes. The act of creating the Marked Script is in many cases

the final test if we have truly identified the Primary Verbs. You should have a Primary Verb for each Intention change. If you find in prep or in rehearsal that there is an additional Intention change you did not plan for, you add another Primary Verb. It is best to add this not only to the Marked Script but in every place of preparation: Two Sentences, List of Verbs and Intention as part of the Three Questions to Choice. In this way, you keep your direction consistent from start to finish.

You have now matched each Intention change to one of your Primary Verbs. Give your actor a starting place, sometimes referred to as a starting mark, a place on the set or location where you want them to begin the scene. As they go through their dialogue and finally reach an Intention change, if they have remained in the same place gently suggest they take a breath and make a move. Perhaps it is to another place remaining on their feet. If they started the scene on their feet, perhaps, depending on the action of the scene, this is a good place to sit. Basically, your marked changes in Intention become places to encourage a Kinesthetic Behavior from the actor. The breath signals the end of a "Chapter" for us as directors and a "Beat" for the actor. Go through the scene from start to finish in this way, from Intention change to Intention change. To help give the actor's movement a purpose, add and independent activity to the movement. In this way, the use of properties is incorporated into the movement.

For the young director, this method of putting a scene on its feet can be challenging, as you must build real trust from the actor. The actor is now collaborating with you to shape the Kinesthetic Behavior of the character. This is a good first step for both the young director and the young actor as comparing ideas about the sixth sense and intuition can make for great experimentation as the scene is put on its feet. This method is a great starting place for scene work as it first gives the actor agency to physically shape the scene. It also gives the director agency to guide the scene from Intention change to Intention change, breath to breath, moving the actor in the space. I encourage you to be guided by this method as you begin your work as a director.

This is the plan for conducting a rehearsal. You should do this for each and every scene. Insist on this – you are an actor's director – so their performances are as important as all the technical issues related to film or television production. Having secured adequate time to rehearse, you move into capture more confidently and bring together the spontaneity of live performance with the technical elements of digital or analogue capture.

Putting it into practice

Begin the rehearsal process by reading the script. It will allow your actors to track their characters from start to finish in the screenplay. In the rehearsal room, the actors can talk about their character's arc, the Super Objective that carries them throughout the entire story.

While the actors read, listen carefully as director and make notes based on hearing the words now read aloud. Note these feelings, ideas, imaginations, inspirations in the margin of your script. After the first read, begin a dialogue with the actors about the scene. If they ask questions, guide your answer by the Five Ws, but don't be afraid to turn the question around to ask the actors: "What do you think?" Of course, responses or questions the actors may pose can cause you to have to take a detour into some uncharted territory, but go with the discussion. Using your preparation, steer it back on track. Or perhaps the actors are on to something you did not see. Be prepared to go with their idea. What you are getting at in this first read is "What is this all about?" "Where this scene fits in the big picture." Trust your actors. Like you, they came prepared too.

Read the scene again, this time mindful of your discussion to see if the scene is changing, is growing, and the tension is building leading to Moments – the way a scene orchestrates. You'll probably now be able to talk about Objectives. First hear what the actors think, and then, gently, ever so gently, suggest yours. This will open the door to discussing the verbs (Intentions), examining the Obstacle, and, finally, looking at where Moments happen in the scene that lead to Choice. If you have a strong feeling or the actors do as well that there is a new Objective created before the scene ends, unpack this together. This could be a new Beat and it could be an exciting addition to the scene.

Talk through the Sensory Images you imagine are part of this world. Be as descriptive and rich as possible. Remember you are guiding their performance by making reference to this experiential world that will generate creative ideas within the actor. You are inspiring ideas how they can use this world in support of their Objective, or how they see aspects of this sensory world that might prove to be Obstacles. Let them walk through it, exploring the world with the dialogue. Watch how your inspired descriptions will magically transform a performance.

Actors want to get on their feet as soon as possible. This is best if done slowly and in conjunction with learning the text. Take the temperature in the room from your actors to be sure everyone is ready to move from table work to getting on their feet. To aid the process of rehearsal, it is

appropriate to have the floor of your rehearsal room marked like the location where the scene will ultimately be captured. Rehearsal furniture that approximates the sizes of the furniture in the actual location or on the studio set is also enormously helpful to the actor. Distances between doors and windows, placement of furniture and other large items will have an effect on kinesthetic activity.

It is always best to work from a hard copy of the script. Mark your script using a ruler and pencil. Chart whenever Intentions change, when Moments happen in new and sometimes unexpected places, and, of course, when you find them, new Beats. This way as things change you have immediately made note of them in your script.

Let the actors "play" a bit saying the dialogue and moving in the space. If they have suggestions about hand props that are not already indicated in the screenplay, have your assistant director or a staff person locate them or find substitutes. The actor needs to develop a kinesthetic life with the character and that kinesthetic life will dictate the properties that need to be on the set. Integrate the use of properties as the tempo of rehearsal dictates.

A dialogue will start up again as they feel comfortable or uncomfortable and want your assistance via suggestions. Do not demonstrate. Do not do the actor's work. Revisit Objective, which will open the door for you to make adjustments in their performance via the Intentions. Maybe there are places in the story you want to adjust, so share a verb. "What if before you talk about _____ how about trying TO COAX?" etc. Use language like this, polite, respectful, but at the same time encouraging the actor to try your direction. Remind them of the Triggering Facts because, as you know, the Triggering Facts lead to the Opening Objective. Craft your Moments and the Dynamic Event in this way.

Run the scene a number of times to allow the actor to find their way in the world of the scene through the eyes of their characters. In this way, the scene is mounted organically. Avoid "blocking." If you block a scene without considering the actor's intuitive movements, you add a layer of artificiality in the world of the story. Allow the text and the actor's commitment to the text interpreted by their character to chart their physical life in the space.

Watch each character during the scene and see if the pursuit of the Objective is clear. Are the "Chapters" (the actors A to B to C) clearly rendered? Do you "feel" the Intention changes, the change in tactics, as they pursue their Objective? Be aware of the Obstacle and where a character(s) finally make a Choice.

Always compliment the actor. This is key: A compliment must precede a note. If you have a note to share, voice it beginning with "What if . . . ?" or "How about . . . ?" and "Could we try . . . ?" You notice that all of these comments are voiced as suggestions, not commands or dictates, just a note that the actor try something new.

One of the most important things to do is keep the actor in the Now. Keep the actor from playing the end of the scene at the beginning of the scene. We as humans know where the story ends and so unconsciously we portray that in the beginning. Sometimes it is in the way we say the dialogue but most of the time it is in the kinesthetic. Our bodies, how we move, how we gesture, that gives us away.

Actors generally move when the Intention changes so we can use this as part of the rehearsal process. Give your actor a starting place where you want them to begin the scene. As they go through their dialogue and finally reach an Intention change, if they have remained in the same place, gently suggest they take a breath and make a move. Your marked changes in Intention become places to encourage a Kinesthetic Action from the actor. The breath signals the end of a "Chapter" for us as directors and a "Beat" for the actor. Go through the scene from start to finish in this way; from Intention change to Intention change. To help give the actor's movement a purpose, add an independent activity to the movement. In this way, the use of properties is incorporated into the movement.

It is always best to find time to rehearse every scene before production. How much rehearsal is not an easy question, but as a rule, you should rehearse only enough so that everyone is comfortable and can still be fresh when you get to the set.

Use these tools as a means of creative collaboration developing the scene with the actors. Run the scene as many times as needed to allow the actors to feel comfortable but not so many times that they begin to "set" things and cease to be creative. This is a tough part to recognize, but I think you will know it when they are attaching specific lines to specific physical behavior. You want the scene and their performances to remain as fresh as possible, but once you sense they are at this point, do one final run, this time using your DSLR, taking some stills in preparation for production. Explain to the actors what you are doing. This will also prep them for the new character in their scene: the camera.

Once the Kinesthetic Behavior is consistent but not routinized, using the left margin of the script, draw simple but clear and concise ground plans for the movement of the characters in the scene. After you record the movements of all the characters in the scene you have arrived at

collaboratively, share this with your DP to plan camera movement. Shot Designer and other current software can and should also be used in conjunction with your completed ground plan. If the way you planned for the characters to move in the space does not occur, your plans and the storyboards will have to be modified, but this is part of the process so get used to it.

Chapter 12

Previsualization

There was a time, not so long ago, that the word "previsualization" would have seemed odd. "Storyboarding" was the term of the times. The beginnings of Previsualization have roots that go back to the silent era. In the beginning of cinema, the production of precise renderings for each "shot" of the film was under the domain of the production designer. This method was designed to bring coherence to the overall production. Storyboarding allowed everyone on the movie a view of the director's vision. This ensured collaboration between all departments in this new form of entertainment. By the 1940s, storyboarding was widely used in Hollywood.

For some filmmakers, the act of storyboarding negated a spontaneous truth that occurs in the Moment. Many of the filmmakers in Europe avoided storyboards even though they admired and lauded the work of the cinema pioneers in Hollywood, pioneers who relied on storyboarding.

When I first heard the term "previsualization" it was also when I first heard the term "capture." Since then it is a term that I have adopted when I speak of the media-making process. By referring to the digital recording of a performance as capture, it enables the director as I see it, to encourage spontaneity from the actor in the live performance. This process coupled with previsualization and storyboarding assures there are technical elements prepared and in place to document this creative action.

Directors have storyboarded for years, and in the world of commercial advertising it is all about the storyboard. The term "previsualization" and the act of previsualizing has now come into vogue because it encompasses a wide range of issues. These issues need to be considered as part of production preparation that is now the realm of the director and not the production designer. The new world of previsualization that became available via green screen and blue screen, along with motion capture and an ever-changing menu of visual and audio possibilities, was a result of moving from an analogue to a digital universe. I don't want to get too complicated in this book when it comes to previsualization, but I thought it would be best to discuss it as part of director preparation.

Referring to visual preparation as only storyboards would be incomplete because the digital template of today is governed by the director. For those who want to dive deeper into the world of previsualization, I hope this chapter describing the workflow from the full rehearsal to visualizing will be a solid start. Let's begin with a two-person scene featuring Greg and Laurel. What is good about this scene is it is a scene with not only numerous Intention changes and tender Moments, it is also a scene with more than one Beat.

```
Int. Greg's Apartment          Evening

Laurel (20s), a free spirit currently working as a
waitress in a small Midwestern town, and Greg (20s),
a policeman who also grew up in this same town. They
have been dating on and off since high school, but
now they are living together. Laurel is packing and
is almost finished when Greg comes in from work.

                    GREG
          What are you doing?

                    LAUREL
          What does it look like?

                    GREG
          I thought we were going to talk?

                    LAUREL
          Go on then.

                    GREG
          I can't when you are doing that.

                    LAUREL
          Okay.

LAUREL stops packing, closes the suitcase.

                    LAUREL
          What do you want to say?

                    GREG
          I don't want you to go. I know we've
          had some disagreements lately—
```

 LAUREL
 Disagreements!

 GREG
 Whatever. But they've been my fault.
 I don't mind you being late . . .
 Well, I guess I do, but I'm going
 to have to live with it. I have to.
 I love you.

 LAUREL
 I love you too, Greg, but you can't
 expect me to turn into a nice,
 loyal police wife, keeping house
 for you, raising your kids and
 helping you up the ladder.

 GREG
 You don't have to.

 LAUREL
 No? I remember all those police
 wives at the presentation. They
 all wanted their husbands to make a
 good impression so they could climb
 up the next rung.

 GREG
 There's more to it than Laur—

 LAUREL
 Yes, there is. Look, I don't want
 you turning into the typical cop,
 doing exactly what you have to do
 to get promoted. I wouldn't care if
 you never got promoted.

 GREG
 You would if you saw the pension!

HOLD on LAUREL'S reaction.

 That was a joke.

LAUREL resumes her packing.

 Where are you going?

> LAUREL
> Away on my own. I've cleared it with the restaurant.
>
> GREG
> Where?
>
> LAUREL
> I don't know.
>
> GREG
> Can I come with you?
>
> LAUREL
> No, Greg.
>
> GREG
> But I've booked my leave.
>
> LAUREL
> You'll have to unbook it then.
>
> GREG
> It's not easy as you think. The Sarge will give me hell . . .

GREG stops when he realizes what he is saying.

> LAUREL
> I think that just sums it up Greg.

LAUREL kisses him on the cheek.

> I'll see you when I get back.

LAUREL leaves.

If this scene could be part of a larger screenplay, we have to put on our thinking cap now to create a full story to start our work creating the Five Ws. My analysis of this one scene is below as if it were part of a larger story. Taking a single scene and coming up with your ideas for the full story is a good exercise to practice the Five Ws as you begin scene work.

What?

This scene is about LOSS OF LOVE, RELATIONSHIPS, JOB STABILITY, COMING OF AGE, and MOVING ON. Greg and Laurel live in a small Midwestern town in Ohio. They both grew up there, dated on and off during high school. When they graduated, Greg worked a number of local jobs, but, due to his family's history with the military, he made his way into law enforcement. He has moved up the ranks and sees himself one day rising to become the chief of police. Laurel has always been a dreamer, but she is also someone who worked to pursue her dreams. In high school she was the lead in all the high-school plays and musicals. After graduation, she continued to perform, first in a small, local summer stock theater near their town until finally landing a role at a regional theater in Columbus. It was her first time away from small-town life. Being around actors from New York and other places far from the Midwest, Laurel knew now was the time to make her move. She has been back in town for a few months since the play closed and picked up a part-time job working in a diner. She has to finally confront Greg about her choice.

Who?

Laurel, a girl from a small town, who now feels a LOSS OF LOVE for her partner, and it is a time of COMING OF AGE for her, a time to MOVE ON. Greg, a member of law enforcement in this same small town who wants to cling to his RELATIONSHIP with Laurel. He has JOB STABILITY that can support them, but he knows this is a time of COMING OF AGE for both of them, and perhaps for the first time, MOVING ON.

When?

It is 2017. Donald Trump has been elected, and small towns like this one in Ohio where law enforcement is highly regarded perceive this president's mantra as a development in the United States, as a boost to their role. People in the arts and education are less enthusiastic and see this administration only hurting their struggling sector of the economy.

Where?

Mansfield, Ohio. A small town between Columbus and Cleveland. That rust-belt part of the Midwest that has become known as the forgotten America.

Why?

Greg and Laurel's story appeals to us because it is the story of so many people from small towns. Do you stay or do you leave? Staying sometimes makes life simple. Someone working in a local job will die and

you'll take over their role. Friends and family are known so there is a comfort in limited expectations and limited surprises. But there is also a yearning for more, for the world outside only seen on television and in the movies. A world that will be a challenge to navigate and win, but why not? Others have done it – why not me?

Storyline Facts

Greg, who has a STABLE JOB as a policeman, returns home after work to have a conversation with his girlfriend Laurel, who is a part-time actor and is contemplating MOVING ON, due to the LOSS OF LOVE in their relationship. Both are COMING OF AGE where choices have to be made.

Three Questions to Choice

Beat 1

Greg:

> Objective: To solidify their relationship.
> Intention: **To reconcile**, to apologize, **to entice.**
> Obstacle: Laurel wants to leave him.
> Choice: Give us another chance.

Laurel:

> Objective: Let's live out our dreams.
> Intention: **To test, to challenge.**
> Obstacle: Greg's need for stability.
> Choice: To move on.

Beat 2

Greg:

> Objective: To save their relationship.
> Intention: to plead, **to surrender.**
> Obstacle: Laurel's mind is now made up.
> Choice: To let Laurel go.

Laurel:

> Objective: To take the risk.
> Intention: To make a new start, **to terminate the relationship.**
> Obstacle: Greg loves her.
> Choice: To pursue her own dreams.

Five Tools

Verbs

Greg: **To reconcile, to apologize, to entice, to plead, to surrender.**
Laurel: **to test, to challenge, to make a new start, to terminate.**

Two Sentences

Laurel **tests** and Greg **reconciles** but Laurel **challenges**. Greg **entices** but Laurel chooses **to terminate** and Greg **surrenders**.

Triggering Facts

Greg comes home with news that he is on the right track to promotion and advancement. Laurel has just spoken to one of the actors from her last show now back in New York, and she's decided to go for it.

Dynamic Event

Greg: "You would if you saw the pension."

Sensory Images

The apartment is simply furnished, mostly with furniture that both have inherited from family. The dishes are washed and stacked in the kitchen area. A couple of posters from local events are just stuck to the walls. You can hear the hum of the refrigerator motor and the occasional sound of a passing car outside. There is the smell of freshly washed laundry and dish detergent. The air is dry but not stale to the taste, and sitting in a chair at the dining table or on the couch is something you want to do. The furniture that has seen better days but still provides comfort.

Kinesthetic Behavior

Laurel is comfortable in this apartment. She knows it well and has kept it like a home. As she packs, she knows where everything is that she desires to put into her bag. Greg feels safe and secure here in their apartment. Many of the things in the apartment came from his family. It has been a long but good day, but he is still ready to talk.

In a previous chapter, we composed full prep from the Five Ws to the Kinesthetic Behavior of the Five Tools so there is no need to review that

again. You can see our full prep for this scene above. Review that chapter if anything is this breakdown of Greg and Laurel needs explanation.

Aside from having a Beat change that signals a change in Objective for both characters, I picked this scene because it represents a scene that could have played two different ways. The way I chose gave the scene a "turn" or a "twist" with the Opening Intention for Laurel triggered by the Primary Verb "to test."

When we read the scene, the actors and I immediately decided how predictable it would be to have Laurel's Opening Intention be powered by the verb "to quit." The scene would ultimately have nowhere to go because her mind was already made up, and the writing indicates that the scene concludes and Laurel will leave Greg. So, to give the actor's something that would raise the stakes, add tension and ultimately some additional Kinesthetic Behavior possibilities, we began the scene by having Laurel play "to test" Greg.

Does Greg love her enough to leave this small town, his job in law enforcement and take a chance? They are both young, now is the time to do it. This gives both actors more to play from the start. When Laurel abandons her initial Objective "To live the dream" to start a new Objective "to take the risk" creating Beat 2, this raises the stakes in the final moments where one must surrender to the other.

So now we must begin to visualize. Start by diving into the Sensory Images and put yourself into this modest one-bedroom apartment. See the layout: you open the door to the living room with an attached kitchen. At the end of the room there are two hallways: one goes to the bathroom and the other to the bedroom. There is a window looking out over the street in the living room and on the other side of the open room, a window also in the kitchen area. Perhaps an overhead fan in the living room for those lazy hot summer days.

Laurel has stacked freshly washed clothing and a few other personal items on the kitchen table next to her suitcase. Greg knows she is not pleased with his role in law enforcement. He probably removes his gun and other items related to his work and places them inside a bag that he carries. This is a small town so everyone knows them, knows his position and hers at the diner. As hard as it might be to do it, they want to keep their conversation private. In the living room there is a well-worn couch with two easy chairs facing each other. The chairs don't match the couch, and there is a coffee table that also matches nothing.

In the rehearsal hall, you laid out this space by taping the floor. The distances between the living room and the kitchen area were matched. The distance from the front door to the hallways where you enter the bedroom or bathroom also matched your actual location. Now the

actors are on location and taking in the Sensory Images of the apartment that you were only able to previously share in words. Give them time to take in a space that up until now was only visualized by your words, or maybe seen in location photos. They need time take it in, to experientially "be there." Let them read through and perhaps walk through the scene. In the process they are reprising their Kinesthetic Behavior and making adjustments in the real environment.

When you previously rehearsed the ensemble, along the way you should have been revising your Marked Script. The places in the text where you felt there was a Moment may have been spot on or may have turned out to be in an earlier or later place in the scene. The verbs you composed to power Intention may have needed to be revised. This revision provided a "turn" or a "twist" as you guided the ensemble to the Beat change. The Marked Script at that time felt like a solid reflection of your rehearsal process. If you are lucky enough to get to rehearse in the space prior to production, you can build your storyboard based on that final rehearsal. But if that is not possible, get yourself ready to do a first pass on your own, creating a simple storyboard for the scene.

Let Laurel and Greg walk through the scene a few times. The simple props for Laurel's packing may now need some additional properties from the attached kitchen area. Maybe she was having a glass of water while she packed, or something to eat? Let the actors bring life to the space. The same goes for Greg. His news of a well-earned leave is meant to be a surprise when he opens the door to already find Laurel packing. How do her actions interrupt his normal pattern, his routine when he comes home from work? Does he normally toss his work bag on the couch or perhaps he puts it in a closet, out of sight? These kinesthetic choices need time to gel so allow the actor's time to find the life of the characters in the space.

I always begin my previsualization, my storyboarding with the Moments in the scene. I will sketch at least three panels for each moment. The first panel is the character saying the line of dialogue that triggers the Moment, the second panel is how I visualize the Moment (a full, a medium or close-up shot), generally the reaction of the other person(s) in the scene, and a third panel which shows the aftermath of the Moment.

My storyboarding method is based on experience. I find that generally after a Moment one of the characters makes a physical adjustment. It could be they rise from a chair; perhaps they choose to cross to the other side of the room. Perhaps the Moment, usually followed by an Intention change, signals handling a property. The impact of the Moment is seen not only in the immediate reaction to this particular line of dialogue, in

a single panel/frame, but, like aftershocks from an earthquake, the reaction reverberates and is often reflected in a single and at times multiple panels and frames. In this way, I approach the process from the inside to the outside. I focus on where I see Moments taking place in the scene and how I would like them to be captured.

A Moment seen in a medium close-up or in a close-up is not always the most powerful way to render it. Sometimes visualizing a Moment in a wider composition allows for you to see the kinesthetic effect on the character. There is a moment toward the end of the film *Michael Clayton* when Tilda Swinton's character has to take in a very powerful turning point in the film. I am certain that the director, Tony Gilroy, probably had a medium or a close-up for coverage he could have selected to show how this news affected her character. In a stroke of brilliance, for this crucial moment, he chose to show the character physically crumbling from head to toe. The impact of this visual was incredibly powerful. The lesson: Don't always visualize your Moments in a tight composition. Observe the actors in rehearsal and take in the full kinesthetic performance. It isn't always about the eyes, or a slight facial twitch, it is about the whole body, seeing how the character reacts from head to toe.

This scene between Laurel and Greg has a similar Moment after Greg's "You would if you saw the pension!" I think as I sketch my storyboard I am going to get Laurel's reaction in coverage as well as both of them in a tight secondary master.

Or

If I start at the top of the scene, there is also a moment when Greg first enters. How do I want to see this? Again, there is something about having the option to either show Laurel's face as she packs in a medium or in a close-up or perhaps from head to toe.

Or

Or

I want to also "match" my coverage when I capture Greg. Match the composition size of his close-up to the size I picked for Laurel and do the same in a medium and Greg's head-to-toe reaction.

Or

Or

A smaller but telling moment is when Laurel stops packing. Here we might clearly want to see the action of her simply closing the suitcase.

Rack focus to Greg as he sees Laurel

or perhaps closing the suitcase, removing it from the table and setting it down at her side.

Laurel starts to push the heavy suitcase off the bed.

Without thinking Greg instinctively leans in to help . . .

Laurel glares at him . . .

He back off as she finishes it herself.

These Choices were perhaps found in the rehearsal hall, but now they are made final on location.

Next is the moment of Laurel's reaction to "If you saw the pension!" This is the dynamic event in the scene and also signals the Beat change. Here again, perhaps it is only matching Laurel's composition with Greg's.

In addition, I would have a tight secondary master to capture their kinesthetic response together.

126 Previsualization

Alternative low angle with bed and suitcase in the foreground.

Now that the Beat has changed and as the expression goes, "the ship has sailed," the next moment "Sarge will give me hell . . ." should not be overly captured. Perhaps just simple matching composition for both Laurel and Greg over the silence will be enough.

Finally, there is the moment where they kiss goodbye. Is it a final goodbye? Or perhaps "see you soon" as suggested by Laurel's line? Again, give yourself the option to choose. To assist this flexibility, I would ask the actors to play it both ways. Perhaps Choice A is that Laurel will not return and her kiss and final bit of caring dialogue is to let Greg save face.

But I would also capture a "second pass" of this same shot, and give the actor direction where it is clear by virtue of the kinesthetic way Laurel wields the suitcase leaving the apartment she is conflicted and hopes when she finds success Greg will change his mind and join her.

The actors will also be on board with the ambiguity of this final Moment so shoot the scene both ways to be decided later when you examine the scene or when editing into the full film.

We've now mapped out capture for the Moments, so the task now is storyboarding the dialogue and actions connecting the Moments. Counting the number of lines of dialogue and any physical action indicated in the screenplay, I will have this number of panels available for my sketching.

My previsualization method mirrors the final edit. I visualize the scene fully edited, including reactions. Borrowing from what we learned editing the Scripted Monologue for presentation, reactions are a key part of the storytelling and underscore the impact of your Moments.

Sketch what you visualize for the opening when Greg comes home since you can always change how this plays in the edit. Leading up to that first Moment when Laurel stops packing, I count six frames or panels according to the script.

The Opening Intention is key. How the character enters the scene can lead the audience to think they know the outcome, or we might create a twist and the audience will realize they were wrong. I like to find a way to visually open a scene in a way that is not generic, not seeing the exterior of an office building before the scene begins inside one of the offices. I ask myself is there perhaps a property, or the character adjusting a piece of clothing, something we can begin with on camera that aids our storytelling and then reveals the character entering the scene?

Visualize starting the camera on the action of Laurel placing an item into the suitcase and continuing up to her face as she hears the sound of Greg's key in the lock then a cut to him opening the door and his expression of surprise.

```
Low angle - tight on suitcase
```

```
Laurel walks
into frame with
folded clothing
and leans.
```

Continues motion,
packing suitcase.

Greg enters house.

Laurel hears his
footsteps and turns
away, clearly
dreading this.

 GREG
What are you doing?

 LAUREL
What does it look like?

 GREG
I thought we were going
to talk?

 LAUREL
 Go on then.

LAUREL WALKS FROM AROUND THE
BED TO THE MIRRORED CLOSET AND
WE PAN WITH HER . . .

Finally revealing Greg in
the mirror as Laurel opens
the closet and starts
getting out more clothes
and bringing them into the
suitcase.

 GREG
 I can't when you are
 doing that.

 LAUREL

 Okay, What do you want
 to say?

After that moment up to the next moment which is also the dynamic event "You would if you saw the pension!," I count ten frames/panels.

 GREG
I don't want you to
go. I know we've had
some disagreements
lately . . .

 LAUREL
Disagreements!

 GREG
Whatever. But they've
been my fault. I don't
mind you being late . . .
well I guess I do, but
I'm going to have to
live with it. I have to.
I love you.

 LAUREL
I love you too, Greg, but
you can't expect me to
turn into a nice, loyal
police wife, keeping
house for you, raising
your kids and helping you
up the ladder.

 GREG
You don't have to.

 LAUREL
No? I remember all
those police wives
at the presentation.
They all wanted their
husbands to make a
good impression so
they could climb up
the next rung.

 GREG
There's more to it
than Laur—
 LAUREL
Yes there is. Look
I don't want you
turning into the typ-
ical cop, doing
exactly what you have
to do to get promoted.
I wouldn't care if you
never got promoted.

 GREG
You would if you saw
the pension!

Roughly ten more frames/panels to the next moment, Laurel's reaction to Greg's "Sarge will give me hell."

LAUREL JUST STARES AT HIM.

Previsualization 133

GREG
That was a joke.

Laurel turns and resumes her packing.

GREG
Where are you going?

PAN TILT WITH HER AS SHE RETURNS TO THE SUITCASE.

LAUREL
Away on my own. I've cleared it with the restaurant.

GREG
Where?

LAUREL
I don't know.

GREG
Can I come with you?

 LAUREL
 No, Greg.

 GREG
 But I've booked my leave.

 LAUREL
 You'll have to unbook
 it then.

 GREG
 It's not easy as you
 think. The Sarge will
 give me hell . . .

Greg stops when he realizes
what he is saying.

After Greg's reaction in response realizing he has done it again, and said the wrong thing, there is only one line of dialogue before Laurel's exit and probably the final image of Greg in a now lonely apartment.

 LAUREL
 I think that just
 sums it up Greg.

 TILT DOWN
 WITH HER AS
 SHE CLOSES
 THE SUITCASE.

SHE STOPS FOR A MOMENT AND
THEY BOTH LOOK AT THE SUIT-
CASE FOR A MOMENT, THEN
LOOK UP AT EACH OTHER.

AFTER A MOMENT, SHE LEANS
IN AND STARTS . . .

. . . TO STRUGGLE TO GET
THE HEAVY SUITCASE OFF THE
BED AND GREG INSTINCTIVELY
GOES TO HELP . . .

LAUREL LOOKS UP AT HIM AS
IF TO SAY "REALLY?"

HE BACKS OFF AND SHE
WRESTLES IT TO THE
GROUND, THEN HE WATCHES
AS SHE EXTENDS THE HANDLE
AND ROLLS IT TO THE DOOR.

136 Previsualization

SHE STOPS AND TURNS.

Laurel kisses him on the cheek.

 LAUREL
 I'll see you when
 I get back.

Laurel leaves.

Having viewed these boards, now create storyboards of your own based on using a combination of secondary masters and moving the camera to follow the action.

Now it is time for you to storyboard. I invite you to storyboard using FrameForge3D or any other storyboarding software or even something as simple as pencil and paper using stick figures.

Maybe instead of what I have drafted you would choose to have a wider capture, a fairly loose secondary master of Laurel finishing a glass of water and moving from the kitchen counter to the kitchen table to resume packing. Sketch a storyboard of Laurel crossing from the kitchen to the table to pack head to toe. Sketch a frame that shows the door knob turning with the sound of keys and again when the door opens, panning up to Greg and his look of surprise. Sketch a storyboard of door knob turning in a close-up widening out to see Greg open the door and his expression.

I am not advocating one approach over the other but just to point out some options as a way to open the scene. Based on the fact we want give this scene somewhere to go, we want to start it with Laurel not really ready to go. Laurel wants Greg to see how serious she is about leaving him and perhaps it will prompt Greg to go with her. These are the issues that govern how you choose to visualize this opening moment of the scene.

Figuring out how to open the scene, I would work my way over the next six frame panels to the first Moment. The problem with dialogue capture is that it tends to be one OTS composition after another without regard for the kinesthetic possibilities. This is yet another reason why rehearsal outside of the capture day is necessary. Actors who know the 180 rule will unconsciously or consciously set themselves up to facilitate this routine way of capture. Actors who rehearse with the director on location or a rehearsal space outfitted like the location, without regard for cameras, eyeline, lighting, and even crossing the line, will find a deeper connection with the character. They are able to dive into as Weston calls it, the "subworld." They are able to explore the private and sacred places within the character. Then on set, in costume and make up, with all the Sensory Images of the world of the scene to interact with, you witness a more powerful and memorable performance.

Remembering these marvelous discoveries during rehearsal and planning for them with your Director's Script, you visualize a scene where the interaction between two characters is not static. It is physically spontaneous and kinesthetic. The frames leading up to the first Moment are not a series of OTS captures with a close watch on eyeline and the position of the character in the frame based on the Rule of Thirds. Instead, perhaps characters are not facing each other all the time but moving about the space as if they own it. So now you must capture this way of playing the scene as you sketch.

Maybe Greg is tentative, cautious about invading Laurel's space now that he realizes she means business. These opening lines of the scene could be played with distance between them. Or maybe in rehearsal, because Greg has had good news at work, he isn't put off by her packing and doesn't respect her space. Instead he crosses over to her hugging or kissing her to break the mood. His actions "raise the stakes" in this scene.

It is too ordinary to play the obvious – "Laurel is pissed so I better stay away." Remember Greg's Objective is "to save the relationship" so I would encourage the actor to play the character moving in toward Laurel, kissing or caressing her and then heading to the kitchen to make this just another day home from the job. He might go into the kitchen and pour a glass of water too, or do something else to try to make

everything feel like just another day. Now the scene has irony because this is not just an ordinary day.

We are just sketching, so for Storyboard Plan A, I would take all six frames and make it a secondary moving master from start to finish. Camera would follow Greg from the door to Laurel and finally into the kitchen. Sketch a series of storyboards of Greg's entrance to Laurel and finally the kitchen.

For Storyboard Plan B, I would sketch another six frames following Greg from the door to the kitchen but adding the pull back to reveal both characters. Sketch a series of storyboards with alternate endings showing Greg in the kitchen and Laurel at the table. Your sketch can be very rudimentary because either you will have a storyboard artist or use software to create the final polished version for distribution during production. Now based on the two ideas I have shared up to now, we need to talk about masters.

There is a traditional rule in film production that you should have a master of every scene. This gives the editor a way to show the full geography of the location. It establishes which character or characters are on the left of the frame and which character or characters are on the right side of the frame. The easiest way to disorient your audience is by flipping left and right in the middle of a scene unconsciously or consciously. This is what is referred to as "crossing the line." The only issue with a master is that because it is a wide view of the scene, creating tension during the action of the scene can be a challenge. That is why in the above illustration, I did not propose a master of the complete scene between Greg and Laurel. I propose using a secondary or, as some people call it, a submaster for the purpose of creating tension in the opening dialogue. By means of visually tightening the composition from the full view of a master to tighter and more specific groupings of characters in the secondary master, you raise the stakes and heighten the tension.

Coming out of my first Moment of Greg coming home, I want to hold the tension that has been created. I may choose to use a dolly to move Laurel and Greg as they process what just happened. In this way, I keep my visuals dynamic and diverse, breaking away from a kind of ping-pong match that occurs bouncing back and forth with an OTS shot. Dollying with the character and keeping one in the foreground and the other character in the background allows the scene to breathe. Now you can pace the next series of shots that will lead up to the next Moment.

We have brought Greg into the attached kitchen and now the Opening Intention "to reconcile" changes to "to apologize" and for Laurel her Opening Intention of "to test" changes to "to challenge."

Remembering Mel Shapiro's mantra regarding a "tension scene," I want this next series of shots to be from the waist up, in medium to differentiate this composition from the secondary moving master that followed the initial Moment. Perhaps now the characters have become more kinesthetic as the stakes have been raised. This composition allows for room in the frame to see the performance in the body.

Greg and Laurel trade lines of dialogue back and forth as the tension finally builds to the Dynamic Event, "You would if you saw the pension!" Since this is also the Moment that triggers the Beat change, we would do well to capture two sizes here. We give ourselves the option in the edit to tighten from the loose medium to a medium close-up. This process is called a "second pass." Tightening composition by changing the lens, we are thereby heightening the tension.

This too is another part of the scene where you can play against the obvious. The dialogue would indicate a possible shouting match culminating with Greg's line. But, perhaps Greg is still trying to convince Laurel to see it his way using his lover-boy tactics. Playing the line about the pension, what if he steps in with that line? His Intention "to apologize" changes to "to entice." Why not physically raise the stakes for both with this bold kinesthetic move? A move he assumes will make her see it his way.

This could be visualized as a continuation of your initial secondary moving master. As Greg moves from the attached kitchen over to Laurel at the table in a "cowboy" or from the knees up. Sketch a storyboard of Greg moving from the kitchen to Laurel at the table. Or, perhaps a "second pass" that is tighter, from the waist up particularly at the end. In this way during the edit you have yet another option if you want to move the scene more dramatically to the Dynamic Event. Sketch a storyboard of Greg moving from kitchen to Laurel (tighter).

Finally, we arrive at the penultimate Moment, the Choice in the scene. Here I am going to want a medium close-up or perhaps even a close-up. This way I can visually indicate who has achieved their Objective and who must surrender their Objective and seek a new path. Covering the scene in two sizes visualized as an OTS on both Laurel and Greg means that now you have three possible ways to visualize Laurel's reaction to Greg's enticement.

Perhaps if Laurel closed the suitcase and put it on floor to initially listen to Greg, now she has the opportunity to kinesthetically display her displeasure. Lifting the suitcase back to the kitchen table opening it in such a way that it strikes the top of the table making a loud noise. The silence that would follow begins the start of Beat 2. Sketch a series of storyboards showing Laurel picking up the suitcase again and putting it on the table loose over Greg's shoulder.

Greg realizes his tactic has failed and "to entice" becomes "to plead" with the start of Beat 2. Laurel at this point with the new Objective "to pursue her own dreams" uses the verb "to make a new start" as it propels the final stages of packing closing the suitcase. Perhaps you encourage the actor playing Greg to still not have a clue. His lover-boy tactic didn't work so maybe the news he has decided to take a leave will make the difference. Sketch a storyboard of Greg's reaction loose over Laurel's shoulder. I would have Greg move toward her up to make this announcement – tentatively and cautiously but with some degree of hope. I see a second pass to capture this as well, one in a medium and the other closer, medium close-up.

Sketch a storyboard of Greg moving forward to a medium close-up. I would want Laurel to hold her ground so you would want to match composition. Finally after his "Sarge will give me hell . . ." leads us to the defining Moment of Laurel's defining line "I think that sums it up" and the kiss. Sketch a storyboard of Laurel matching Greg's medium close-up. Greg's reaction tells the tale and with a Moment of this magnitude, match the coverage on both.

To end the scene, we return to the secondary master that brought Greg to Laurel. This time beginning with the tighter composition of both we ended up with on a second pass, we pull back and open up. The camera moves with Laurel as she crosses toward the door. Laurel now in the foreground looking toward camera and Greg in the background for "I'll see you when I get back." Sketch a series of storyboards as Laurel completes packing and moves to the front door. You would also want to get an OTS of this final moment and add a turn for Laurel to look back to him when she says her last line with the ambiguity of one day returning and match composition on Greg as he takes in this in this final line with hope in his eyes. Sketch a storyboard of clean single of Laurel looking back at Greg followed by a clean single of Greg and his reaction as she leaves.

Below is the complete scene marked as a Director's Script that created the storyboards using the software FrameForge3D. The scene is now ready for capture.

```
Int. Greg's Apartment        Evening
```

Beat 1

"I want to talk to you"

Laurel OBJ: Let's live the dream.
Opening INT: To test.
Greg OBJ: To hold on to the relationship.
Opening INT: To reconcile.

Laurel (20s), a free spirit currently working as a waitress. Greg (20s), a policeman in a small town. They have been dating on and off since high school, but now they are living together. Laurel is packing and almost finished when Greg comes in from work.

>GREG
>What are you doing?

>LAUREL
>What does it look like?

>GREG
>I thought we were going to talk?

>LAUREL
>Go on then.

>GREG
>I can't when you are doing that.
>——————— MOMENT

>LAUREL
>Okay.

Laurel stops packing, closes the suitcase———————
>>Laurel: to challenge

>LAUREL
>What do you want to say?———————
>>Greg: to apologize

>GREG
>I don't want you to go. I know we've had some disagreements lately . . .

>LAUREL
>Disagreements!

>GREG
>Whatever. But they've been my fault. I don't mind you being late . . . Well, I guess I do, but I'm going to have to live with it. I have to. I love you.

142 Previsualization

> LAUREL
> I love you too Greg, but you can't
> expect me to turn into a nice, loyal
> police wife, keeping house for your,
> raising your kids and helping you
> up the ladder.
> Greg: to entice
>
> GREG
> You don't have to.
>
> LAUREL
> No? I remember all those police
> wives at the presentation. They
> all wanted their husbands to make a
> good impression so they could climb
> up the next rung.
>
> GREG
> There's more to it than Laur—
>
> LAUREL
> Yes there is. Look I don't want you
> turning into the typical cop, doing
> exactly what you have to do to get
> promoted. I wouldn't care if you
> never got promoted.
>
> GREG
> You would if you saw the <u>pension</u>!
> - - - - - - - MOMENT

HOLD on Laurel's reaction.

> That was a joke.

Laurel resumes her packing.

Beat 2

> *"Yester You, Yester Me"*
>
> Laurel OBJ: To pursue her dreams.
> Opening INT: to make a new start.
> Greg OBJ: To save the relationship.
> Opening INT: to plead.

> GREG
> Where are you going?
>
> LAUREL
> Away on my own. I've cleared it with the restaurant.
>
> GREG
> Where?
>
> LAUREL
> I don't know.
>
> GREG
> Can I come with you?———————— MOMENT
>
> LAUREL
> No, Greg.
>
> GREG
> But I've booked my leave.
>
> LAUREL
> You'll have to unbook it then.
>
> GREG
> It's not easy as you think. The Sarge will give me hell . . . ————
> ———————————————————————— MOMENT

Greg stops when he realizes what he is saying————
> Greg: to surrender
> LAUREL
>
> Laurel: to terminate
>
> I think that just sums it up Greg.

Laurel kisses him on the cheek.

> I'll see you when I get back.

Laurel leaves.

As you can see, it is always necessary to reformat the screenplay, to make it your Director's Script. Notice also how the page is completely bisected when a new Beat begins, just like a hard boundary.

Putting it into practice

As I suggested at the start of this chapter, find a scene, just a scene, two characters preferred, and use your imagination to build a complete story around this scene. Then do full prep: The Five Ws up all the way through the Five Tools and create a Marked Director's Script that is production-ready.

Begin to visualize capture by first creating a ground plan for the movement of the characters in the scene. Starting from how you visualize the Moments and then how you visualize the story frame by frame leading up to each Moment. Find a variety of ways to visualize the dialogue that leads into and out of moments to avoid simple and ultimately unimaginative OTS capture. Indicate where you see the use of a secondary moving master and any places where a "second pass" will be used. Now is the time to be a visionary and create your unique signature.

Chapter 13

Digital capture
Putting it inside the frame

Up until now you have occasionally heard me use the word "capture." As I explained earlier, "capture" is a term I adopted after hearing it used in relationship to previsualization. I prefer it to "shoot" or "shooting," which was a phrase that was coined by early filmmakers. They saw their hand-cranked cameras similar to the hand-cranked guns of the time. A cameraman would shoot a film in the same way you would shoot bullets from a machine gun. Not to overlook the work of his predecessors, it was Étienne-Jules Marey's invention, the chronophotographic gun, in 1882, that some regard as the precursor to the cine camera. Marey's shooting of animals led to his work being known as "Marey's animated zoo."

After learning about this history of cinematography and the evolution of the words "to shoot" and "the shot," I welcomed another way to describe the act of preserving a live performance. These stories reminded me of the early days of photography when people refused to allow their photo to be taken because they saw it as robbing their soul. The word "capture" also could be seen as a violent word used to describe moving a live performance to a performance frozen frame by frame. In my eyes, "capture" is not violent but in many ways seeks to preserve the live and spontaneous nature of performance by an actor. You want to capture the living, breathing action of performance so that it may be released again to an audience. Since hearing "capture" more widely used in today's world of digital cinematography and previsualization, I want to get on board with the times, times that are moving forward. Still, I leave it up to you the reader to draw your own conclusions and decide on your own vocabulary. But, for the sake of the terminology in common use today, I have been using the word "shoot" or "the shot" for this book.

My methodology for production is to have the actor dictate the work of the camera and not the other way around. When I worked in prime-time television, one of the early lessons I learned was to stage the actors for the benefit of the cameras. We were working with four

cameras that were assigned four different responsibilities. The cameras to the far left and far right were referred to as the outside cameras, and the two cameras in the middle were obviously the inside cameras. The outside cameras were often used for medium close-ups, a way to pull out the person speaking the dialogue from the background. The inside cameras were generally used when characters moved on the set or made entrances and exits. This pattern is still common today if you watch any of the popular situation comedies.

For me there was something very stagey and static about this method. It did not allow for real spontaneity. The actors learned the system as well and without prompting would align themselves in the proper positions to facilitate this method of production. I became bored with this type of paint-by-the-numbers setup and instead rehearsed the performers more theater-style, as if doing a play to encourage them to break out of this television template. When I was fortunate to have actors who were originally from the world of theater, they were delighted to have this kind of freedom. As a result, the pace and tempo of the show picked up, and the comedy was organic and natural. Still in postproduction we always inserted a laugh track, audio "wallpaper" to boost real laughs from our intended audience in the comfort of their home.

It is in this way that I approach directing: It is always performer-based, actor-driven. If you have rehearsed and have done the proper preparation beforehand along with storyboards and your Director's Script, you are ready to capture. Your storyboards created during previsualization will often determine how many times the camera must move and how many sizes of composition with each move. Normally for editing you want no fewer than two sizes: a medium and a medium close-up from each camera position. In this way, you can increase or decrease the tension putting to use the size of the composition.

You probably have secured a camera and a DP who is probably also operating the camera with an assistant. Along with this team, you will have a sound team comprised of a boom operator who holds the microphone and a mixer. But what about lighting? Lighting is probably the one aspect of filmmaking that an actor's director knows very little about, and, as a result, their lighting can be marginal to just plain bad.

When I was the AFI intern on *Trading Places*, the DP was a guy named Bob Paynter. Bob was from the UK and a very old-school DP. When working with his gaffer, some of the lighting arrangements were almost works of art in the combination of lights, stands, and baffles he assembled. Bob would walk around examining the setup, viewing it with a single lens in the form of a monocle. I was so curious about his methodology in arranging these

elements, so when I asked him how he came about it, he just smiled and said quite simply, "Experience, and let's see what it looks like in dailies." We were working in film back then, 35mm. When I would attend dailies, even before color correction had been done, the work was stunning. This was my maiden voyage in lighting for the feature film, and I must confess it had me completely baffled. Much later, when I began to teach, I met a well-known lighting guy in Boston named Morris Flam, better known as Mo Flam. Now, Mo is a very interesting guy. When I reached out to him to tell him I was writing this book, he was sailing in the Caribbean. I call what Mo taught me his method of the tried and true: Three-Point Lighting. If you ask Mo, his lighting bears no resemblance to the traditional Three-Point Lighting scheme. This was his response when I asked his permission to share his lighting tips: "No problem, but I am certainly not a proponent of Three-Point Lighting, so what did I say at Emerson? You can use my rules as long as you credit me. Thanks, Mo." Well Mo, as you can see, you got the credit. So here are Mo's rules:

1. Observation is the key to good lighting. Pay attention to images, scenes in movies, paintings, pictures and real life. When you see an image or lighting that you like, take note! The key to good lighting is recognizing it when you see it. You need to have an idea of where you are going when lighting a scene. Start with the time, place, mood and where it is in the story.
2. Don't let the big light (the key light) get behind you! Think about how you are lighting the scene. Is it too flat? Has the key light gotten behind the camera?
3. Light the money! Who or what is the most important thing in the shot or scene? Prioritize. Work from the most important thing out.
4. Place the light for the look: upstage side. My starting point for where the key light should be.
5. Hide lights behind stuff. Always look for ways to hide your light so it can be in an optimum position. Behind props, an arch, a doorway, a window, a column.
6. Have contrast in the frame. Something light, something dark, to create dynamic visuals, utilize the entire latitude and tonal range of the format you are shooting.
7. Less is best. Simplicity is always the best policy, don't overdo anything. Does what you are doing look real or fake?
8. Learn what you can get away with. Don't try to make everything perfect. You have to let go of some things for time. Learn what those things are.

9. Better to make good bad-looking movies, than bad good-looking movies. Shoot the director's movie and get as much coverage as you can, even if you have to make some lighting sacrifices. It will only make you look better. There are exceptions to every rule!
10. Show up on time. Self-explanatory, probably the surest way to sabotage your job. No one tolerates being late or unreliable. In fact, you should show up early! You will learn more before the formal day begins when you can actually get some information before the stress of the job starts.
11. Don't dis the boss! Give your ideas in a diplomatic way and accept it if they aren't taken. Do the job you were hired for! There are many pressures on your boss and you may not get the full explanation in the heat of battle. If your ideas aren't immediately accepted, move on.

I have implemented so many of Mo's Rules in my teaching because many of them are my rules as well. Rules learned from coming up through the trenches. Mo says, "Show up on time." My expression is "Be in time." This comes from observation when I was doing locations on the film *Ragtime*. When we began production it was my responsibility to be there early. That meant arriving at roughly 6 a.m. before the semi-tractor trailers driven by Teamsters with all the gear for production. There would be craft services delivered early for the drivers to keep them happy, and I noticed that along with the drivers and others who had to be in early as well you would find one of the producers. Not the line producer, but one of the executive producers. They would be dressed in jeans and look just like anybody else on the crew. They were there "in time" to be sure the machine of production was cranking up for the day. They hobnobbed with everyone. I learned early that it is a people business. I saw the very same thing years later on *Trading Places* and have observed it time after time. These individuals were once production assistants, PAs. They moved up the ranks to where they were now but never forgot the lessons learned by "showing up in time." I cannot tell you how many times I have repeated this to students because I believe it is something you learn early in this business and once you learn it it is in your DNA.

But Mo's contribution to this chapter is lighting, so let's get back to that. Mo's first, third and fourth rules are the rules that I primarily teach to directors. Understanding Mo's simple approach to lighting is crucial, particularly now in a digital world. Observe how natural light plays in a room and instead of trying to defeat it work with it. If there is natural

light coming from a window, see how it plays on the characters and let it determine how you use any additional lighting instruments. The "key light," or, as Mo calls it, the "big light," should never be behind the camera, but, as he points out, "Place the light for the look: upstage side." I cannot tell you how many students just plain ignore this rule even when I show examples of how almost everything we see in film or on television is lit this way. If the key light is in front of the actors, basically behind the camera, you are going to get shadows. You can extend your stands as high as you want, but they are going to have to be really high to get rid of the shadows. Using a very simple kit with three or four lights you can do wonders if the light is upstage.

In a typical scene of two people speaking to each other, the key lights for each are placed upstage, or behind the actors. By doing this, the shadows fall off outside of the frame. Now these same key lights are positioned so that on the way to lighting the upstage side of the actor's face, they also create backlight for the actor they are set up behind. Backlighting an actor pulls them out of the background. In this way, two lights do the work of four lights. The greatest takeaway is that when these key lights illuminate the actor, they bring out the upstage eye. Without this eye, you witness only 50 percent of the actor's performance. This eye can be lost because the third light in a typical kit is the "Fill" and it is deliberately set to be softer. This light is usually bounced from an umbrella to provide overall frontal illumination. This light will never bring out the upstage eye. If you have a fourth light, you would use this to illuminate some part of the background, something that identifies where we are. Watch a few films or dramas on television and you will see this lighting scheme in practice scene after scene. This basic knowledge is key for the actor's director because this setup is how the audience will witness the work you and your actors have come to share.

So now you have a basic idea of how to light your actors and your storyboards created using previsualization provide a roadmap for camera movement necessary to capture the scene. As a rule, give yourself not less than 30 minutes every time the camera needs to move if it is fixed on a tripod. Less time is needed if you are on a dolly or handheld, but because of lighting there are always things to tweak and fix.

At the beginning of the shoot day, start off with a master. It should be wide enough to contain all the movement in the scene, and, most important, it should determine the geography of the scene: who is to the left and who is to the right. This is so important because this is how you prevent yourself from crossing the line. Once this is done, based on

your previsualization, also capture a submaster or what I like to refer to it as a secondary master. One of the things we discussed in the previous chapter while illustrating previsualization is tension. As a scene progresses and the tension rises, if you visualize coverage of the actors mostly OTS, at some point you have to come out for movement or to just to give the audience a breather. You can only stay OTS for so long. When you come out, you don't want to return to your original master. Doing so psychologically and emotionally returns the audience to the beginning of the scene. All the tension you have built is lost. I call it the *Groundhog Day* effect. I am sure you know the film with Bill Murray where every morning he wakes up and it is the same day. If you return to your opening master, you emotionally take us back to the beginning of the scene, and you don't want to do that after spending so much time building tension.

To prevent this from happening, capture a secondary master, always tighter than the opening master. This allows for perhaps a character to move and settle in a new place, as we saw in our previsualization for the scene between Laurel and Greg.

Previsualization also creates priorities, or, as Mo put it, reasons to "Shoot the Money." You have created storyboards, storyboards that mirror your future edit, so if you have managed your time efficiently you'll be able to get all the coverage you need. But what if you fall behind? This is when you follow what you have storyboarded and particularly regarding coverage.

It is a luxury to have both mediums and medium close-ups of your actors along with OTS shots to be able to freely edit. But if you know based on your previsualization that as the tension increases you plan to see the actor's faces in a medium close-up, all that additional coverage will not be of use. Feature films generally have conservative page count to accomplish each day so they can get lots of coverage. (Look back at Mo's rule about that!) In television and certainly the indie world, there is no such luxury. So the takeaway: spend time in previsualization to know what you need to tell the story. Hopefully, if you get what you need, you'll make your day and still have time, time you can use to set up that really special capture that hopefully will become a hallmark of your movie.

Follow your plan and no matter what, until you get what you need, do not deviate from the plan. The mantra of the director is "make your day" so respect that and make it happen.

A few more things to remember about production: First, inserts. These are those specific props or actions you want to call attention to because

they are key to your storytelling. One thing about inserts is that you must spend time in previsualization to figure them out. Looking back again to *Boardwalk Empire*. In the opening moments of the pilot, the camera focuses on a pocket watch of the period. The shot widens as the person brings that watch up to examine the time and ends on a close-up of this man's stare across a fog-filled ocean. Because they chose to use an old film technique of opening up from black to the watch, it works for the storytelling. Later in the pilot, Nucky Thompson pushes some large bills into the hand of Margaret Schroeder to help her family get through the non-tourist months of the winter. This time there is a quick insert of their hands touching and then a quick cut to Margaret's reaction. Perhaps they also captured this sequence in the same way they did with the watch, using a quick pan from the money up to her face. Scorsese is known for this kind of swish pan style. But no, they opted for a clean insert instead.

Think these choices through very carefully. After all the work you have done beginning with the Five Ws, you are now shooting the pieces of a large visual tapestry, and you want to be sure all the pieces will be there to assemble your grand vision in the edit room.

Because we are dealing with actors, and actors tend to be creative all the time, we have fashioned this experience to encourage spontaneity and creativity. It is always good to leave a bit of space for something special to occur in the Moment. This is another reason why rehearsal is important. Explore all the twists and turns of the scene so that you and your ensemble have tried multiple ways to play it. When you finally settle on a version you will previsualize for capture, you will have prepared yourself for the unexpected and still make your day. Nevertheless, be on the lookout for that "light-bulb" moment, and if it is something suggested by the star of the film, or as Mo says, "the money," go for it.

During production, be mindful of wardrobe changes and makeup considerations. These can be time-consuming, and, with the proliferation of SFX, green and blue screen, you must confer with your wardrobe and makeup teams to give them the time they require. Most recently, Christian Bale spoke of the four-hour session to get him made up to be Dick Cheney for *Vice*.

This is production, the final endeavor that began with this project only in your mind's eye. It's a project that you have developed collaboratively with your actor, and now with your DP and the rest of the team. You will soon head into the editing room to assemble a completed work. Your patience and diligence throughout all the stages of the process will ensure successful storytelling.

Putting it into practice

Now is the time for production. Because you have done all this preparation to be ready for production, make adjustments where needed to facilitate shooting the scene with respect to the 180-degree line. The actors may not know they shouldn't "stack," that is, stand behind each other as they do in theater when working for the camera. They too are learning about the "line," so work together. Even after calling "action," let the scene brew a bit before the first line of dialogue. Encourage the actors to absorb their experiential world via reminding them of the Triggering Facts, which in turn creates the Opening Intention in pursuit of the Objective.

During capture, make sure the actors are framed correctly, either frame left or frame right with lead space. Don't forget after securing a master, you need a secondary master to hold the tension of the scene as it plays. Generally, after the first Moment in the scene, whenever you move out from OTS to a secondary master, that secondary master should tighten the frame. Keep it simple. It is about storytelling, and performance tells the story.

Follow the rules outlined regarding lighting and keep the key light upstage of the performers. Be sure to shoot the secondary master that you previsualized and make plans for a second pass so that there are at least two sizes of all the capture.

Chapter 14

Responding to scene work

When we previously looked at the monologues, we were focused on different things so let's review them again. What to look for in the Improv Monologue is all about the Moments. Does the actor's performance accurately deliver the moments during the storytelling? Are the A to B to C (actor's vocabulary) or in the director's vocabulary the "Chapters" of the story clear? You also want to check where the camera is placed. OTS is preferred because that helps the actor's eyeline and maintain the intimacy of the story. The final observation: Overall, do you see collaboration between director and actor in the finished work?

We are looking for honesty in the performance – a performance that demonstrates the actor is comfortable telling the story. The actor is quote unquote not acting. This kind of honesty and forthrightness is something we want to always maintain when building a performance. We must feel that what they are presenting is truthful. To aid this, there should always be a scene partner, someone there to witness. You don't want the actor playing out to the heavens or to themselves. There must be a point of contact, a person who is there to support the sharing.

When you review the Scripted Monologue, look at how the director and actor collaborated to capture the work of the screenwriter. Does the presentation still feel like an actor's monologue, an audition piece, or is there a feeling that they worked on it together transforming it for the screen? Did the actor find places to move so that the director along with the DP had to make adjustments in composition? Did you maintain eyeline and manage not to cross the line? In the edit, were the reactions of the scene partner carefully placed to make them most effective coinciding with the moments created by the actor?

We want to encourage the Kinesthetic Behavior: to get the actor performing the monologue up and moving. The scene partner is there to witness the performance, and this may also be an opportunity to have them move as well. Their movements counter the speaking actor's

physical movements. For scene work, you want to begin to incorporate other styles of composition: mediums along with medium close-ups that are clean singles in addition to "dirty" OTS framing. Now with movement in the work accompanied by an independent activity, the incorporation of properties is also an option. Incorporating properties becomes part of the organic physicalizing of the character and not arbitrary movement to use a property just for so-called "staging" or "blocking." All of this is done with the director's eye on truthful performance. Now that they are on their feet, as the actor moves from A to B to C creating places in the storytelling for Moments, the Moments should be more resonant and impactful. These were the challenges we addressed in the Scripted Monologue and we also address in scene work.

I encourage you, the young director, to start first with a two-person scene, much like the Greg and Laurel scene detailed in Chapter 12. It is better to get used to orchestrating two characters before you begin the much more difficult task of three or more characters in a scene. With only two characters, the focus on truthful performance is made simpler. The characters say what they mean and mean what they say. Be firm but gentle in rehearsal. Don't let actors substitute an Action for their Objective, or if in discussion you happened to ask them about their Objective and they respond with the expression "I kind of," this is nonspecific. Objective is always specific, so that when Moments resonate, there is an affirmation from the scene partner. The scene partner is granting permission for the character to continue. Each character has an action to play, and this should prompt reactions and dialogue from the other character. This give-and-take process needs to be closely monitored. Add to this that you want both characters to move, to incorporate kinesthetic choices into their performance. When it comes to the use of properties or "business," it must be generated by pursuit of Objective and not simply added like an accessory to a costume.

Using the Greg and Laurel scene as an example, this is a sensitive and intimate scene between two people who are in love. The way the characters interact has to be honest. If the rehearsals were conducted in a manner to allow the actors to dive deep into their characters, the actors were given the platform to fully express what they felt in the Moment. If this was the process, the result in production will be compelling.

A vital part of allowing an audience to be a part of the drama is in how the visuals are composed: a careful selection of frame sizes along with a secondary moving master. This method is best to capture the tempo and pace of the scene and has the ability to shoot the scene in one uninterrupted take. The actors like this style of production because this

mirrors performance in the theater. A scene starts and plays out to completion without a stop. The stop-and-go method of film and television production can at times be counterproductive to the work of the actor. As actors' directors, we need to visualize a plan that allows for capturing the performance without interruption whenever possible. You will find in editing that this style of production provides the most truth and honesty. We are able to see the actor playing the character from head to toe, a complete surrender to the kinesthetic world. Then if needed – and generally it is needed – you can do coverage of specific portions of the scene. The actors have now created a physical roadmap that is repeatable as you stop and go. They have an emotional and kinesthetic memory that coincides with each portion of the scene.

These are the primary things I look for in scene work. Now sometimes creating a moving master is not possible due to the space or the nature of the material, but try your best to visualize one. As we saw in the Greg and Laurel scene, maybe we won't be able to use our moving master for the entire scene. Particularly at the opening as the secondary master will probably spread the composition far too wide at the start. But incorporating a secondary master after Greg has entered and using it to follow his movements and Laurel's movements to the end, could be very powerful.

Seize the opportunity to be an actor's director and rehearse the scene in a way that will inspire the performances of your actors. When it is time to capture, you will be capturing them at their best. Ken Cheeseman, my acting colleague, has some very specific things that he points out to his actors. I find these same things are important to point out to actors' directors as well.

Ten things to look for in your scenes and monologues

1 At the start of the scene, are you aware of the "Key event" (Dynamic Event for directors) and in response to what? Are you breathing? Taking in your scene partner and the moment? Do you slowly come up to speed in the scene or do you start connected and alive? Are you holding your breath or freezing when your partner is speaking?
2 Change. Tilt. "Reversal of the situation." How are you different at the end of the scene from the beginning? Where do(es) the change(s) occur?

3 Tempo. Is the rhythm too fast? Too slow? Is it determined by listening/responding or are you self-generating?
4 Do you understand the given circumstances of the scene (Storyline Facts for directors) and the story? Are you clear? Are you specific?
5 Character is determined by action. What do you want? Do you have a Super Objective? Objective? Actions? Are you getting what you want in the scene or are you failing? What are your obstacles in the scene? At the end of the take does your action "resonate"? Does it "sustain"? Or does it drop off suddenly? Are you waiting to hear "cut"?
6 What is your status in the scene? What is it in relation to others in the scene? What is it in relation to the environment of the scene? (Sensory Images)
7 Is there an independent activity in the scene? Is it truthful? Is it overwhelming the scene or enhancing the scene? Will you be able to match it for continuity?
8 How much movement does the scene require? Are you aware of the framing of the shot? Is it a wide shot? A close-up? Is it the master shot?
9 Are you making "emotional appointments," which are self-generated, or are you allowing the emotions to be in response to a failed or successful action or the given circumstances of the scene?
10 Are the stakes life or death? Are you committed to the material?

Putting it into practice

Scene work is harder than the monologues so let your response to what you see in your classmates work be generous and encouraging. Technical considerations about production should be separated from your response to the performance of the actor, which is where the focus should be. We have traveled a long way now from initial preparation to this capture, so make the response about performance.

Chapter 15

Building your sixth sense
Breaking out of your comfort zone

I closed the preface for this book with this bit of advice: "That final part in director preparation is life experience. Life experience is needed to develop the director's sixth sense, their knowledge of human behavior in all types of situations. In essence, that is what we do as directors: We guide an actor in the re-creation of human behavior. We guide an actor to "be" and hopefully, not to "act." Unfortunately, due to the ease of technology and social media, we all can be sheltered from the real goings-on in the world and in the process what is lost are the skills of observation and participation. The world is being overly guided by technology and at worse controlled. So much of what is happening in our present world cannot be experienced via a smartphone. So, in addition to this book or any book on directing, you must break out of your comfort zone and experience the world around you."

We have taken a long journey from composing our Five Ws and building our Storyline Facts which are the bridge to the Three Questions to Choice. All of this leading to the Five Tools used to fine-tune the work of the actor. This culminates in the creation of our Director's Script. During rehearsal, we begin the previsualization process and prepare storyboards and other preproduction planning needed for our shoot. Finally, we shoot and after that we edit our final product. All of this is structure designed to help every director develop their craft, their way to work with actors to create memorable performances. But this is only part of the journey on the road to become an auteur, a media-maker with a signature. The other part of this is life.

If you want to be a director, you must be curious about the world, curious about people and places. You must have an irresistible urge to investigate your surroundings and seek out new surroundings to develop your sixth sense. Everywhere you travel, take in the Sensory Images. You must develop what I called in an earlier chapter, the courage to "Creatively Eavesdrop" on life as it happens all around you. Every day

I try to find people and places to observe in order to take away a new understanding of human behavior. I am fascinated with this present we call life. This prompts the question, beyond walking around in a curious way, how does a young director do this?

I am going to suggest a few examples. These examples will not put you in any danger. These are adventures you can take that will enable you to observe and hopefully takeaway a new understanding about human nature and behavior.

The curious wanderer

This is a very easy adventure to take. If you are in an urban area, or you can get to one, find a landmark in this particular city as a starting point. If you are unfamiliar with this particular city, then do a bit of research so you don't put yourself in any danger.

Once you arrive in the neighborhood where you wish to start, without following any sort of map, begin to walk. When you reach a corner, you must wait for the light, no jaywalking allowed! When the light changes, cross the street, and at the next corner make a random decision to go either straight, left or right. There are always cues in the street to tell you where to go, where not to go, and what side of the street you should walk on. Even though the city is full of signs that point you to go certain directions, pay no attention to these signs. You don't want to think about where you are going; you just want to follow your gut. Follow your instinct and intuition, your sixth sense about which way might be the most interesting way to walk. Notice I did not say "the right way" but the most interesting way. If you want to make it more fun, do the old-fashioned thing. Toss a coin. Heads you go this way, tails go the other way.

Give yourself a bit of time to do this. Just wandering with no destination in mind. When you see something interesting, slow down, stop and take it in. If you are feeling a bit braver, perhaps you may come across people having a conversation. Slow down, keep a safe distance, and without drawing attention to yourself, creatively eavesdrop. Perhaps you will hear a story, an explanation, maybe even a confession. Delicately absorb it and when the urge pulls you to move on, just move on. If you give yourself just one hour, I guarantee you will discover people and places you were probably never aware of. If, at the end of the hour, you are not in the place where you started off your journey, don't panic. Be brave enough to ask someone for directions to point you in the right direction, or perhaps you find that you can take public transportation

to where your journey began. You have now opened yourself to another opportunity to creatively eavesdrop.

I find taking public transportation yields a gold mine in terms of observing human behavior. As people travel in the public space, you can encounter so many different experiences. Public transportation and public spaces are treasure chests.

Follow the turtle

At the turn of the century in Paris, Parisians wanted to experience a carefree life, so they would put a turtle on a leash. Like you would do with a dog, they let the turtle lead them. As we all know, turtles are slow, they often stop and generally don't seem to mind where they are going. This practice led to a style of strolling without a destination, allowing Parisians to see and experience their city moment by moment.

Now I am not suggesting that anyone find a turtle and put them on a leash today. PETA or some other organization is sure to come after me for suggesting this. But we can follow this example in other ways. In the same way you chose to wander in the first exercise, this time your wandering is slowed down significantly. Follow the Turtle is best experienced in a public park, or some outdoor space where you don't need to go far, but the opportunity to "creatively eavesdrop" is full of possibilities. During this adventure, wander very slowly and deliberately and remember – please – no turtle on a leash! As you do this, you are embedding yourself in the world around you so that you can become invisible to others in the immediate environment. You are just another bystander in the park or another public space. "Following your turtle," your sixth sense, take it all in.

The changing leader

Now I am going to suggest a slightly more daring adventure all with the intention of pushing you out of your comfort zone. The changing leader is much like the curious wanderer but with an added feature. Instead of just wandering when you reach a corner or an intersection, this time you are to pick a person in front of you to follow to the next corner or intersection. Following behind them at a safe distance of course so that when you reach the next crossing you can choose a new leader. If following this new leader takes you into a store or perhaps the lobby of a building, keep following. If someone looks like they are going into their home, don't follow them there!

Now this adventure is a bit more ambitious and I would say requires that you to experience the first two adventures before you try this one. You want to develop not only the courage to wander in places around the city you have not visited but also you have begun to hone your tools of observation and deep listening. It is known that people who are visually challenged have an increased sense of hearing, smell, taste and touch. The body naturally compensates to give the other senses added power. As you begin to witness these adventures, if you are a sighted person, you will begin to experience an added awareness of what your other senses are picking up. I would say do this for an hour as an exercise, but perhaps if you are encountering interesting people and places, stay with it as long as you can.

Hiding behind the lens

This should be an easy one, and it would be if you chose to do it in places you know. But because you have had the experiences of being the curious wanderer, of following the turtle, and of following the changing leader, we want to add something to this experience: taking photos. You can use your phone for this, but it is even more interesting to use a camera since nowadays real cameras have become so rare.

Find a new area to explore and, using any of the three adventures as a guide, now add taking photos to the mix. When you add the camera you are also perhaps drawing attention to yourself, so you must be not only discreet but also respectful of people's privacy. It is one thing to creatively eavesdrop on someone and perhaps witness something that could be deemed delicate. It is another to be documenting the same occurrence with your camera. In this case, the camera, because it draws attention, becomes a means for you to encounter a stranger. People may approach you wondering if you are a photographer. Well, yes! Today you are a photographer. Have a spontaneous conversation with someone who approaches you, which is an extremely informative moment-to-moment encounter. Perhaps if your conversation allows the person to relax, you can take their photo as a memento of this adventure. The important thing is to observe not so much what you see through the lens but how this device draws people to you and the spontaneous interactions that will happen.

I want to talk to you

Now you are becoming bolder, but as you can see all of these adventurers rely on you doing the previous one in advance. Adding a camera to our

last adventure has probably led to the fortune of attracting onlookers. Maybe someone was so curious they decided to talk to you. Now you can add another layer to your observation: conducting an interview.

In one of the areas you have chosen to wander in, find a person, or perhaps it is someone who has chosen to speak to you, and do an interview with them on the spot. This is a random encounter, and you must not launch into the interview like a news reporter covering a story. Let the interview happen naturally. It is an exchange. They were curious about you so now you can be curious about them. Adding a camera to our last adventure has probably led to the fortune of attracting onlookers. Maybe someone was so curious they decided to talk to you. Now you can add another layer to your observation: conducting an interview.

Just think: If you were to give yourself enough time on a nice day in your city or town you could observe and maybe even participate with others in your world who, prior to this day, you didn't even know. The important thing is to lose control, and losing control is a problem in our modern world. We let the city, the town, the environment, the world control us. These adventures will hopefully help you break this phenomenon and in doing so do more than just coax you out of your comfort zone. You will want to break free from your comfortable world so that you can be bold in your work and bold in your vision as a director.

These exercises are experiments in chance, and to be a director we want to let chance happen. Chance will enable the auteur in you.

Chapter 16

The power of improvisation

Along with working with Ken Cheeseman and his advanced actors, improvisation is something that has been an important part of director training. Bates Wilder, an actor, musician, and teacher of improvisation and games, has helped to train young directors for more than 20 years. After you begin to get out of your comfort zone via the practice of creative eavesdropping and some of the exercises I outlined in the previous chapter, the next step is to add more tools. You want ways to get the actor out of their comfort zone, away from their character for a moment and just have some fun. Here are a series of exercises that Bates Wilder shared with me that you can do. Some are best used at the start of a rehearsal period while others can be incorporated at a later stage of rehearsal and even during long days of production. All are very useful and fun to do for directors and for actors because they continue the process of taking chances and getting out of the comfort zone.

Warm-up

This can be anything you find that connects with your physicality. A connection to the physical, intellectual and emotional part of you is necessary for both actor and director. How these connect affects the work. If the actor is tense and restricted, the actor's work will suffer. The actor will be considering the way they feel while they are at work to play a character instead of living and breathing the life of the character. The actor has to find a neutral place to start from in order to get into being the character.

An actor with their head down, their arms crossed, they are closed. But if they are at neutral, arms unfolded, held by their side at the ready, they can go anywhere. It's called "jumping into the volcano." Give in and be willing to jump into the volcano, dive into the unknown and know when the scene is over you brush yourself off and you will be okay.

Be willing to be so exposed, completely vulnerable to the other characters. Don't worry about the camera. Focus on only what you want and what the other character wants from you. Find a way to incorporate task orientation. Without being physically aware and available you can't get to other things. Most of all, understand that acting is a safe space. Make it your safe space.

Mirror mirror

This is a basic mirror exercise. One actor (the Follower) follows the other actor's (the Leader's) movement. This is great as an icebreaker. The takeaway has to do with talking and listening. It's two actors paying attention to each other. As they get comfortable, you switch Leader and Follower. It will test if they are paying attention.

Being and doing

This is a game to know the difference between representation and presentation. Presentational acting is "I'm being happy or I'm being sad." This is the kind of acting that results from ROD. This kind of acting becomes very one dimensional. Representational means the actor is focused on the task. The actor is living the story not just telling the story. Writers and directors tell the story, but the actor is the one who lives the story. When you were a kid, you wanted someone to read a story to you out loud. Now as an adult you want someone to live the story, be the story.

Circle, square, triangle

You ask the actors to get in a circle. Readjust as needed to make a real circle. Observe as people move forward and back to try to define a real circle. Once you have everyone in the best circle they can make, then ask them to make a square. More moving forward, backward and sometimes to the side. Once they do it and it is the right configuration for a square, now ask them to make a triangle. One person always wants to be the point so let them negotiate who gets that role. When you finally have a triangle, then ask everyone to go back to the circle.

So, during this game, what happened? Taking directions happened, communication, knowing our shapes are the takeaways from this exercise. Let each director understand that by forming these shapes, each one lived an honest action. Creating a moment to make an adjustment. These became real moments of importance because they want to get it right.

Each might have a differing degree of interest in the game, but faced with this task they all work together to make adjustments.

Pass the pulse

Have the actors stay in a circle and hold hands. One person squeezes the person's hand next to them, and one by one they try to pass the squeeze around as fast as possible. This helps to teach them to want something, allow themselves to get in that place of wanting. They care about something as simple as squeezing the person's hand next to them.

The name game

The task in this game is to engage with the purpose of winning! You put everyone in a circle again. If you have five people then you assign each one a name from A to E. Then you begin: The first person starts "Hi! I'm Alan." Then you move to the next: "Hi, Alan, I'm Bob." On to the next: "Hi Alan, Hi Bob, I'm Claire." When someone makes a mistake you start with the letter D and move forward, "Hi Alan, Hi Bob, Hi Claire, I'm Dan." When people mess up, tease them. Not in a malicious way, but in a way to spur competition. The person who made the mistake knows they made a mistake, and depending on where you are in the alphabet, you want someone else to screw up. And when you finally get it right, everyone screams with joy that they remembered all the names. So, what is the acting value? You allowed yourself to become emotionally involved in something. Emotionally involved in remembering names. You put all your attention on this exercise. When you are working on the text, this lesson can be used with your actor to help shape emotional attachment to the story.

The name game (with colors)

Instead of a name, you are a color. Once a mistake is made with a particular color, that color cannot be used anymore. If the first color used was red, now you can use the color "bright red," or you can be "candy apple red" to avoid making another mistake. The first time you go around is usually easy, but as they become focused on getting it right, raise the stakes to make it important if you fail or succeed. In the absence of the risk to succeed or to fail, nothing happens. Make the actor want something and know if they don't get what they want, what it will mean to them. Now you have an actor that is ready to jump in the volcano.

Old King Cole

Everyone knows the song "Old King Cole was a merry old soul and a merry old soul was he." Start by putting the actors in a circle. Get them to say each phrase one at a time: "Old King Cole" "was a" "Merry old soul" "and a" "Merry old soul" "was" "he." This will teach them all the words. As they say it, on the "was" the person saying "was" bends at the knees. On "and a" everyone bends at the knees. This is a good one to elicit spontaneous emotions. The actors become emotionally attached to getting it right. Victory is important. Live, live, live and not die. If I bend right I win, and if I don't, I fail and I die. This is a good one for raising the stakes. Make something ordinary more important.

Minefield

The takeaway of this game is that you don't have to show a lot to communicate a message. You don't have to telegraph to make someone understand you. One actor has to make a decision, a decision that has two outcomes, a decision that could end with life or death based on what one actor communicates to the other actor. So how do we start?

Two actors face each other with a chair in the middle between them. One actor knows which side is safe to cross and which side has the minefield and the actor will be blown to pieces. The other actor has to figure out which way is safe by watching the actor who knows. How does the actor who knows indicate which way to go? Let the class make suggestions to the actor that has to cross.

The actor who knows can only blink or breathe in the direction of the other actor who moves from side to side all the while checking in with the actor who knows which way is safe. They cross left, then stop, then they move back to the right, stop and watch for a reaction. The actor must always land, come to a complete stop. As the actor is moving back and forth, they are watching for a clue sensing the right or the wrong way to go. When they finally feel they know, the actor makes a move to cross on the left or right side of the chair. So, is the actor dead or alive? The class then guesses. The actor who knows shares the answer. If they wanted the actor to live or they wanted the actor to . . . The other actors celebrate if they get it right or punish themselves if they get it wrong.

Bus stop

You place a bench in the middle of the room. It's the bus stop. The actor decides what is the place they are leaving from before they reach

the bus stop and where are they going when they get on the bus. When they enter, they can choose to sit or not sit while they wait for the bus. Then someone announces, "The bus is coming." Then moments later, "The bus is here," and the actor walks forward to get on the bus. Have one of the other actors ask the actor waiting for the bus where they are coming from and where they going. When they got to the bus stop, how does where they are coming from and where they are going effect how they wait? Maybe the person is running away from home, or they just robbed a bank, etc. The actor has to be specific. You want them to live in the Moment.

Letter endowment

You ask one of the actors to write themselves a note. The actor is now the writer and director. The actor puts the folded note on a table and then proceeds to make up a scene that will be interrupted when they read the note. They move to the side and then begin their journey from one place to another when they discover the note and pick it up. They read it. Something about the note makes them put it down and return the way they came.

What is really important is that they write their own note. The actor makes the choice to make the note important. This exercise is about adjustments. The actor wants to make the audience guess what is in the note. Then the audience is interested in the outcome.

In conclusion, here are some parting words from Bates: "The most important thing is that directors should understand the acting process. Directors can't dictate the world of the actor; they have to let each actor find their own way. A director guides, but it is the actor who engages in the journey. Give the actor the opportunity to do the work. Actors work best when they are not told what to do. Directing is an art form, a collaborative art form. The same goes for acting."

Epilogue

The journey of the actor's director hopefully begins with these exercises to build craft and continues to be nurtured throughout your life experience. With each project I have been fortunate to mount, I have learned something new about life and about myself. As I shared a story from my life in the chapter devoted to the Improv Monologue, I am reminded of just one of the multitude of experiences and encounters. I encourage every person who wishes to direct to get out of your comfort zone because I know firsthand that I have been getting out of mine since I was a child, whether it was on my own or with members of my family who knew to take a chance and that change was good.

To be a director is to be a master storyteller, but you cannot assume this role without experiences to share. Your experiences create stories to render and an openness to continue to invite the unknown into your life. So wherever you are, no matter your age, race, nationality or religion, there is a story from your life that you can share with the rest of the world. I hope this book has encouraged you to do that.

Continue reading and studying the works of directors – not with the intention to imitate or copy in some way. Let their works inspire you to dig down and tell a heartfelt, soul-stirring story from your life experience. In order to guide and encourage the actor to go deeper in their portrayals, we too as directors must be willing to go deep, maybe even deeper than the actor, as a demonstration of our passion and commitment. Our work honors the truth, the honesty of the moment. This I believe is our contribution to the process when we are working with actors, our willingness to go deep as a demonstration of how much we care about the work.

There is a chart in my syllabus that I share with my students, and, coincidentally, that is how it is spelled: CHART: Challenge, Honesty, Accountability, Reliability and Trust.

Challenge: Challenge yourself as a director to do the research, the necessary woodshedding to build a strong and overflowing wealth of information starting with your Five Ws, so that you can feed the entire preparation and production process. Pick the kind of material that will inspire you dig as deep as possible to unearth the truth. You want to bring to the world projects that you feel passionate about.

Honesty: Be honest with yourself as a director when you pick a project. Know in your heart that you are the person best suited to bring this project to life. Be honest with all your collaborators. You don't have to have all the answers. Most times it is best just to listen. Be honest about your abilities so that you can delegate and not dictate.

Accountability: First be accountable to yourself and what you set out to do. Be accountable to your actors and to all your collaborators because they all look to you to make it right. Be accountable to the budget and to time. Above all, be accountable to the truth of the project you are bringing to world.

Reliability: Let everyone working with you know that you have their back – particularly your actors. What you say you mean and you mean what you say. All things related to the production happen "in time."

Trust: This is the big one and particularly for the actor. Knowing they can trust their director is huge. We earn everyone's trust by what we do and how we honor all of those words that culminate with trust. Without trust, everything else breaks down. If you are about to embark on a project and you are building a team to help you realize that vision, trust is most important now.

Trust further breaks down in the following ways:

Trust your prep

You have spent hours and hours researching, thinking and planning before you even start to compose your Five Ws. Follow the steps of the process all the way to the documents and tools you need to rehearse and then start production. Do not act in the Moment without your prep! We all want to experience the spontaneity during production when the actor is alive in the Moment, but we also know that the ability to be free and ready to take a chance, comes from the backup and protection of preparation.

Trust your actor

The actor too has done their homework. They've done their woodshedding to prepare the role. They've researched the character and sometimes spent time in the real world of the story. They have perhaps even altered their physical appearance to get that much closer to who this character is. They come with skills, and what marvelous skills an actor has, to surrender themselves to portraying the life of the other. They are ready to believe in you as director and in your skills, so believe in them.

Watch the performance not your paperwork

Your prep is done, and, just like in an exam, you don't bring your books and your notes to the exam room. Study your work thoroughly at each step, and, as you use the work in rehearsal, which is the "open book" test of your preparation, begin to embody all of your work. Embody each layer and step in the process so that it lives in you and you can recall it at any time. If you have followed the steps, the steps are designed to feed the next step that follows so there is always a link to the beginning. Focus on the actor's performance. Be with them in the Now, in the Moment. This is how you become one with their process.

Recognize where the moments "really" are

You will plan and you will plot. You will rehearse and revise and continue to rehearse and revise, but recognize that the truth of performance is in the Moment. Moments can be composed via the craft of preparation, but once the actor is in performance and we are no longer rehearsing and now doing the work, this is where the Moments become real. When the actor has surrendered themselves to the character, they are just the vessel, and the essence and spirit of the character they are portraying, takes over. The performances that are celebrated in film, television, and theater were all rehearsed and, to a degree, planned. Still, remember all the stories we hear from the set that remind us that the world of acting is spontaneous, serendipitous, and sometimes even magical.

Let the verbs do the work then make adjustments

As we have seen from all the chapters in this book, verbs are the fuel that power the actor's work. We use our sixth sense, our intuition, our gut to compose verbs for each character and then via the Five Tools, identify the Primary Verbs that we need to drive the scene. These same

verbs are markers in our Director's Script to help us trigger the Intention changes that create tension resulting in Moments and Choices. Stronger than using "What if...?" verbs focus the work and take it out of the actor's head and put it into their body enabling the Kinesthetic Behavior. When the scene is not working, it is probably because you need to look at your verbs. Once the scene is up and moving along, then make your adjustments from your toolbox via the Triggering Facts, the Dynamic Event, and the all-important and powerful Sensory Images.

If you have made it this far, it is time to stop reading and go to work. The process has been explained, and you have taken it in. This book will be around, so when you need it put it to use along with other books that have been suggested for your library.

It has been a pleasure to travel with you on this journey, and I look forward to the film, television projects, and media projects of all sorts that were guided by these lessons. I feel privileged to be able to share my journey with the hope it inspires your journey to become an actor's director.

Addendum

Here are some of the handouts I use in class with my directing students to develop use of the Five Ws, Three Questions to Choice and the Five Tools.

Three Questions to Choice

Character analysis must be experiential – What the character needs and wants.

Objective

What the character is pursuing. Some call is motivation, need, but we use "Objective." The Objective is not an Action, the Objective generates an Action, so it is linked to the character's emotional core. Objective should also "raise the stakes," a term actors will use for the character, so that pursuit of the Objective becomes life or death. Also, because the Objective generates an Action, it is the source of Kinesthetic Behavior for the character. Pursuit of the character's objective is what causes Moments and in the scene.

Intention

"How" the character goes about achieving the Objective is Intention. What means do they use at their disposal or what opportunities do they create in pursuit of the objective. Intention is expressed via verbs: "to seduce," "to surrender," etc. Verbs initiate Action, as character is defined by Action. In our preparation, there are several steps we take to arrive at the Primary Verbs or Intentions. These are the verbs that principally power the character's pursuit of their Objective.

Obstacles

In simple terms, the Obstacle is the direct obstruction to Objective. The Obstacle is what the character faces and must overcome in pursuit of the Objective. The Obstacle should be external and is strongest if it is the other person(s) in the scene or an immediate external situation. Characters do not create Obstacles to their Objective by themselves. If the Obstacle is of the character's own making, that character flaw, that "Achilles heel" is triggered by the other character in the scene or an external incident.

Choice

If the action the character chooses to take results in the original Objective not being achieved, a new Choice is made in pursuit of a new Objective. Choice is best expressed by harvesting the description of Objective and finishing with a description of the Choice. If there is logic in these two statements, both Objective and Choice are accurate.

The Five Tools

List of Verbs

This section begins with listing the verbs for each character in chronological or "arc" order. That is from the Opening Verb (Opening Intention) to the Final Verb of the scene. This section is built by harvesting the verbs from Intention in the Three Questions to Choice. These are all the verbs previously found via the sixth sense, that the director feels the actor is using to pursue the Objective. This is a key step to compose the Two Sentences.

Two Sentences

Using the list of verbs above, create Two Sentences that become two verb-driven statements of Action describing the scene. No explanation or description is needed. This step requires multiple revisions to finally create two sentences that reveal the Primary Verbs. These are the verbs that will power the scene. Once found, these verbs should be identified via **bold** type, *italics* or in some way that sets them apart from the List of Verbs. This same indication is made in the List of Verbs and in Intention as part of the Three Questions to Choice.

Triggering Facts

These are not the actor's "given circumstances," which belong as part of the Storyline Facts after the Five Ws that provide backstory to preview the characters and the scene. The Triggering Facts focus on "what just happened" to cause this scene to happen. The facts needed here are the facts that launch the scene, the immediate incident that bring us to this Now moment.

Dynamic Event

There are unique happenings within the scene that the characters must respond to, but the Dynamic Event is different. The Dynamic Event is the game changer, often unexpected, or triggered by one of a character's actions. Sometimes called "the turn" by actors, the Dynamic Event usually triggers Choice in the scene.

Sensory Images

This is where your five senses and ultimately the five senses of the actor – sight, hearing, taste, smell, and touch – get involved. What do your five senses encounter in the world where the scene plays? Slowly experience each of these senses one at a time and describe the experience of each one. You do this as an observer. Do not place the characters in this world – that comes next. The Sensory Images are most important because they are the keys to the subworld of the character, the place where the actor wants to be so that their performance is "being," not "acting."

Kinesthetic Behavior

When we place the characters in this world, the Sensory Images trigger Kinesthetic Behavior. This section describes how the character pursues their Objective in the Sensory world you have created, how that Sensory World either supports or obstructs achieving their Objective. This is where the actor puts the performance into their body and gets it out of their head. This is where they make tactical adjustments that we witness in their physical behavior. You begin composing this section by first harvesting Objective for both characters so that it is clear what they want, and then, without describing any physical gestures or activities, talk about how the sensory world assists or obstructs their pursuit of the Objective. This is a hard section to compose because it tests

the director's ability not to dictate physical behavior, not to create "emotional appointments" or "ROD." This final section takes patience because in this final section, the director must let go and let the actor put the performance into the character's body.

Boardwalk Empire

Here are a series of assignments using *Boardwalk Empire* to put the Five Ws, Three Questions to Choice and the Five Tools to use.

What?

Set in the dawn of Prohibition, *Boardwalk Empire* is about ORGANIZED CRIME, CORRUPTION, VICES, JUSTICE, COMPETITION, POWER, GREED, VANITY, and FAMILY. It tells the tale of a new American frontier where money and bootlegged alcohol replaces law and order. Taking advantage of the nationwide criminalization of alcohol, America's mob bosses and politicians conspire together in smoky speakeasies filled with whiskey, jazz, and prostitutes. The nation lies disfigured and carved up in countless gang territories. Selling illicit alcohol proves extremely profitable – the mob bosses live outlandishly in mansions and drive the fastest cars, but when their interests collide, however, war erupts in the streets.

Who?

Many of the characters are inspired from, or taken from, real figures from the 1920s.

Enoch "Nucky" Thompson

His real name is Enoch Thompson, and he was actually Atlantic City's treasurer during this period. Born in squalid conditions among wharf rats, Nucky Thompson learned from an early age how to fend for himself. Having an abusive drunk for a father, Nucky had to work since he was young to provide for his family. As the unspoken ruler of Atlantic City, he decides the day-to-day life of the town. He lives in two worlds. In the first, he is the respectable father-like figure, the treasurer of Atlantic City, who is always there to help someone in need. The second is a shadow world, where he is able to provide for another constituency through breaking the very law that he was sworn in to uphold. His business attitude in this criminal underbelly is ruthless, cold, and calculating. The

only things he believes in are those that he can physically grasp, those that make him money.

His wife, a very beautiful woman, died from consumption, so for Nucky life has taken away every pleasure, every semblance of happiness: FAMILY. He is a shell of a man who is dead on the inside. He unceasingly vies for control so that life will never again take anything away from him. In an era marked by excess and good times, Nucky stands aloof without allegiance to anyone. Everything is business; everything is transactional. Anyone obstructing his business ventures will feel the tip of a cold steel bullet in their skulls as a personal gesture from his own, smoking gun.

Margaret Schroder

Mrs. Schroeder is an Irish immigrant. Brought up as a good Catholic girl, she consciously tries to do good. Her husband is a drunk, and he beats her. She is pregnant with their third child, and the family does not have the means to support another baby. She came to America for a better life but now lives in misery and constant fear of a man who drinks away all their money. Her values as a good Catholic girl are choking her existence. She cannot find it within herself to ask for help. Seeking financial aid from anyone in her eyes would be beggary, and she cannot conceive of leaving her husband no matter how badly he behaves toward her. It just wasn't done during this time. She made a vow "for better or for worse," and that is the way it is. But, like Nucky, there is a desire to control her destiny burning deep within her. Beneath her humble exterior lives AMBITION.

Eli Thompson

Grew up under his brother's protection. Nucky would take beatings from his dad in Eli's place. Now as sheriff Eli repays his brother by doing his dirty work. Eli is physically larger and more attractive than his brother but feels somehow cheated out of his life. Childhood loyalty and fear of his brother stops Eli from acting on his own hidden feelings of envy.

Nelson Van Alden

A Prohibition agent. His mission is to bring bootlegger bosses to justice by finding and destroying large stores of alcohol in illegal speakeasies and distilleries. Deeply religious and puritanical, Agent Van Alden

takes great pleasure in smashing casks of whiskey with a hatchet as he relinquishes God's wrath upon the filth of this Sodom by the sea. He is in a loveless marriage. He represses his sexual desires by whipping his back with a belt to remind himself that his profession is godly. He derives satisfaction of living in superiority to the filth that are prostituting themselves out for money and drugs.

Where

The series is set in Atlantic City, New Jersey, and other cities such as New York City and Chicago as well. Situated on the coast, Atlantic City historically served as a major importing point for bootlegged alcohol from Canada and Europe. The city is built with blood money. It is known for its boardwalk that boasts night clubs, casinos, and the Ritz. The city is segregated based on race. Its large black population works on the lower rungs of the social ladder as bus boys and trash men. They report to their boss Chalky White, who in turn reports to Nucky Thompson. Much of the white population is Irish Catholic. Touching the Mason–Dixon Line, the KKK is alive and well in a post-Civil War world. The cosmopolitan nature of Atlantic City encapsulates a changing and diversifying America. Although race wars explode on the streets occasionally, generally the city operates smoothly with different races working together because of the shared riches that bootlegging offers.

When

The period is the 1920s. It is an era defined by excess on a histrionic scale. With technology progressing at an unprecedented rate, cites like New York roared with delirium. Writers like F. Scott Fitzgerald and Ernest Hemingway had an obsession with finding meaning in an increasingly materialistic society. More people during this period lived in cities than any other in American history. The city symbolized untapped dreams where its fruition was only a grasp away.

World War I has recently ended. American soldiers returned home eager to forget about the inhuman trenches in which they lost their belief in God. They drink to forget and to dream up a new and better reality. The dawning of jazz music transmits this idea of change. With its improvisational nature, it taps into the social subconscious that is fast-paced, constantly transforming, and free-thinking.

The political mindset has been altered drastically. Women have received the right to vote. Flapper girls wear short dresses and hang out alone at

parties. The movie industry has recently been born. Again, it represents an ability of changing one's own reality. Whether you are from a small town with dreams of becoming a movie actor, or someone in the audience who wants to escape from a grueling work day, the inception of cinema has created a way to travel to different worlds without leaving a darkened room. The 1920s rendered reality superfluous.

Why

Boardwalk Empire peels back our justifications for our choices we make. Nothing is black and white. The characters are forced to make hard decisions in situations that they are involuntarily hurled into. Above the criminal underworld, these gang bosses walk through the city streets with their children and wives. They are family men as well. It is as if when they climb down underneath morality they are entering a game in which there are a few unspoken rules. It is a game where lives are wagered for their own ends. Participants know that the merit of the game is not inherent in itself but rather in the value of that which is put at hazard. Games of chance require a wager to have meaning at all. It validates their existence and choices. *Boardwalk Empire* is a dark portrayal of bloody, vicious American Dream.

Storyline facts

Coming from a world of ORGANIZED CRIME, CORRUPTION, VICES, JUSTICE, COMPETITION, POWER, GREED, VANITY, Nucky must wear the mask of a man of virtue and temperance meeting with Mrs. Schroeder as Prohibition has ushered in a new reality that he must now navigate. Margaret Schroeder trying her best not to surrender to the world of ORGANIZED CRIME, CORRUPTION, VICES, JUSTICE, COMPETITION, POWER, GREED, VANITY, forces herself to take a chance on meeting Nucky Thompson. He is perhaps the only person with the power to save her family.

Three Questions to Choice

Nucky

Objective: Uphold his public persona.
Intention: **To charm**, to decipher, to recognize, to demand, **to comfort/** console, to distract, to confess, **to accommodate, to insist**, to diffuse/disarm.

Obstacle: Ms. Danziger could expose him.
Choice: To uphold his public persona, he helps Margaret financially.

Margaret

Objective: To ensure the survival of her children.
Intention: to pretend, **to cower, to compose**, to confide/**confess**, to relate, to conceal, to plead, to refuse, **to oblige**.
Obstacle: Threat of Nucky's refusal.
Choice: To accept the money from Nucky to ensure her survival.

Five Tools

Verbs

Nucky: **to charm**, to decipher, to recognize, to demand, **to comfort**/console, to distract, to confess, **to accommodate, to insist**, to diffuse/disarm.
Margaret: to pretend, **to cower, to compose**, to confide/**confess**, to relate, to conceal, to plead, to refuse, **to oblige**

Two Sentences

Nucky **charms** then **comforts** Margaret, as she **cowers**, until she **composes** herself and **confesses**. Nucky **accommodates** her needs and **insists** until Margaret **obliges**.

Triggering Facts

The morning of New Year's Day and Nucky is surprised by his valet who announces there is a woman waiting to see him – and she is pregnant! Margaret has waited an hour in the lobby of his office when she knows that leaving the house for this long will arouse suspicion from her husband.

Dynamic Event

Ms. Danziger makes an unexpected appearance.

Sensory Images

The room smells of rich walnut. It is not the bar room of Nucky's night club, a place where hooligans get drunk and fight – it is pristinely

maintained. It is a place of power, where the elites of society dissociate themselves from the common riffraff. The ceiling is high, echoing the power of the elite. Calliope music is heard in the background from the merry-go-round on the boardwalk. You can smell the remnants of pipe smoke mixing with the smell of walnut adding to the rich allure of the room. A great wooden desk sits at the end of the room; it is grand and stately, not unlike the Resolute Desk found in the Oval Office. Touching the wood, you know it is real and the furniture makes everyone sit upright. The taste in this room is a mix of cigars and the remnants of good scotch.

Kinesthetic Behavior

Nucky: To uphold his public persona.
Margaret: To ensure the survival of her children.

Margaret enters the room as if she is entering a new world. She is careful not to disturb anything – everything is too beautiful. The tall ceiling looms over her as some great cold god that is looking down upon her, judging her every movement. It frightens her, and she settles into the chair in a way to protect herself and her baby from the unknown.

The grand desk and the rich aroma of the room reminds Nucky of his escape from a life of misery. It invigorates him. He will never go back to that life; it's what keeps him fighting. He glides across the room with ease. This is his dance of life – and he has done this many times before.

FrameForge

All storyboard images (see Chapter 12) were created in the FrameForge Studio Software, winner of a Technical Achievement Emmy for the program's "proven track record of saving productions time and money." Users of FrameForge routinely tell us their shoots went dramatically faster and smoother than before they used it, and that they not only wrapped on time but also got more coverage due to the time savings produced by having a real blueprint of the shots.

Readers of this book can get an extra 20 percent off our lowest prices on FrameForge (excluding upgrades and individual expansion packs) by entering coupon code "<shortened Book title>" at www.frameforge.com.

Index

Accountability 168
Actions 16, 17, 19, 27, 28, 30, 42, 71, 118, 128, 137, 150, 156
actors 1, 15, 17, 105, 162, 166, 169
Arc Order 28, 55, 172

Barlovento, Venezuela 38–39
Beat changes 58, 63–64, 67–70, 118
Beats 54, 58, 63–64, 66–70; *see also* Intentions
Beautiful Boy 87, 88, 89, 97
Black Panther 3, 6, 23, 102, 103
blocking 85, 101, 107, 154
Boardwalk Empire 12–14, 15, 62–64, 65, 151, 174–179; Choices 23–25, 177–178; Dynamic Event 33, 178; Intentions 56–60, 65–67; Kinesthetic Behavior 53, 54, 179; Moments 23–25; Objectives 23–25, 57–58, 63; Primary Verbs 28, 29, 30, 31, 59, 65–66, 178; Sensory Images 52–53, 178–179; Storyline Facts 13–15, 177; Triggering Facts 31, 32, 178; Two Sentences 28, 62, 63–64, 178
Boston Marathon bombing (2013) 20–21, 88
bus stop 165–166

capture 110, 137, 145, 146, 149–150, 152, 154–155, 157
Challenge 168
Chapters 57, 67, 75, 76, 77, 94, 97, 101, 104, 107, 108, 153
character building 3–4, 15, 16–18, 19–20, 22; *see also* Schroeder, Margaret; Thompson, Nucky
CHART (Challenge, Honesty, Accountability, Reliability and Trust) 167–168
Cheeseman, Ken 92–93, 94, 95, 155
Choices 23, 24, 25–26, 55, 58, 61, 67, 157, 171–172; *Boardwalk Empire* 23–25, 177–178
cinematography 77–78, 110, 145
close to the line 78, 96, 97

collaboration 1, 72, 82, 85, 86–87, 95; *see also* Improvised Monologues; Scripted Monologues
Crawford, Alonzo 18
creative eavesdropping 20, 21–22, 48–49, 50, 80, 157–161
crossing the line 96, 104, 137, 138, 149
curious wanderer 158–159

Darkest Hour 7
directions, taking 163–164
directors 1, 2, 21–22, 105, 166, 167
Director's Script 30, 54, 61, 67, 70, 99, 103, 104, 157; Greg and Laurel 140–143
Dynamic Event 32–33, 55, 59–60, 102, 173; *Boardwalk Empire* 33, 178

emotional involvement 164–165
Ex Machina 6
eyeline 77, 78, 96, 97, 153

Favourite, The 23
five senses 21–22
Five Tools 60, 62, 99, 101, 157, 172–173; *see also* Dynamic Event; List of Verbs; Sensory Images; Triggering Facts; Two Sentences
Five Ws 2–8, 9, 10, 11–12, 16, 20, 27, 62, 157
Flam, Morris (Mo) 147–148
focus 60, 81, 154, 156
follow the turtle 159
FrameForge Studio Software 179

Get Out 7
given circumstances *see* Storyline Facts
Gods Are Not to Blame, The 36–37
Green Book 23, 103
Greg and Laurel 111–118, 119–127, 128–136, 137–143, 154, 155
guiding 1–2

Hambone 35–36
Her 6

Index

Honesty 168
Hubert and Elena 68–70
human interaction 56, 59

improvisation 162–166
Improvised Monologues 71–76, 78, 79, 81–83, 84, 92, 93–96, 97, 153
inserts 150–151
in the body 85
Intentions 18–19, 25, 54, 56, 58, 61, 65, 171; *Boardwalk Empire* 56–60, 65–67; List of Verbs 20, 22, 28–31; Opening Intentions 27, 28, 30, 32, 55, 57, 64, 67
interviews 161

Jason and the Argonauts 22

Kinesthetic Behavior 34, 43, 45, 47, 52, 103, 104, 105, 107, 108, 153–154, 170, 173–174; *Boardwalk Empire* 53, 54, 179; Scripted Monologues 85, 97; *see also* Sensory Images
Kingdon, Tom 62, 65

Leader, Changing 159–160
lighting 147–149, 152
List of Verbs 20, 28–31, 65, 172; Intentions 20, 22, 28–31

Marked Script 30, 54, 61, 62, 63, 67–70, 85, 94, 99, 103, 104–105, 107
Mary Queen of Scots 17, 71, 81, 103
masters 149–150, 152, 155
Meter 19–20
Michael Clayton 119
Midnight Sun 5
Minefield 165
Mirror Exercise 163
Moment of Choice *see* Choices
Moments 54, 56, 58–59, 60, 61, 65, 67, 93, 154, 169; *Boardwalk Empire* 23–25
monologues 70, 71–76, 84–85, 89–90, 93, 94–96, 153–154
Musuko 41–42

Name Game 164
Native Son 50–52
note writing 166

Objectives 16–17, 19–20, 22, 23, 25, 26, 34, 53, 54, 55, 62, 65, 171; *Boardwalk Empire* 23–25, 57–58, 63
Obstacles 22–23, 25, 26, 57, 62, 172
Ogunmola, Kola 37–38
Old King Cole 165
Opening Intentions 27, 28, 30, 32, 55, 57, 64, 67
orchestras 2

OTS (over the shoulder) 78, 81, 97, 150, 152, 153
Ozu, Yasujiro 40, 41

Paynter, Bob 146–147
photographs, taking 160–161
physical behavior *see* Kinesthetic Behavior
preparation 1, 8–9, 54, 60–61, 168, 169
presentational acting 163
previsualization 103, 110–111, 118–119, 128, 137, 144, 146, 150, 157; *Greg and Laurel* 119–127
Prezi (visualization tool) 10
Primary Verbs 22, 27, 28–30, 33, 55, 57, 59, 65, 104–105, 169–170, 172; *Boardwalk Empire* 28, 29, 30, 31, 59, 65, 178
production 145–151, 152, 154–155, 157

Ragtime 9, 42–44, 148
read-through 99–100, 106
rehearsals 34–35, 36, 99–102, 103–105, 106–109, 137, 151, 157, 169
Reliability 168
representational acting 163
response 92
ROD (Result-Oriented Direction) 15, 20
Roma 3, 6, 102
Rotimi, Ola 36–37

scene partners 78, 89–90, 93, 98, 153–154; Improvised Monologues 71, 72; Scripted Monologues 85, 87, 88, 89, 90, 96–97, 153
scene work 153–156
Schroeder, Margaret (*Boardwalk Empire*) 13, 23–25, 151, 175; Choices 24–25, 178; Dynamic Event 33; Intentions 56–57, 58, 59, 60, 66–67; Kinesthetic Behavior 52, 53, 179; Objectives 24–25, 58, 63; Opening Intentions 57, 64, 67; Primary Verbs 28, 29, 30, 31, 65; Sensory Images 54; Storyline Facts 14, 15, 31; Triggering Facts 31, 32
Scripted Monologues 85–88, 89, 90–91, 96–98, 153
secondary masters 150, 152, 155
Sensory Images 34–38, 40, 41–48, 50–54, 55, 62, 102–103, 106, 157–161, 173; *Boardwalk Empire* 52–53, 178–179
Shape of Water, The 102–103
Sherpas 1–2
shoot (the shot) 145
Song of a Goat 40
Star is Born, A 23
Star Wars 7, 22
storyboards 110–111, 118–119, 128, 138–143, 146, 157; *Greg and Laurel* 128–136
Story Exchange 71–76, 79–80, 81–83, 84

Storyline Facts 10, 12, 13–15, 27, 62, 157, 173; *Boardwalk Empire* 13–15, 177
Story of Barboza, The 46–49

technical rehearsals 34–35, 36
television 145–146
tension 138–139, 150
Thompson, Nucky (*Boardwalk Empire*) 12–13, 23–25, 151, 174–175; Choices 177–178; Dynamic Event 33; Intentions 56–57, 58, 59, 60, 65–67; Kinesthetic Behavior 52–53, 179; Objectives 57–58, 63; Opening Intentions 64, 67; Primary Verbs 28, 29, 30, 31, 65; Sensory Images 54; Storyline Facts 14, 15; Triggering Facts 32
Three Billboards 5, 7, 17
Three-Point Lighting 147–149, 152
Three Questions to Choice 36, 45, 47, 48
Tora-san film series 7–8, 40–41
Trading Places 44–46, 146–147, 148
Triggering Facts 15, 31–32, 55, 62, 101–102, 107, 173; *Boardwalk Empire* 31, 32, 178
Trust 168–169

Two Sentences 62, 172; *Boardwalk Empire* 28, 63, 64, 178

verbs 18, 19–20, 22, 25, 27, 28–31, 169–170; *see also* List of Verbs; Primary Verbs
Vice 3, 6, 17, 103, 151
visionary prose 8–9

wallpapering 90, 97, 146
warm-up 162–163
Weston, Judith 18, 19, 27
What 2–3, 12
When 5–6
Where 4–5
Who 3–4, 20
Why 6–8
Wilder, Bates 162, 166
World Trade Center, New York City 88–89
Wright, Richard 50

Yamada, Yoji 7, 8, 40, 41
Yoruba Opera 37–38